EUROPEAN
PORCELAIN

EUROPEAN
PORCELAIN

JAN DIVIŠ

PEERAGE BOOKS

English edition first published 1983 by
Peerage Books
59 Grosvenor Street
London W1

ISBN 0 907408 76 1

Printed in Czechoslovakia
2/09/06/51–01

Designed and produced by Artia
Text by Jan Diviš
Translated by Iris Urwin
Photographs by Soňa Divišová
Drawings by Ivan Kafka
Graphic design by Miroslav Houska

Contents

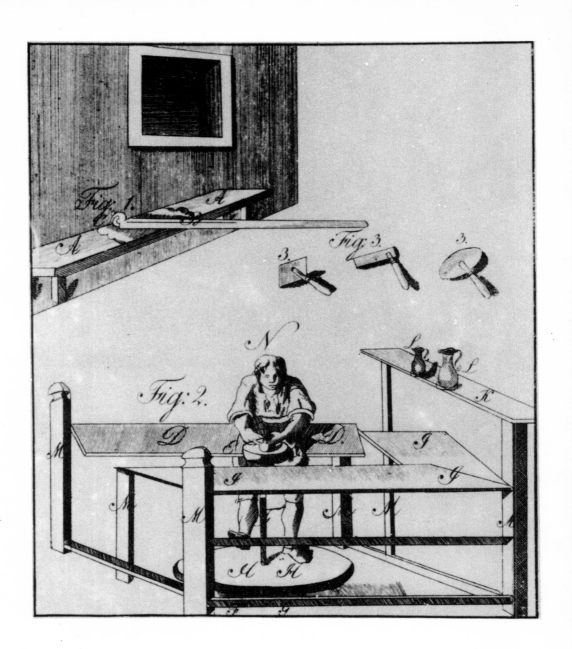

Introduction

Man has made use of pottery ever since prehistoric times: his home and his life-style are unthinkable without it. Starting with the simplest clay vessels, he progressed towards the finest ceramic material — porcelain. This first happened in China; it was centuries before Europeans discovered the secret of porcelain manufacture, and even then, technically speaking, it was not porcelain of the Chinese type that was produced.

This book is about European porcelain, which came into being because of the fame of Chinese porcelain, after years of experiments by simple potters and by famous "alchemists". Perhaps these very difficulties account for the enthusiasm with which the new material was welcomed; before long Europe had her own artists in the making of porcelain, able to produce anything from articles of everyday use to large statues. Many streams united to form this broad flood, each flowing from its own source, with its cultural tradition and attitude to art, its own techniques and even a different composition for the material used for porcelain. The European attitude towards porcelain changed, too, in the course of time, from one of admiration, when only acknowledged artists were entrusted with the precious material, to the mass production of utility articles with no regard for artistic standards.

It is the aim of this book to give at least the rough outlines of this involved story and lay down guide-lines for those interested in the history of porcelain. It is thus a book for the layman with little previous knowledge of the subject, who will probably want to go deeper on his own. Hence the division into separate sections, and the full list of specialized literature. The Concise Encyclopedia of Porcelain (pp. 147—209) then presents the inexperienced collector with practical basic information about the technology of porcelain making and about factories and modellers, and explanations of the commonest technical terms.

Naturally enough, the book lays principal stress on the eighteenth century, the time when the art of porcelain making reached its zenith; the nineteenth and early twentieth centuries are treated so as to bring out all trends which decided later development. In keeping with the author's intentions, the illustrations not only serve to document the successive historical periods of the art, but also provide material for comparative study. It is his hope that the book will win new admirers, collectors and connoisseurs of porcelain, and encourage them to take their interest further and deeper.

It is also the author's pleasant duty to thank the Director of the Museum of Decorative Arts in Prague, Dr. Dagmar Hejdová, for permission to photograph the majority of the items figured in the illustrations, and Mr. Otto Koči, of the Museum, for his help in selecting the material.

Europe
and Porcelain

Porcelain, the finest and loveliest ceramic ware, was the invention of the Chinese, who had always regarded pottery with as much attention, theoretical study and individual enthusiasm as the people of Europe gave painting and sculpture. Hence it was in China that the first collectors of pottery appeared over eight centuries ago.

The family tree of Chinese porcelain goes back a very long way, to vessels made of a material now known as proto-porcelain. Chemical analysis of the greyish body and the olive-grey glaze confirmed that the clay used was rich in felspar. Although in many cases the provenance of these vessels is known — Shen-si province, the region round Nanking, the province of Che-chiang — it is very difficult to date them at all precisely; this kind of pottery was made over a very long time, from the Han dynasty (206 B.C.–220 A.D.) through the T'ang dynasty (618–906 A.D.). Ringing hard, with a glaze that is almost inseparable from the body, this ware represented a technical step forward of fundamental significance. The potters of China were thus working with a ceramic paste that only needed further improvement in the technology of production to give a white translucent porcelain. This stage was reached at the latest under the T'ang dynasty, when the first true porcelain is found. In China, however, the distinction between porcelain and other ceramic ware is never so firm as in Europe; porcelain is simply one type of pottery, and the language does not even have a special word for it.

During the Middle Ages Chinese porcelain rarely reached Europe, where Chinese silk was the traditional import, carried by merchants operating from the Middle East. Not that Chinese porcelain was completely unknown, for apart from sporadic appearances as an article of commerce porcelain was often among the gifts brought by official emissaries. The Crusaders made the acquaintance of porcelain ware on their campaigns in the Holy Land, and it was certainly tempting booty. Several pieces dating from this period are still preserved in Europe. The fact that old Chinese porcelain was highly esteemed can be seen from the later fashion of setting porcelain pieces in precious metals, like the celadon bowl of the Sung dynasty (960–1279 A.D.) which was set in silver round about 1450. It is now in the Landesmuseum in Cassel. New College, Oxford, possesses a Chinese porcelain bowl probably belonging to Archbishop Warham (c. 1450–1532) which was set on a silver stand about 1530.

Many efforts had been made from Europe to establish contact with the great continent of Asia which, although it was Europe's nextdoor neighbour, as it were, seemed shut off and strange. In the thirteenth century these efforts were intensified. The first step towards direct contact was taken by the Church: Pope Innocent IV sent two missions to the Mongols, from Lyon; one, led by the Franciscan monk Laurentius, set off to cross Syria and reach the Mongol tribes in Persia, while the other, led by another Franciscan, Giovanni di Piano Carpini, wanted to reach Khan Güyug, who then lived to the west of the town of Karakorum. Neither of these missions was successful. Another set out in 1249, aiming to reach the eastern Mongols; sent by the French king Louis IX, it was led by Andreas of Longjumeau. After unsuccessful negotiations with the widow of Khan Güyuk, Oghul-Qaimish, the mission returned to France in 1251. The Franciscan monk William Rubruk, who was sent by the king of France to establish diplomatic relations with the Mongols in 1253, left a lengthy account of his unsuccessful visit to Khan Mangu.

Official attempts to penetrate the world

of Asia were thus unsuccessful, so it was all the more important for Europe when the Venetian merchant Marco Polo set out for China, not to further religious or political aims, but to engage in commerce. In the company of his father Nicolo and his uncle Matteo he left Venice at the end of 1271 or early in 1272, and arrived back home in 1295 or at the beginning of 1296. Among the achievements of his voyage was the book he wrote in 1298, which was so popular throughout Europe that over 140 manuscripts and early editions have been found. Marco Polo's *Travels* revealed to Europe a new world of which till then only tiny fragments had been seen. The book has a particular relevance for us, because it is the first practical account of Chinese porcelain and how it was produced. In Book 2, Chapter LXXVII (the Ramusius version as published by the City of Venice in 1956), Marco Polo wrote: "Following the main course of the river to the North, we came to the city of Tingui. All that we can say of the place is that porcelain bowls and dishes are made there, in the manner which was explained to us: they take special clay from a certain pit, pile it in a heap and leave it in the wind, rain and sunshine for thirty or even forty years, and do not touch it. During this time the clay becomes so fine that they can shape bowls of it, and paint them with colours as they wish, and then fire them in a furnace. So that those who dig this clay do so for their sons or grandsons. There is a great market in the city, where porcelain wares are sold, and for one Venetian groschen you can buy eight bowls." This account is not only the first report we have of the technology of porcelain making, but the first example of the use of the word itself in European literature.

Trade with China was very limited during the Middle Ages, for lack of communications. Not until two hundred years after Marco Polo's book appeared did the Portuguese navigator Vasco da Gama discover the sea route to India, thus opening up for Europe the wealth of the Orient. The maritime countries of Europe struggled fiercely for primacy in these new fields; Spain watched jealously as Portugal grew rich with trade, and in 1580 conquered her neighbour and grabbed the East Indian connection. Holland and England were not content to sit back and watch; in the seventeenth century the

Dutch became very active, in the eighteenth century the British. Trade with Asia was proving remarkably rewarding; besides spices, silks and precious woods, porcelain was not the least valuable of the imports. From as early as the sixteenth century European society was cultivated enough to appreciate the unique quality of porcelain, perhaps because European maiolica and faience (tin-glazed earthenware) had already reached a high standard. In his "Bergpostill", which first appeared in Nuremberg in 1562, Mathesius wrote that porcelain was so precious and expensive that merely the highest society could afford it, and he also noted the superstition that a porcelain vessel would shatter if the food or drink it held contained poison, a superstition which had quite a long life in Europe.

Porcelain was expansive, and a highly profitable article of trade. The auction of a single cargo of porcelain in Amsterdam in 1602 brought the merchants a clear profit of five million gulden. In the seventeenth century the merchants of Holland and England completely monopolized trade with Asia, thanks to the vastly superior construction of their ships, the navigational skill of their sailors, and the establishment of the East India Company in England in 1600 and its Dutch equivalent in 1602. These two companies, with their sound capital, could trade with Asia on a large scale. In 1612 a ship brought 38,641 articles of porcelain from Nanking to Amsterdam, while two years later another cargo consisted of 69,057 items. It is estimated (M. Beurdeley) that between 1604 and 1656 the Dutch imported over three million pieces of porcelain. In 1698 France also set up an East India Company, followed later by other European countries: Denmark in 1728, Sweden in 1731, Austria in 1775. This flood of Asian porcelain imported into Europe became even greater when Japanese porcelain was first introduced in the middle of the seventeenth century. The record cargo seems to have been one carried by a Dutch ship and said to have been made up of 80,000 coffee cups, 300,000 tea cups, 2,000 fruit bowls, 1,658 bottles for rosewater, and 187 chamber pots. It is estimated that Sweden alone imported eleven million pieces of porcelain ware between 1750 and 1775.

When political conditions were quieter

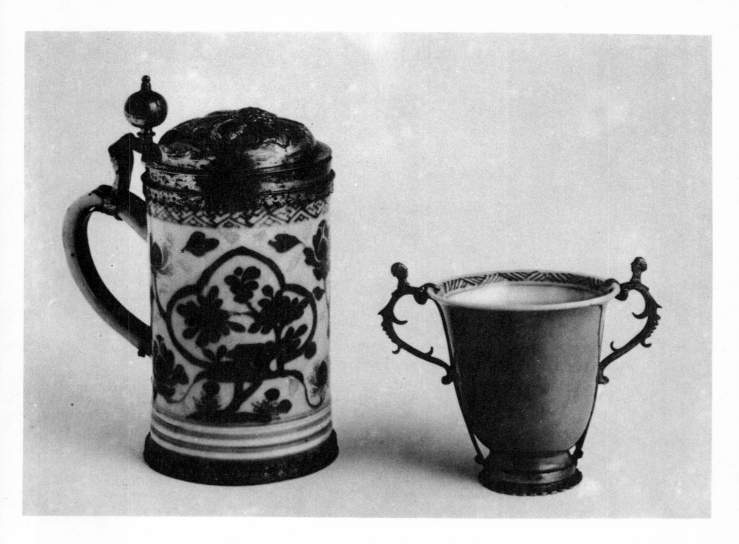

1 Chinese porcelain of the second half of the seventeenth century, mounted in contemporary European style

after the Thirty Years' War, the use of porcelain spread among the well-to-do burgher families too, but its high price still restricted it to the wealthiest among them. For those who could not afford true porcelain there were maiolica and faience at a more reasonable price. Dutch potters, loftily calling themselves "bakers of porcelain", met this demand with blue and white faience which took the place of Asian porcelain in less wealthy families. The Delft potteries were the most famous for this ware, but similar faience was also made in Germany, France and England (where it was called "delftware").

Towards the end of the seventeenth century royal and aristocratic collectors began to arrange special rooms to display their porcelain. These "porcelain cabinets" were a variation on the "cabinets of curiosities" and works of art, popular at greater and lesser courts ever since the Renaissance. A piece of porcelain was still rare and precious, and porcelain therefore deserved its "cabinet". No architect designing an eighteenth-century residence could omit this essential feature, and engravings suggesting various arrangements for the cabinet were also published. The earliest date from the last quarter of the seventeenth century, in F. Blondel's *Cours d'architecture*. As F. H. Hofmann has said, the principles on which the porcelain cabinets were arranged derived from the silver display sideboards of the late seventeenth century, in which the exhibits were arranged on shelves. In the eighteenth century, however, the general impression of the whole

11

room, filled with porcelain, was considered more important than the beauty of individual pieces. For this reason the walls of the cabinet were lined with mirrors, and bracket-shelves bearing the exhibits covered them right up to the ceiling. It was the quantity, rather than the artistic quality of the porcelain on show, that was meant to impress, as can be seen from the designs for the Dresden Japanese Palace. The Elector of Saxony, Augustus the Strong, who was one of the most zealous collectors of porcelain, wanted to have every room in the palace full of porcelain; the arrangement was purely decorative in intent. Work started on the project in 1719, but it was never completed.

The greatest number of porcelain cabinets were to be found in Germany, the first being set up in Bamberg and Munich around 1700, followed for example by Charlottenburg (1705), Pommersfelden (after 1710), Ansbach (about 1730), and the Monbijou Palace in Berlin (1730). They were not alone in Europe, of course: in Austrian Monarchy the Dubský Palace in Brno had a porcelain cabinet (1725–35); in Italy there was one in the Portici Palace, Naples (1757–9), while in Spain the Royal Palace in Madrid (1770) and the palace in Aranjuez (1780) both had cabinets. Natu-

rally by this time it was not exclusively oriental porcelain that was being desplayed; local production accounted for the greater part of the material. The porcelain cabinet in the Dubský Palace in Brno, for instance, was decorated with wares from the Vienna factory, the Capodimonte factory provided the exhibits for the Portici Palace, while the two Spanish palaces, Madrid and Aranjuez, were both furnished from the Buen Retiro factory. The Dubský Palace cabinet already boasted porcelain picture and mirror frames, and porcelain was used for door panels and to decorate chairs and tables, and even the mantelpiece was of porcelain. Today this cabinet can be seen in the Österreichiches Museum für angewandte Kunst in Vienna. In Queen Maria Amalia's Portici Palace the walls were decorated all over with Rococo bas-reliefs, tendrils, male and female Chinese figures, birds and monkeys, in porcelain. The floor and ceiling were both of porcelain, and great porcelain chandelier hung from the ceiling. The ceiling and the chandelier were destroyed during World War II; King Ferdinand IV had the porcealin floor removed in 1799 when he fled from Naples to Palermo to escape the invading French. The rest of the porcelain from the cabinet was

2 Zacharias Longuelune, Project for the Japanese Palace, Dresden, c. 1735. Staatsarchiv, Dresden

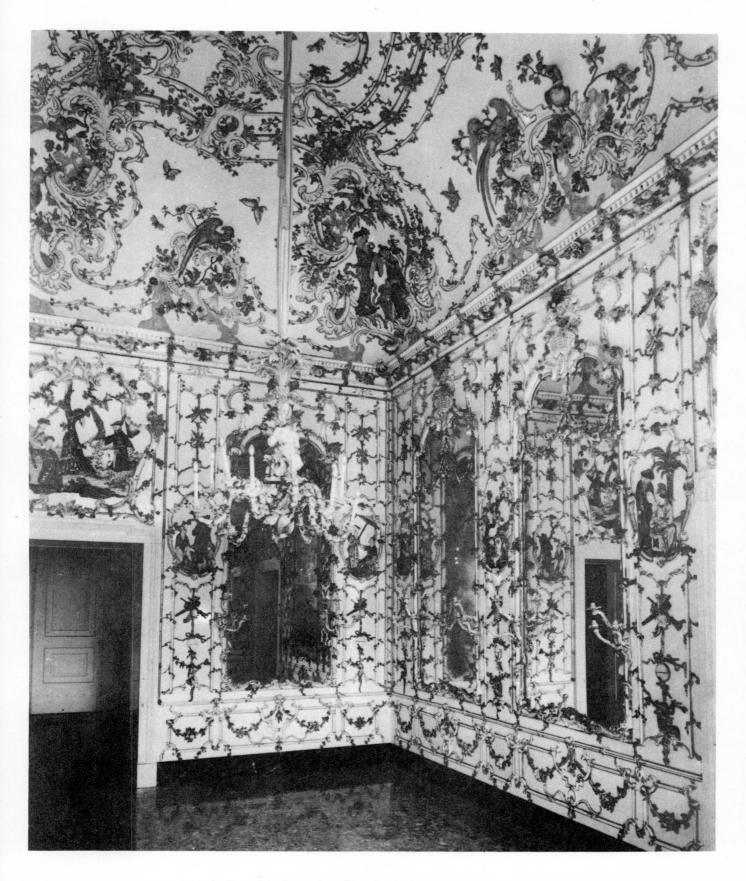

3 Part of the decoration of the salon in Queen Maria Amalia's Palace, Portici, Capodimonte, 1757–59.
Museo di Capodimonte, Naples

moved from Portici to the Capodimonte Palace in 1865. The Cabinets in Madrid and Aranjuez were decorated in similar style after the Capodimonte factory was moved to the royal residence of Buen Retiro, not far from Madrid, in 1760. The cost of furnishing a cabinet in this style was not negligible: 70,000 ducats were paid out for the Portici cabinet, 256,958 reals for the Madrid cabinet, and the somewhat more spacious cabinet in the Aranjuez palace cost 571,555 reals.

These porcelain cabinets with their contents cannot yet be described as collections in the modern sense. It was a matter of royal or aristocratic prestige to possess a collection of porcelain, whether oriental or, later, European; it added lustre to a court. At first no attention was paid to artistic quality, and European collectors failed to appreciate the unique quality of the finest oriental porcelain. This can be seen from the fact that they preferred Japanese Imari ware, porcelain produced by the business-like Japanese purely for export to Europe, with an overgrown pseudo-Baroque decor that was probably suggested by the Europeans who commissioned the ware.

Pewter, silver, faience and other vessels were sent to China to serve as models for porcelain ware, so that the Chinese porcelain offered on the European market included purely European forms. The same was true of the painted ornament on oriental porcelain; prints and drawings served as models, and sometimes the European customers ordered ware bearing their coats of arms. Christian motifs appeared in the painted decoration, either directly commissioned from Europe, or made for the home market. Jesuit missionaries in China had set up their own school of porcelain painting under two monks, Jean Denis Attiret, and Castiglione, and ware of this type is known as "Jesuit porcelain". It disappeared in China at the beginning of the eighteenth century, when persecution of the Christians began, and later Chinese porcelain decorated with Christian motifs was made purely for export. The same was true of Japan.

It was no wonder that the enormous European market for oriental porcelain, not to mention the vast profits to be made from importing it, encouraged efforts to discover the secret of making it, efforts which did not bear fruit until after long years of exhausive experiments and many abortive attempts.

Attempts to Solve the Riddle of Porcelain Production

Europe was fascinated by Chinese porcelain, by its whiteness, its lightness, its translucency and its perfect glaze. No wonder it was credited with extraordinary powers, such as reacting to poisoned food or drink served in it, according to a superstition we have already noted. No wonder, either, that Europeans made every effort to produce porcelain for themselves. Ever since Marco Polo brought the first practical information about Chinese porcelain-making it had been obvious that porcelain was made from similar material to that used in other ceramic techniques, while the character of the body suggested that glass-making might also offer a solution.

Italy was the first country where attempts to solve the mystery of porcelain were made, understandably enough, for both pottery and glass of high quality were made there. It was probably also the first European country to see porcelain, thanks to trade contacts with the Near East. From the outset two lines of experiment were followed, one trying to achieve porcelain by perfecting the technique of maiolica with a blue decoration "alla porcellana". The vitreous body of porcelain ware, however, suggested that glass-making techniques might open another possible path. The first reports of success date from 1470 when one Antonio di San Simeone of Venice is said to have made something like porcelain ware from Bologna clay. Unfortunately nothing has survived that can be attributed to Antonio di San Simeone, and so we do not know the composition of his material. At the beginning of the sixteenth century another Venetian, Leonardo Peringer, a glass-worker who came from Nuremburg, tried to make porcelain by glass technology; his products were simply frosted glass, made white by the addition of tin oxide. There are several articles of this type, with a blue decora-tion, in the Museo Civico in Turin and in the British Museum in London.

The Renaissance saw some of the first experiments in the natural sciences — perhaps alchemy would be a better word; several Italian noblemen took this path, hoping to solve the mystery of porcelain in their alchemists' laboratories. We know a little about such experiments in Savoy and in the town of Urbino; the Duke of Ferrara established a porcelain and maiolica workshop in the city, and in 1560 engaged the brothers Camillo and Battista da Urbino to work there. Once again, none of the ware produced in this workshop has survived, and we cannot judge of their success.

It would seem that all these experiments led no further than to imitation of porcelain, and yet the Italians were on the right track. The Grand Duke of Florence, Francesco Mario de Medici, himself an enthusiastic alchemist, set up a pottery where Flaminio Fontana of Urbino, maker of maiolica ware, and Bernardo Buontalenti, worked on the problem and produced something which was said to be the first proto-porcelain made in Europe; today it is known as Medici porcelain.

The first account of Medici porcelain comes from Giorgio Vasari's *Le vite de'più eccellenti Pittori, Scultori e Architettori*, the principal work by this painter, architect and art historian, of which a second, enlarged edition appeared in 1568. In 1575, the Venetian ambassador to the court of Florence also wrote that the Grand Duke had succeeded in making "Indian" porcelain after ten years of experiments, when he called in a "Levantine" to help.

What was this Medici porcelain like? Fifty-nine pieces have so far been identified, most of them in museum collections. The formula has also been preserved in Florence; white clay from Vicenza was

(continued on page 25)

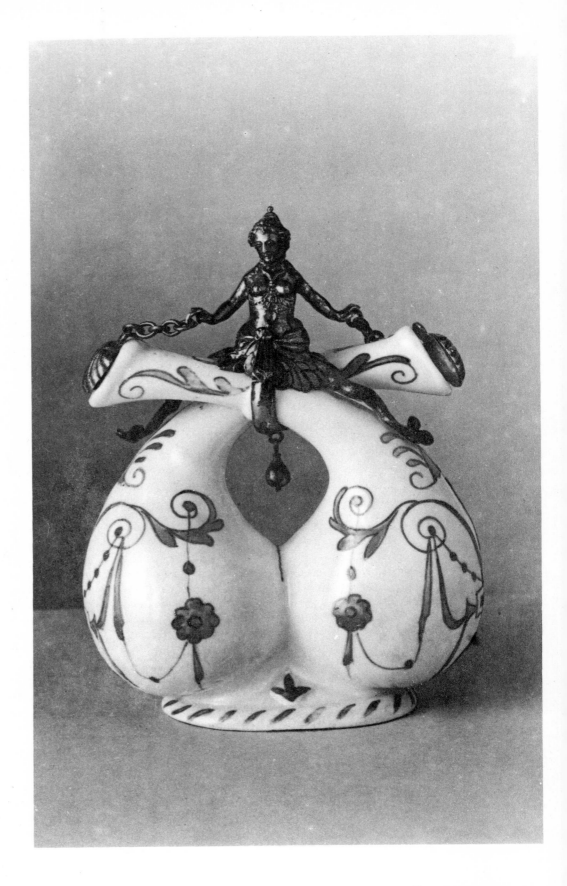

4 A double flask, mounted in gilded silver, Medici porcelain, c. 1575–80. Österreichisches Museum für angewandte Kunst, Vienna

16

5 Jug and bottle, Meissen, Böttger stoneware, 1710–13; bottle 15.5 cm, jug 10 cm high

6 Jug, Meissen, Böttger porcelain, painted by Höroldt, 1725; 14 cm high

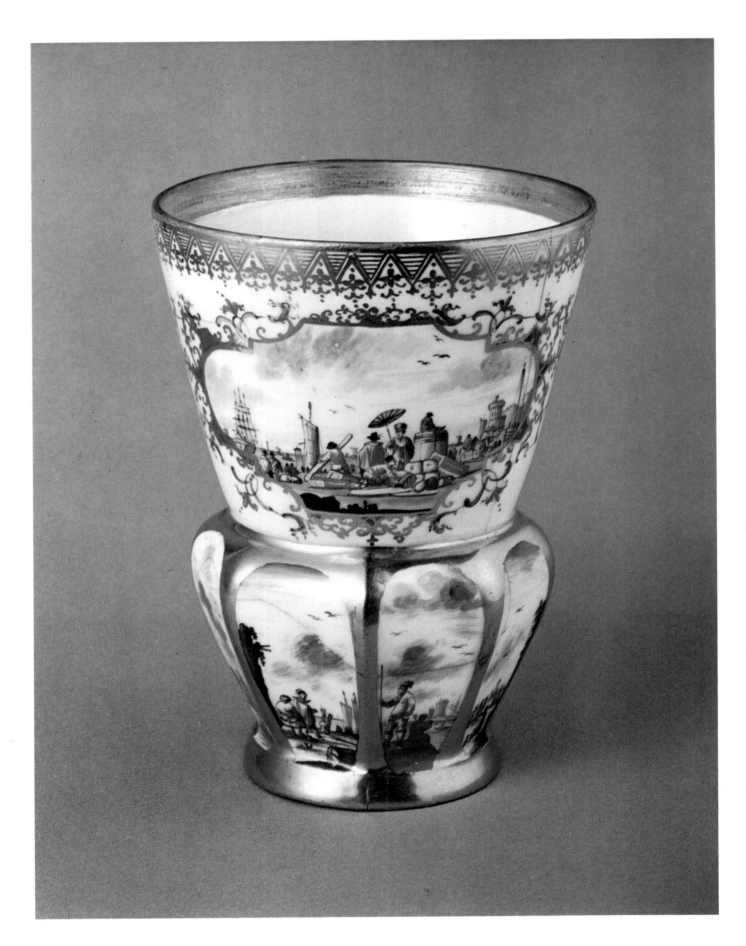

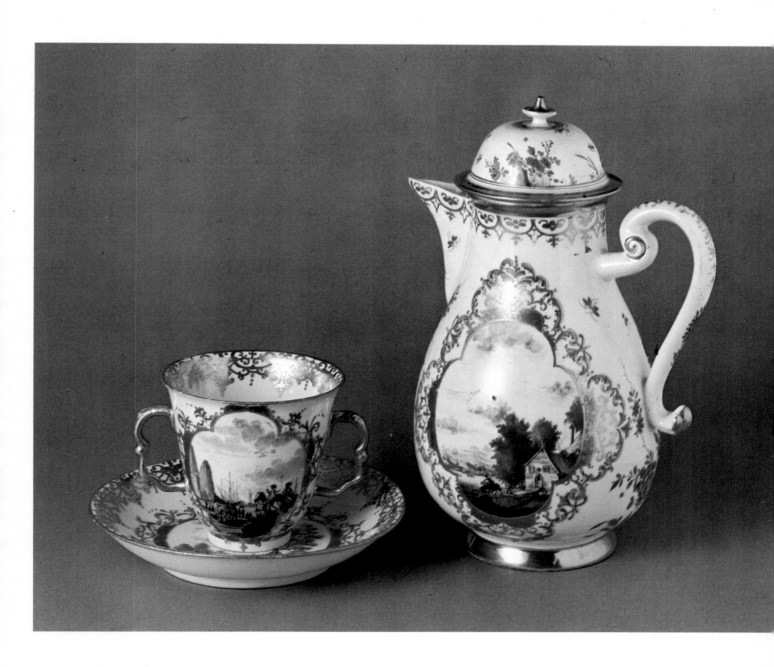

8 Part of a coffee service, Meissen, Höroldt
period, 1725; pot 20.5 cm high

◀

7 Goblet with harbour scenes, Meissen, Hö-
roldt period, 1730; 12.5 cm high

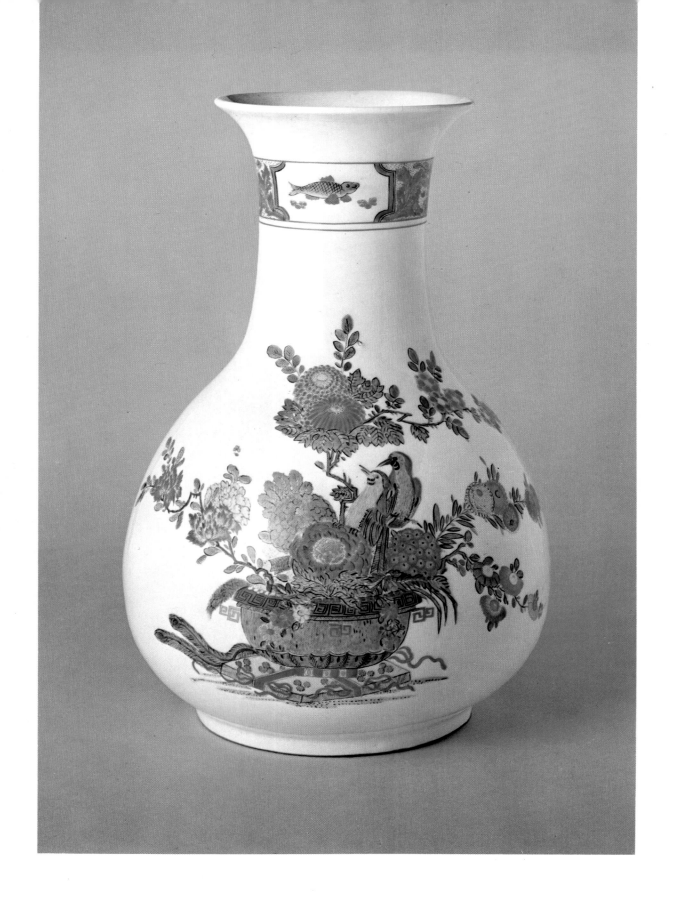

9 Vase with "Indian flowers", Meissen, Hö-
roldt period, 1760; 29.5 cm high

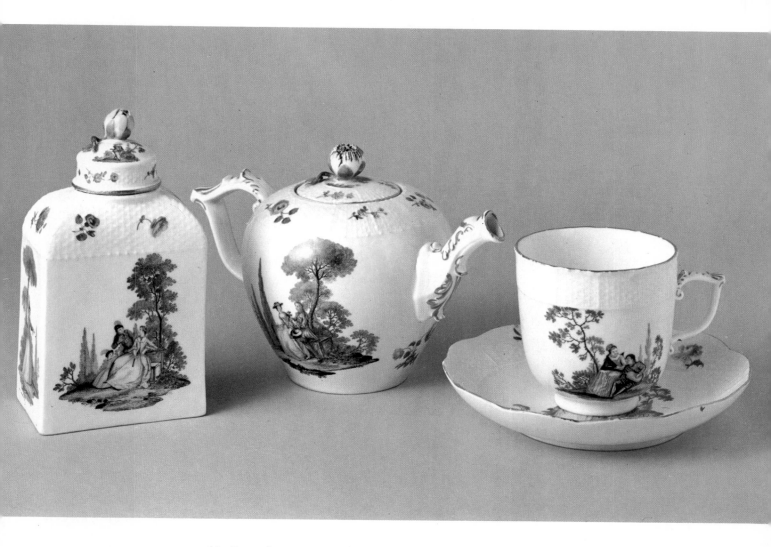

10 Part of a tea set, Meissen, 1750; teapot
13.5 cm high

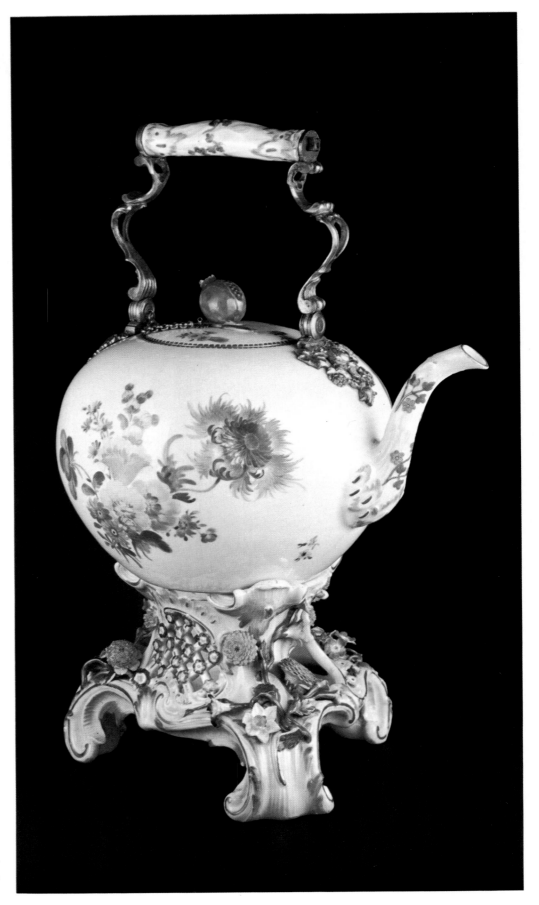

11 Pot with warmer, decorated with "European flowers", Meissen, 1760; 42 cm high

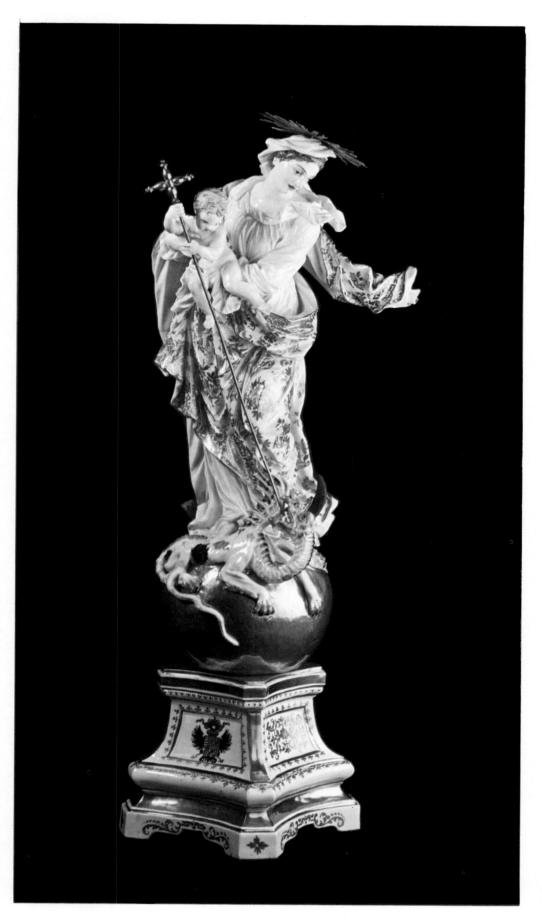

12 Madonna, Meissen, modelled by J. J. Kaendler, c. 1740; 58 cm high

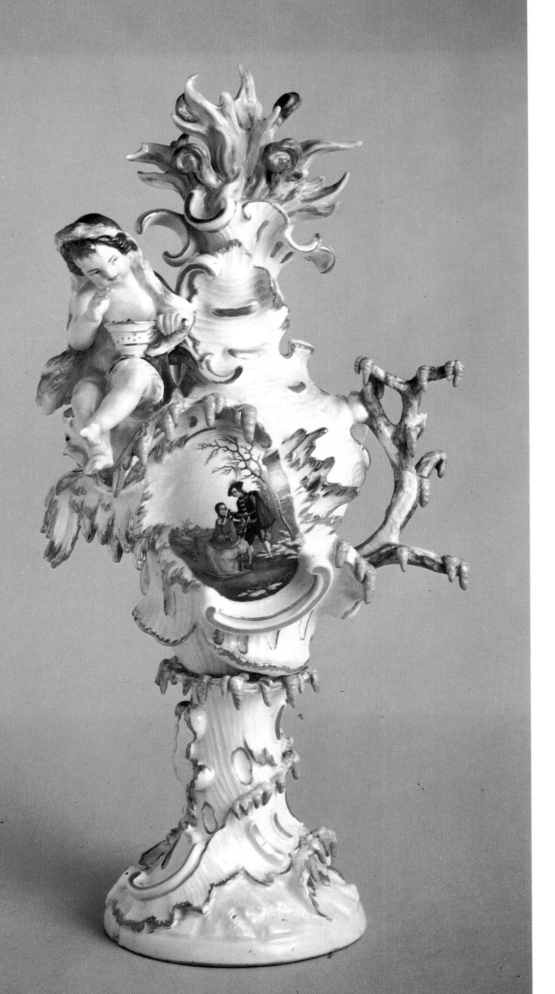

13 Vase, allegorical figure of Winter, Meissen, 1755; 35 cm high

mixed with white sand, and ground rock crystal, tin and lead flux added. The resulting body was yellowish, sometimes whitish to grey, and resembled stoneware; this was given a white glaze containing tin oxide. The overglaze decoration, in blue or manganese red, was fired by a similar method to that used in Italian maiolica ware "alla porcellana". A second low-temperature glaze containing lead was then applied. Like the body of Medici porcelain, the glaze varies from one piece to another, from opaque to brilliant, and is often crazed.

Medici porcelain seems to have been systematically produced from 1576 onwards; the kilns stood in the Boboli Gardens and in Casino di San Marco. No details of how much porcelain was fired are known: only that Flaminio Fontana was paid for firing 25 to 30 pieces in the year 1578. Production was certainly not large, and Francesco de Medici had no commercial ambitions; to desplay porcelain of his own manufacture would add glory to his court — an attitude found later, in the eighteenth century, in some noble families north of the Alps. We have no knowledge of how long this Medici porcelain was produced, but it is clear that it fell off rapidly after the death of Francesco Mario de Medici.

There is a short note dated 1592, saying that one Nicolo Sisto was making porcelain in Florence, but it is not clear whether he was connected in any way with the Medici workshop. This same Nicolo Sisto seems to have carried on firing porcelain in Pisa perhaps as late as 1619 or 1620. Historical sources tell of guests at the Pitti Palace in Florence being presented in 1613 with the Medici coat of arms painted on porcelain. This can be taken to mean that Medici porcelain was still occasionally made at that time, but it must be borne in mind that up to the end of the eighteenth century the term "porcelain" was used very liberally.

It is likely that when the Medici workshop ceased to exist, this interesting forerunner of European porcelain was no longer produced. There are no known pieces which can be attributed to Nicolo Sisto, and so his porcelain cannot be classified.

In the seventeenth century attempts to discover how to make porcelain centred on France, where the reign of Louis XIV created the right atmosphere. Again it was a potter from Holland, the home of excellent faience, who is said to have produced porcelain, although how far he succeeded cannot be said since none of his work is known. Nevertheless, Claude Réverend was the first to be granted the privilege of producing porcelain in France, in 1664.

Medici porcelain mark,
c. 1575–1620

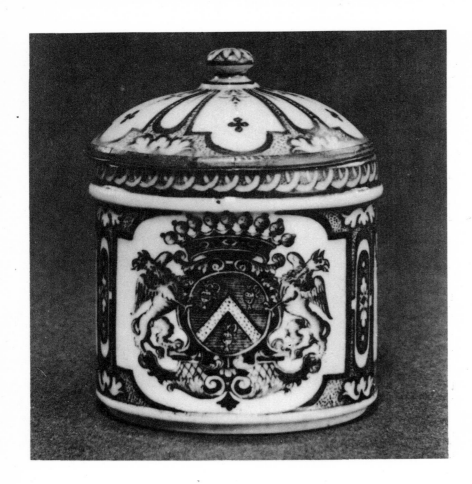

14 Mustard pot with the arms of Asselin de Villequier, Rouen, the Louis Poterat workshop, before 1696. Musée national de céramique, Sèvres

His ware was probably faience of the Delft type, since he recruited his workers from Delft and Rotterdam.

The true inventors of French frit porcelain or pâte tendre are thus believed to be the Poterat family, of Rouen. In 1673 Edmé Poterat was granted the second French privilege of making porcelain, for his sons Louis and Michel. The beginnings were modest; we learn from the brothers' 1694 application for the privilege to be prolonged that most of their ware was faience. Very few pieces have survived, and one which is believed to have been made by them is a mustard pot decorated with the coat of arms of Asselin de Villequier, burgher of Rouen. Louis Poterat died in 1696, and this seems to have marked the end of frit porcelain production in Rouen.

French frit porcelain was thus an earlier discovery than the hard-paste porcelain of Böttger, but all over Europe potters were bent on discovering the secret of "true" porcelain, by which of course they meant oriental porcelain. Italy, England and Germany came back into the field. There is only one report of Italian experiments, in Johann Joachim Becker's *Närrische Weisheit oder weise Narrheit* ("Foolish Wisdom or Wise Foolishness"), which appeared in Frankfurt in 1680. He mentions Manfredo Settala, a canon of Milan, "who can make porcelain", but we do not know what Settala actually achieved. Even E. W. von Tschirnhaus, the German scholar and future colleague of Böttger, who visited Settala in 1676, failed to elicit from him any instructions on how to make porcelain.

England did not lag behind. Francis Place (1647–1728), a painter and engraver, tried to make porcelain of local clay in his workshop at Manor House, York. He succeeded in making grey stoneware, as can be seen from the black and brown marbled coffee-cup preserved in the Victoria and Albert Museum, London. No pieces of true porcelain which can be attributed to Place have been found, however. His experiments landed him in financial straits, and although he was clearly on the right road at last, he was forced to drop his experiments in 1714.

26

The next experimenter was John Dwight, who started a pottery in Fulham and was granted a patent to make "transparent earthenware, commonly known by the names of porcelain or china", in 1671. The renewal of this patent in 1684 attests continued attempts to make English porcelain. The broad sense in which the term "porcelain" was understood can be seen from the lawsuit brought by Dwight against the Elers brothers for infringement of his patent; John and David Elers came from Holland and settled in England before 1686, at first working in Hammersmith and later starting a factory in Staffordshire. It appears from the pieces attributed to them that they made red unglazed stoneware similar to the Chinese stoneware from I-hsing, which was considered at the time to be porcelain. The lawsuit shows that the ware produced by Dwight and by the Elers brothers was similar.

The many attempts to produce porcelain in Europe not only prove that enterprising minds were at work, but suggests economic necessity as well. The import of oriental porcelain was rapidly depleting gold and silver stocks in Europe, because European traders had to pay for their imports from Asia with gold and silver coins. This drain on precious metals was felt throughout Europe. King Louis XIV of France went so far as to have silver vessels melted down in order to pay for exotic imports to his court. The production of local porcelain was thus a possible solution to the problem.

The Elector of Saxony, Augustus the Strong, was one of the European monarchs who encouraged local industries, and it could be expected that he would view with sympathy the setting up of a porcelain factory. Ceramics were among the subjects for experiments made by the Saxon scholar Ehrenfried Walther von Tschirnhaus, who had considerable experience in the establishment of glassworks and the polishing of precious stones, and was charged by the Elector with exploring the natural riches of Saxony. Tschirnhaus had been interested in porcelain for a long time; a serious scholar, he was made a corresponding member of the Paris Academy for his experiments with melting mirrors, which he saw in Lyon in 1675, where they had been invented by François Villette. Tschirnhaus used the mirrors to observe the behaviour of various

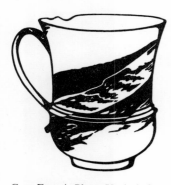

Cup, Francis Place, York, before 1714

metals and clays during the melting process, and the experiments he carried out at home in Kieslingswalde led to the discovery of a new ceramic material he called "Wachsporzellan" ("wax porcelain"). Some scholars believe that Tschirnhaus's discovery was no more than vitreous frit porcelain, while others claim that he had already discovered true hard-paste porcelain. In 1701 he presented the Elector of Saxony with a proposal for setting up a porcelain factory and instructions on the production process. The silence which followed this remarkable proposal suggests that the results of his experiments were not too successful, however. Tschirnhaus did not give up; so far, however. no pieces have come to light that can be reliably identified as Tschirnhaus's "Wachsporzellan".

Throughout almost the entire eighteenth century the production process of true porcelain remained a carefully guarded secret, and even after Böttger had discovered how to make hard-paste porcelain, experiments did not cease. Great efforts were made particularly in France, where it was realized that frit porcelain was after all not the same thing as the secret Chinese material. Reports from China itself encouraged the experimenters, among them letters from the Jesuit missionary Père Dentrecolles which arrived in Paris in 1712 and were published in 1716 in the *Journal des Savants*; in them the priest described the production of porcelain in the Ching-te-chen factory.

The best known of the French scholars concerned with porcelain experiments was René Antoine Ferchault de Réaumur, physicist and zoologist, who was a member of the Académie Royale des Sciences. The most famous of his achievements still remembered today was the Réaumur thermometer, and hardly less important was his discovery of porcelain. In 1739 he published a *Mémoires sur l'art de faire une nouvelle espece de porcelaine* ("Memorandum on the art of making a new kind of porcelain"), but his product has little in common with true porcelain, being glass subject to a long and slow melting process and crystallizing into a translucent white material.

Another member of the Academy, Jean Etienne Guettard, who was a student of Réaumur's, drew attention to a kaolin clay in the vicinity of Alençon, in 1755. The

discovery of this deposit moved the Count of Lauraguais-Brancas, Louis Léon, to experiment with porcelain in the laboratory at his manor of Lassay in 1763–8. He exhibited the hard-paste porcelain he produced at the Académie Française, but we still do not know today whether the Count made his porcelain from Alençon clay or from a sample of Chinese kaolin secretly smuggled into Europe. Several pieces have survived, of a grey and impure body, which came from the Lassay laboratory.

All over Europe experiments were being made, all aimed at that one goal: porcelain. But it was in Meissen in Saxony that the most important discovery was made.

Success in Meissen

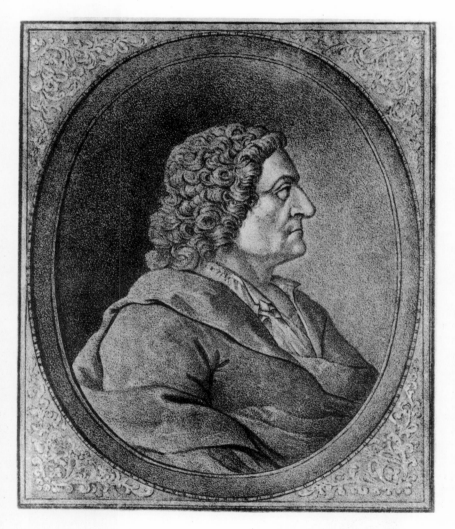

15 Portrait of Johann Friedrich Böttger. VEB
Staatliche Porzellan-Manufaktur, Meissen

At the turn of the seventeenth and eighteenth centuries the secret of how to make porcelain still eluded all experiments. Contemporary connoisseurs did not consider the French frit porcelain to be the real thing; it is enough to quote Haudicquer de Blancourt, who wrote in his *De l'Art de la Verrerie*, published in Paris in 1697, that porcelain was "une terre préparée, qui s'émaille avec l'émail blanc" ("a prepared clay that is glazed with a white glaze"). Little more progress had been made in England; true porcelain was still a mystery awaiting revelation. It was the coincidence of favourable factors that when success arrived, it was somewhat to the east of the traditional centres of experiments with porcelain — in Saxony.

Modern writers agree that there were three men who were directly responsible for this success, although not all to the same degree; the discovery of true porcelain in Europe was due to the well-known scholar, Ehrenfried Walther von Tschirnhaus, the alchemist, Johann Friedrich Böttger, and Augustus the Strong, Elector of Saxony and King of Poland. The king, of course, takes the credit for his willingness to finance an enterprise of whose success he could not be certain. Saxony was not in a good financial position, and according to economic theory at the time, the only way out of the mess was to become self-sufficient. This was to be achieved by setting up factories, among them a porcelain works, for this was an expensive product. And then, in his proposal of 1701, E. W. von Tschirnhaus asked no more than 3,000 thalers as his reward and to equip his laboratory, while Böttger's experiments in the alchemy of gold were said to have cost the Elector 40,000 thalers. Nevertheless the two men who were decisive in the discovery of porcelain in Europe were E. W. von Tschirnhaus and J. F. Böttger.

It is still not clear which of the two was the more important, and it will probably never be known for certain.

Johann Friedrich Böttger was baptized on 5th February 1682 in Schleiz, but grew up in Magdeburg with his stepfather, Tiemann, an engineer. In 1698 his parents apprenticed him to a Berlin apothecary, Zorn, and it was here that his career as an alchemist really began — or rather, his attempts to transmute common metals to gold. It was still generally believed that gold could be made with the help of a legendary "tincture", and Böttger was thought to have acquired this from a mysterious Greek monk, Lascaris. From the accounts which have come down to us, however, it is difficult to see how Böttger acquired his reputation as a successful alchemist. His experiments not only came to the notice of the well-known German scholar Gottfried Leibnitz, but reached the ears of the King of Prussia, Frederick I. Warned in time, Böttger fled to Wittenberg in Saxony in 1701; here he thought he would be safe, and intended to continue his studies, as can be seen from his registering as a student of medicine at Wittenberg University. His hopes were dashed, however, for that same year the Elector of Saxony had him arrested and sent to Dresden under military escort. Here he spent two years, strictly guarded, and in fact a prisoner, searching in vain for that coveted "red tincture" which would once and for all free his captor from all financial troubles. His situation became unbearable, and in 1703 Böttger tried to escape. He managed to get away and reach neighbouring Bohemia, only to be arrested there and sent back to Saxony. After a short period of internment in the castle of Königstein he was sent to Dresden again, where his experiments began once more, from 25th May 1704, watched over by E. W. von Tschirnhaus and the Bergrat Pabst von Ohain.

It was thus in 1704 that von Tschirnhaus began to work with Böttger. We do not know for certain, however, when it was that Böttger dropped his experiments in alchemy and turned to porcelain, presumably at the instigation of von Tschirnhaus. In 1706 Böttger was transferred again, this time to the castle of Albrechtsburg in Meissen. Here his experiments with ceramics began in earnest, as we can see from an account given by Böttger's first assistant, Paul Wildenstein. These experiments, of course, were still far from yielding practical results. Work was suddenly interrupted on 5th September 1706, when the Elector had Böttger removed again to the castle of Königstein; this was clearly done to protect him from the Swedish army which then threatened Saxony. It was a year before Böttger returned to Dresden, and with Tschirnhaus's help set up a new laboratory in the chambers in the thickness of the walls, in the eastern fortification of the city called *Jungferbastei*. In spite of the inconvenience of the location, work started again. It must be borne in mind that the whole proceeding was purely empirical, and that hundreds of experiments had to be made with each of all the different blends of clay, at very varied temperatures. The first positive results were achieved at last, in November 1707 — and yet the product was still not true porcelain.

Böttger succeeded in producing the red stoneware known as "Jaspisporzellan", which was an encouraging success, but one which had already been achieved in Delft by Ary de Milde (1677–8) and in England by Dwight and the Elers brothers. Böttger's red stoneware was then produced by the newly founded (1708) "Delfter Rund- und Stein Backerey zu Altendreßden", for which potters were recruited in Holland and Peter Eggebrecht, a thrower, brought from Berlin.

The decisive step towards the discovery of how to make porcelain was the realization that clay needed to be mixed with a suitable flux in such proportions that it would fuse when fired and produce a hard, non-porous body. Jaspisporzellan was made of clay containing a proportion of ferric oxide, which gave the ware its characteristic reddish to dark brown colour. The problem was then to determine the right mixture to produce a white body. After innumerable experiments, we learn from Böttger's notes that on 15th January 1708, at long last, three batches out of seven came out of the kiln white and transparent. European hard-paste porcelain was a reality.

A long time was still to pass, of course, before continuous production of porcelain could be maintained; it was over a year after these successful samples and further experiments that Böttger himself addressed a memorandum to the Elector, on

16 "Jungfer", the eastern wing of the ancient fortifications, Dresden, from the painting by F. Hagedorn. VEB Staatliche Porzellan-Manufaktur, Meissen

28th March 1709. In this "memorial" he gave his famous and oft-quoted pledge to make "good white porcelain". A commission was sent to study Böttger's achievement from every possible point of view, and especially to assess its commercial possibilities. Then, on 23rd January 1710, a royal decree was issued setting up a porcelain factory in Dresden. On 6th June of the same year, however, the factory was moved to Albrechtsburg in Meissen, and the first director to be appointed was Michael Nehmitz, an official at the court of the King and Elector.

European porcelain was now a fact. What part was played by Ehrenfried Walther von Tschirnhaus in the success story? We know from what has already been said that Tschirnhaus had succeeded in making what he called "Wachsporzellan", and that in 1701 he had proposed to the Elector that a porcelain factory be set up. The road from sample production with the help of melting mirrors, to the production of commercial ware, was a long and involved

one, as we know from the story of Böttger's trials. Tschirnhaus certainly met Böttger from time to time after the latter's arrest and removal from Wittenberg to Dresden, but it was not until 25th May 1704, on orders from Augustus the Strong, that he began to pay systematic attention to Böttger's experiments in alchemy. Together with Pabst von Ohain Tschirnhaus was expected to keep an eye on what Böttger was doing, for his alchemy was costing the Elector a pretty penny. It is enormously to the credit of Tschirnhaus that he recognized the uselessness of this search for a miraculous "tincture", and that he succeeded in convincing influential members of the court of Saxony, and the Elector himself no doubt, that Böttger should turn to more practical goals. In the view of Tschirnhaus this could be nothing other than the firing of true porcelain. We know that his experiments towards this goal began no later than 1706, when Böttger was moved from Dresden to Albrechtsburg in Meissen, and that they were undertaken

in all seriousness can be seen from the testimony of Böttger's assistant Wildenstein that there were twenty-four kilns in the secret laboratory.

The question now arises: why did Tschirnhaus not apply his own discovery and perfect it to the point of practical production? Why did those expensive experiments still have to be performed in the chambers in the Dresden fortifications, to arrive at the first successful results only six months before the death of Tschirnhaus? It is most probable that the "Wachsporzellan" that Tschirnhaus discovered was not the true porcelain that was sought, but a type of soft-paste porcelain that had little practical use. Nevertheless we have much to be grateful to Tschirnhaus for: it was he who turned the unsuccessful alchemist's attention to something Böttger had no knowledge of as yet — how to produce true porcelain. Tschirnhaus certainly gave him valuable advice and turned his experiments in the right direction. It can certainly be said that European hard-paste porcelain was the result of the knowledge and skill of two men: J. F. Böttger and von Tschirnhaus.

The burghers of Meissen were not pleased at the thought of a porcelain factory in the walls of the castle; nor were the church authorities happy to have it so

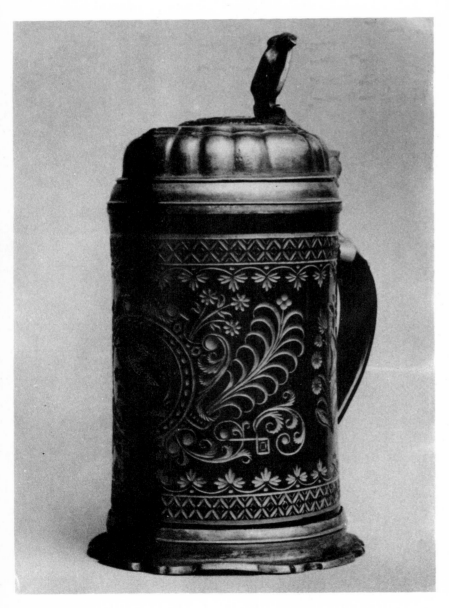

17 Beer-mug with incised ornament, Meissen, Böttger stoneware, 1710–15; height 24.5 cm

Sake flask, Böttger stoneware, Meissen, 1710–15

close to their cathedral. Nevertheless the factory started production there, presumably because the medieval fortress was thought to be a safe place where the secret of porcelain manufacture could be kept hidden. The "arcanum", that is to say the composition of the body and of the glaze, the method of firing, the construction of the kilns, in short, the entire production process, and the protection of its secrets, were the constant anxiety of official circles in Saxony. Although Böttger was appointed "administrator" of the factory as soon as it was established, and was responsible for the smooth running of the works, for the staff and for the commercial side of the business, the Elector himself insisted that this should be done from the "laboratory" in the Dresden fortress. The secrets of porcelain-making had to be passed on to two reliable men, Dr. Jacob Bartholomäi and Dr. Heinrich W. Nehmitz, the former being initiated into the composition of the body and the latter into the secrets of the glazing. But since anyone working in the factory could gradually penetrate the entire secret arcanum, each phase of production was separated and guarded. Thus for many years the only man who was acquainted with the complete process was Böttger himself.

Even after the factory was moved to

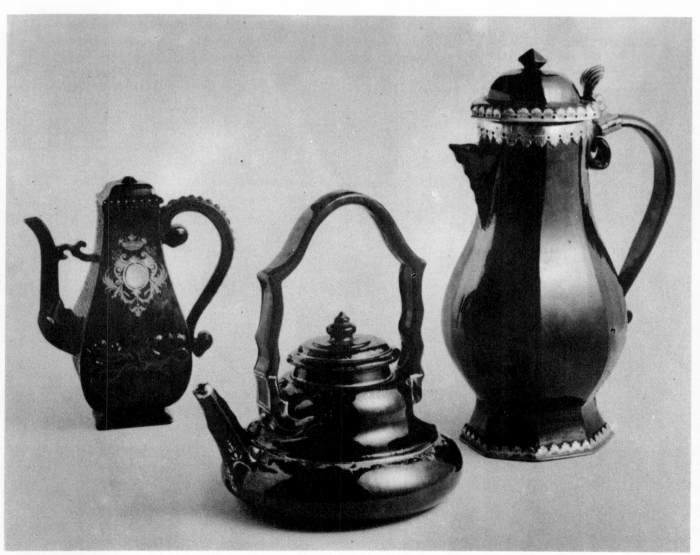

18 Three jugs, Meissen, Böttger stoneware, 1710–13; the tallest jug is 23 cm high

Meissen Böttger was still unable to produce white porcelain on an industrial scale; the ware fired there was still red stoneware, although this in itself was a highly prized article. Böttger worked continually to improve the decoration of this ware, using some techniques taken over from glass production, like the carving of Baroque designs in the hard surface of the red stoneware, grotesque patterns, flowers, and symbols; the surface was then polished like glass. Glass-cutters were recruited from Bohemia to give this ware the right finish. Böttger lost no chance of giving his products the gleaming magnificence of the Baroque, using different colours, precious metals and even precious stones in the decoration.

Chinese porcelain remained Europe's model not only in decoration, but even

Jug, Böttger stoneware, Meissen, c. 1715

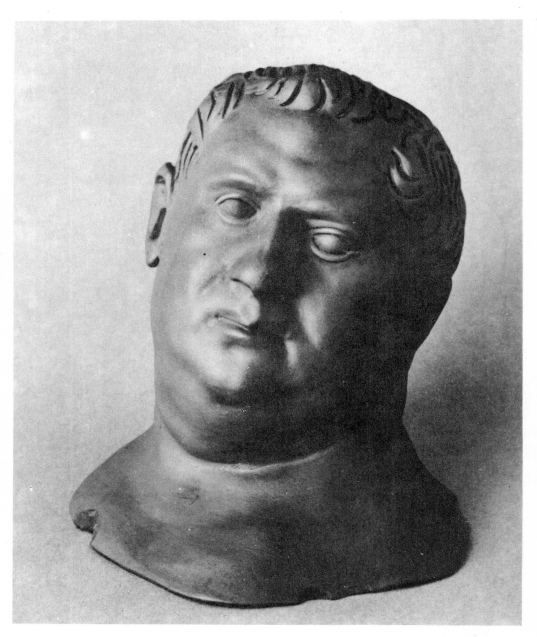

19 Head of the emperor Vitellius, Meissen, Böttger stoneware, modelled by P. Hermann(?), 1708 to 1713; height 10.8 cm

20 Vase and lidded vase, Meissen, Böttger stoneware, 1715–20 and 1713–15; vase 24.2 cm, lidded vase 24 cm high

in shape, as we can see from the Meissen ware which could have come from Chinese moulds. This was not surprising, for a centuries-old tradition had brought Chinese forms to such perfection that the vessels were admired throughout Europe. Before long, however, the court silversmith of Saxony, Johann Jacob Irminger began to collaborate in Meissen designs, and to imprint Baroque forms on the plastic red body. It seems to have been Böttger who arranged for him to participate; his first visit to Albrechtsburg took place on 29th October 1711, and contrary to all custom and all protective measures Irminger was allowed to take three cwt. of the red body away with him to his workshop in Dresden. It was a fortunate move to have made; while Irminger used the traditional shapes of gold and silver vessels for pitchers, cups, goblets, bowls, etc., he adapted them remarkably well to Böttger's red stoneware. Small statuettes were also made; although the names of Dresden sculptors like Benjamin Thomä, Bernhardt Miller and Paul Hermann appear in the records no individual artist can be assigned to the figures dating from this time, such as the statuette of Augustus the Strong in armour, with his marshal's baton, the Harlequin of the Italian Commedia dell'arte, the figure of the Crucified Christ, the bust of the Roman emperor Vitellius, the medals and portraits. Some of the articles, like the bust of Vitellius and the head of Apollo, are copies of famous statues, while others, like the figure of Augustus and the statuette of Harlequin, were modelled probably for the Meissen works.

Böttger overestimated his chances when he declared that he could make good white porcelain for His Majesty. In spite of obstacles the first white porcelain from Meissen was on show at the Leipzig spring fair in 1710. But it was not until 1713 that the factory achieved this, and even then it

35

was not felspathic porcelain but one containing calcium sulphate. Böttger's porcelain had thus a yellowish tone and was not translucent. The glaze was not perfect, either; it had a greenish shade and sometimes bubbles formed. Böttger himself was well aware of these shortcomings, for it was his goal to make snow-white porcelain. Firing was a very chancy business at first. The success rate was unpredictable and often there were only one or two pieces in the whole batch that were neither deformed nor collapsed.

The modelling of porcelain vessels, unlike red stoneware, had changed little; Oriental models were still followed, as well as those of the silversmith, Irminger. At first, before colour techniques had been mastered, most of the decoration was in relief, especially plant forms. The most urgent problem was now that of painted decoration, and Böttger approached it from several angles. First he used lacquer for the relief patterns, but it was difficult to make the lacquer adhere to the porcelain body. He also experimented with overglaze colours, although they still produced a different effect from that of more modern, improved products. And then, Böttger tried the effect of gold and silver fired on to the body. The one thing he did not succeed in was the underglaze cobalt blue of classic oriental porcelain. That problem was not solved until much later.

This experimental stage in the making of Meissen and indeed the first European hard-paste porcelain came to an end with the death of Böttger. His mind worn out by the constant pressures on him, and by the stresses of his life as a virtual prisoner (it was not until 1715 that the Elector restored his personal freedom), Böttger took to drink. Early in 1719 his health was seriously undermined and on 13th March 1719 at 6 p.m. he died, aged only 37.

21 Tea caddy and pot, Meissen, Böttger porcelain, 1715–20; pot 11 cm, caddy 14.3 cm high

The Revelation of the Arcanum

The production process of Meissen porcelain was a carefully guarded secret, and the measures taken to preserve it so were constantly being brought up to date. Böttger himself was isolated from the outside world, and each separate stage of production inside the factory was strictly set apart from the others. The first sign that the secret of Meissen would find a welcome elsewhere was the desertion of Samuel Kempe, a kiln-master whose work was preparing the clay; in 1713 he ran away to Plaue an der Havel, to the estate of Friedrich von Görne, the Prussian Minister. Here a factory producing red stoneware indistinguishable from that of Meissen was soon at work, and by 1715, in two years, it was being offered at the Leipzig fair. This caused an uproar in Dresden, although in fact the arcanum which had been betrayed was only the secret of good quality red stoneware which was equally well known both in Holland and in England. Still, it could only be a matter of time before the secret of white porcelain also trickled out. Inefficient management at the Meissen factory made it all the easier for industrial espionage. Although he was officially the "administrator" of the whole works, Böttger had little real influence on the running of the factory, and during the last years of his life, already a prey to alcoholism, he probably failed to realize the threat to his arcanum. It is clear, in any case, that he must have been involved in the events of 1717 and 1718.

The imperial "Hofkriegsagent" Claudius Innocentius Du Paquier, presumably inspired by the success achieved at Meissen, decided to set up a porcelain factory in Vienna. When he managed to get the enameller Christoph Conrad Hunger away from Meissen in 1717 he thought that nothing stood between him and true porcelain. He therefore joined with Hunger and two others, Peter Heinrich Zerder and Martin Becker, in a request for the privilege of monopoly production and sale of porcelain throughout the Emperor's hereditary domain. This was granted by Charles VI (III) on 27th May 1718. However, in the new factory they set up at Rossau near Vienna things did not go well; Hunger was obviously not initiated into the whole of the arcanum. Matters improved when Samuel Stöltzel was brought in from Meissen; he was an expert in firing, and in the preparation of clays, and had been Böttger's assistant since 1705. Then Böttger's stepbrother arrived in Vienna, with a paper model of the porcelain firing kiln, made by Böttger's colleague and friend J. G. Mehlhorn. To illustrate the methods of the period, we must say that Stöltzel secretly left Meissen after Du Paquier had promised him free lodgings, carriage and a 1,000-thaler salary. In addition, Stöltzel arranged for supplies of Saxon kaolin to be delivered to Vienna, and so in April 1719 the first porcelain left the Vienna kilns. It is very probable that Böttger was not entirely innocent in this betrayal of the secret; at least the identity of those concerned would suggest that he was implicated.

Du Paquier did not make as much profit as he had expected, however, and so he was unable to fulfil his promises to Hunger and Stöltzel. In 1720 Hunger disappeared from Vienna and turned up in Venice, where he helped the Vezzi brothers to set up the first factory for hard-paste porcelain in Italy. Stöltzel, on the other hand, went back to Meissen, taking with him the young painter Johann Gregor Höroldt, who was destined to become one of the most famous decorators of Meissen porcelain. It was perhaps in order to clear himself in the eyes of the management of

the Meissen works that Stöltzel claimed to have caused 15,000 guilders' worth of damage in Vienna. We do not know whether he did indeed cause so much damage; probably not, for Du Paquier soon had production going again, and new ware to put on the market. What Stöltzel could not undo, however, was the revelation of the arcanum, of the secret of the preparation and firing of the clay. And although neither Hunger nor Stöltzel realized it, Vienna became the centre from which knowledge of the secrets of true porcelain spread throughout Europe. In this a major role was played by Joseph Jacob Ringler, the son of a Vienna teacher.

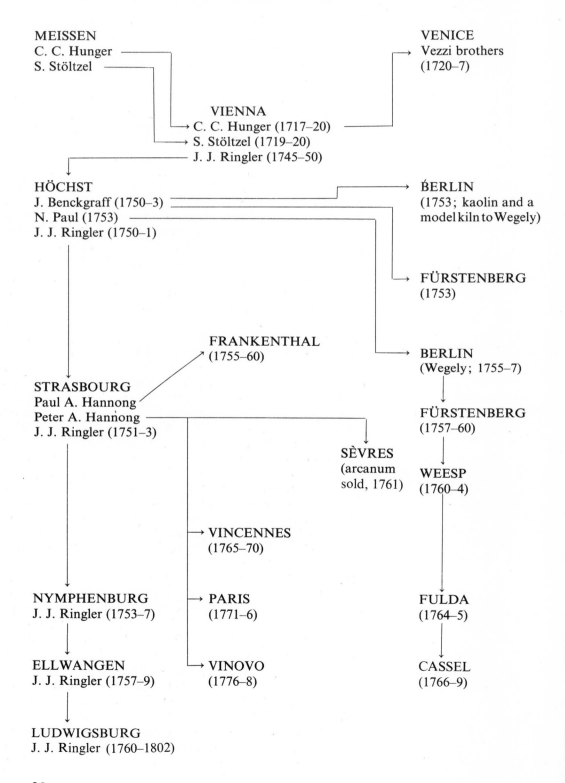

MEISSEN
C. C. Hunger
S. Stöltzel

VENICE
Vezzi brothers
(1720–7)

VIENNA
C. C. Hunger (1717–20)
S. Stöltzel (1719–20)
J. J. Ringler (1745–50)

HÖCHST
J. Benckgraff (1750–3)
N. Paul (1753)
J. J. Ringler (1750–1)

BERLIN
(1753; kaolin and a model kiln to Wegely)

FÜRSTENBERG
(1753)

FRANKENTHAL
(1755–60)

BERLIN
(Wegely; 1755–7)

STRASBOURG
Paul A. Hannong
Peter A. Hannong
J. J. Ringler (1751–3)

FÜRSTENBERG
(1757–60)

SÈVRES
(arcanum sold, 1761)

WEESP
(1760–4)

VINCENNES
(1765–70)

NYMPHENBURG
J. J. Ringler (1753–7)

PARIS
(1771–6)

FULDA
(1764–5)

ELLWANGEN
J. J. Ringler (1757–9)

VINOVO
(1776–8)

CASSEL
(1766–9)

LUDWIGSBURG
J. J. Ringler (1760–1802)

Born in Vienna in 1730, he was apparently employed in the Vienna porcelain factory from the age of fifteen and soon became an expert at the firing kilns. He appears to have gained his knowledge of the arcanum in the simplest possible way: by establishing a friendly relationship with the daughter of the factory's director, according to Franz Joseph Weber (1798). Whether Weber was right or not, Ringler was undoubtedly an expert maker of porcelain. In 1750 he was invited to Höchst, where two Frankfurt merchants, Johann Christoph Göltz and Johann Felician Clarus, had been trying since 1746 to make porcelain, aided by the porcelain painter A. F. von Löwenfinck. The painter obviously had incomplete knowledge of the arcanum, and so what he produced was faience, of excellent quality, which he called "Fayenceporzellan". Göltz and Clarus were not satisfied with Löwenfinck's results, and so they first called in Johann Benckgraff of Vienna, in 1750, and then Ringler. They worked hard and in the incredibly short time of five months the men from Vienna succeeded in producing the first Höchst porcelain.

Ringler then left in 1751, for Strasbourg in France, where he introduced porcelain manufacture for Paul Anton Hannong, who had been trying to find the secret for himself since 1745, without success; his faience works had been founded by his father Karl Franz Hannong in 1721. With the arrival of Ringler the first large-scale production of porcelain on French soil was assured, but the monopoly granted to the Vincennes factory prevented Hannong from continuing; in 1754 he was forced to stop production. However, he would not give up, and after winning the support of Karl Theodor, the Elector, he transferred his porcelain works to Frankenthal in Germany, in 1755. Meanwhile Ringler had moved again, in 1753, and was helping the master potter Franz Ignaz Niedermayr of Neudeck, near Munich, to achieve true porcelain; here the Elector Max Joseph III was the patron, and had already brought in three experts from Vienna to help: Johann Theophil Schreiber, a "repairer", Lippisch, a kiln-master, and Jacob Helchis, a painter. It was autumn 1753 when Ringler arrived in Neudeck, and by the following spring hard-paste porcelain was being fired in the kilns there. Ringler was a restless character; after three years in Neudeck he turned up in Utzmemmingen in Württemberg, where he set up porcelain production for Arnold Friedrich Prahl. The manufacturer died that same year, however, and after his widow had moved the factory to Ellwangen, she was forced to close it down in 1759, in the interests of the faience manufacturer, Bux. And so Ringler moved on again, in 1760 becoming manager of a porcelain factory in Ludwigsburg which had been founded in 1758 by Duke Karl Eugen, and which flourished under Ringler's management. Here he remained until he retired in 1802; two years later he died in Ludwigsburg, on 5th June.

Ringler not only bears the credit for developing porcelain production in these important German centres, however; under his guidance other men learned the arcanum, and their names soon appeared at other factories. Nicolaus Paul and Johann Benckgraff seem to have been let into the secret in Höchst; when Benckgraff quarrelled with the owner of the Höchst factory, Göltz, in 1752, he got in touch with Wilhelm Caspar Wegely of Berlin. Wegely was originally the owner of woollen mills, but with the support of Frederick II he intended to set up a porcelain factory in Berlin. In 1751 the king not only granted him a fifty-year monopoly, but gave him a site to build the new factory there. In the autumn of 1752 Benckgraff went to meet Wegely in Berlin, and after apparently successful discussions not only gave him a model of the kiln, but also revealed the formula for the clay body. Meanwhile, however, Benckgraff's old friend von Molck had undertaken the difficult task of finding an efficient "arcanist" for the Fürstenberg porcelain factory. Remembering Benckgraff from Vienna, he offered him the post, along with the title of "Bergrat" and an annual salary of 12,000 guilders, as well as the usual perquisites. In May 1753, then, Benckgraff came to Fürstenberg, only to die a month later on 7th June. Nevertheless, production at the Fürstenberg plant began, and on 3th November 1753 the first batch of porcelain was fired.

Nicolaus Paul was the other employee of the Höchst factory who was initiated into Ringler's secrets. He seems to have been tempted away to Wegely in Berlin as early as 1753, perhaps to take the place of Benckgraff who had gone to his friend in

Fürstenberg. In 1755 the ware made in Berlin was already on the market in considerable quantities, although neither the body nor the glaze were first-class. Paul remained in Berlin until 1757, going to Fürstenberg for the next three years and then entered the service of the Count van Gronsveldt-Diepenbroik, who had bought the faience factory in Weesp near Amsterdam, in 1759, with the intention of making porcelain there. Two years later, in 1762, the new kilns had been set up, kaolin brought from Passau, and production was under way. Two years later still, however, Nicolaus Paul returned to Germany, to start up production for the burghermaster Johann Philipp Schick in Fulda. Successful there, he nevertheless moved on again, this time to Cassel, where he was employed from 28th April 1766 by Count Friedrich von Hessen, for whom he fired the first Cassel porcelain in mid July 1766. The Hannongs of Strasbourg did not keep Ringler's secrets to themselves, either; as we have seen, Paul Anton transferred his porcelain factory to Frankenthal, while his son Peter Anton, who continued to run the Strasbourg faience works after his father's death, in 1761 sold the secret to the Sèvres works, which led to his fellow heirs removing him from his position as manager. In 1769 Peter Anton Hannong is found in Paris, helping to set up a porcelain factory in the suburb of St. Denis in 1771. In 1776, together with the broker Giovanni Vittorio Brodel, he set up another in Vinovo in Italy; in 1785 he was back in France, establishing the new Vincennes factory for the Duke of Chartres. He died in Paris in 1794.

Thus in spite of the strictest precautions, the secret of hard-paste porcelain manufacture that Meissen was so anxious about spread throughout Europe; nevertheless it would be wrong to assume that all the hard-paste porcelain in Europe came from Böttger's discoveries. We know that many people were trying to reach the same goal, both scholars of the French Academy and simple potters, and that is why Thuringian porcelain, for example, is of a different composition from that of Meissen or Vienna; it derives from the discoveries of the theologian and chemist G. H. Mecheleid and the Greiner family, who were responsible for the flourishing porcelain industry in Thuringia in the sixties of the eighteenth century. A Russian engineer, Dimitry Ivanovich Vinogradov, was experimenting in Petrograd, independently of Böttger, and is said to have produced the first hard-paste porcelain in Russia early in 1747. The famous czarist porcelain factory in the capital worked on this basis.

The merits of Böttger and Tschirnhaus in the discovery of the secret of porcelain cannot be doubted; the Meissen works which they helped to bring into being played a very important part in the development of this craft, and is still one of the most famous porcelain factories in the world.

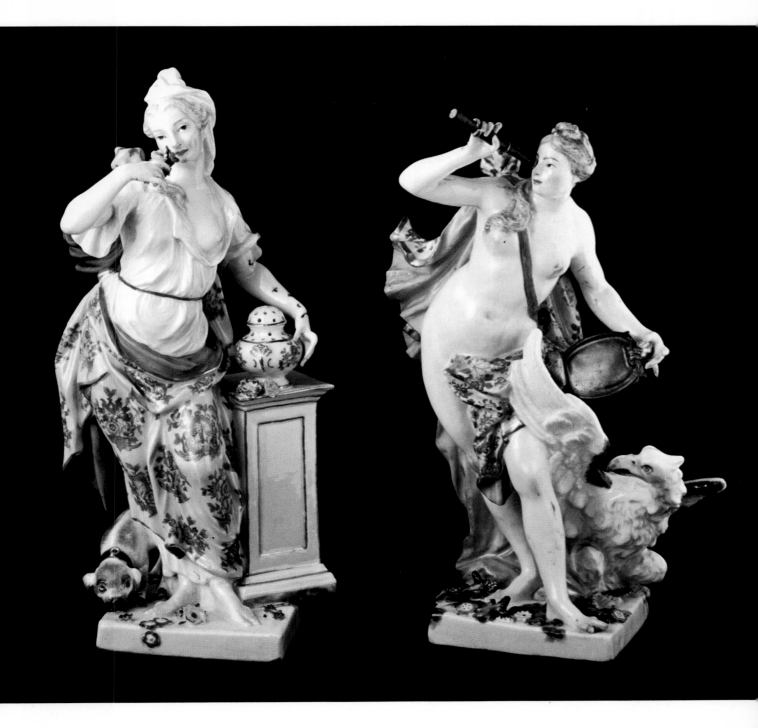

22 Personification of Sight and Smell, Meissen,
J. E. Eberlein, c. 1745; height 26.5 cm and 28.5 cm

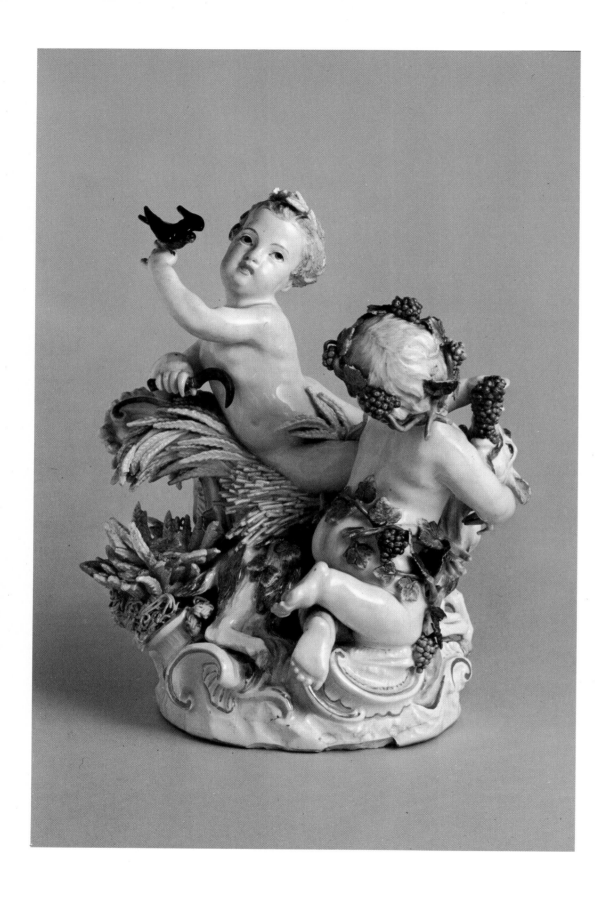

23 Allegory of Summer and Autumn, Meissen,
F. E. Mayer, 1750; 24.5 cm high

42

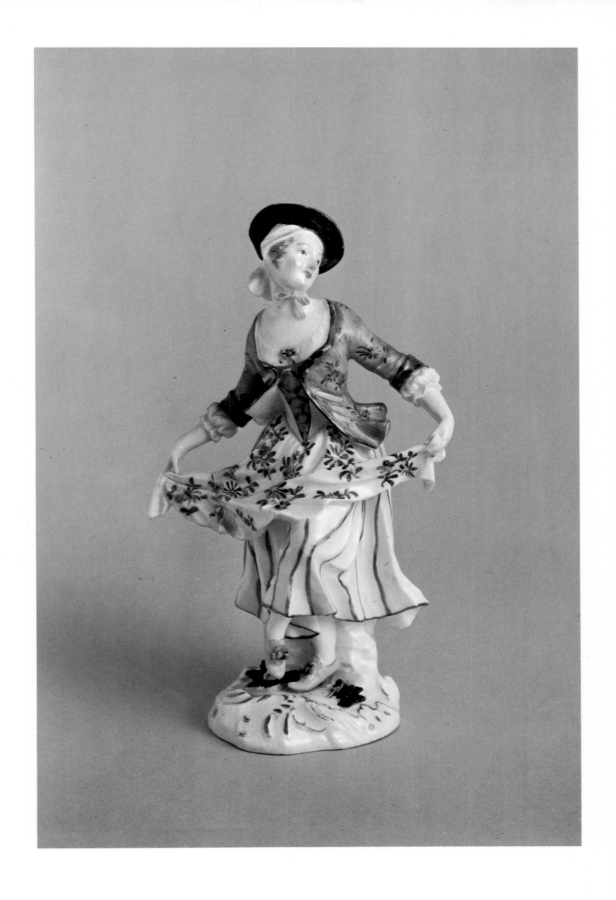

24 Dancing girl, Meissen, J. J. Kaendler, 1750;
19 cm high

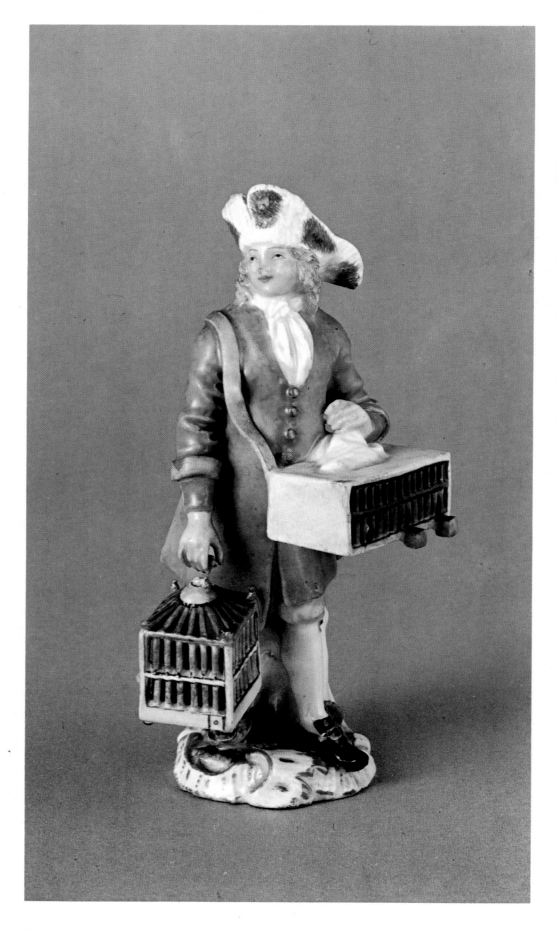

25 Birdcatcher, Meissen, P.
Reinicke, c. 1753; 12.3 cm high

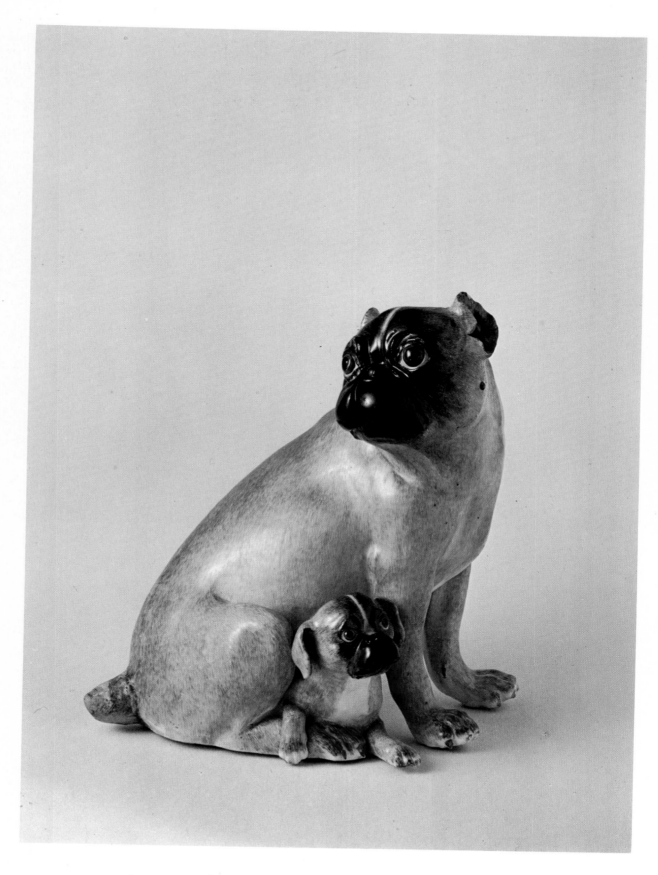

26 Pug-dog, Meissen, J. J. Kaendler, 1741;
18 cm high. Private collection, Prague

27 Tureen with "European" floral decoration,
Vienna, 1725–30; height 26.3 cm with lid

28 Tobacco jar, Vienna, 1725–30; 21.5 cm high

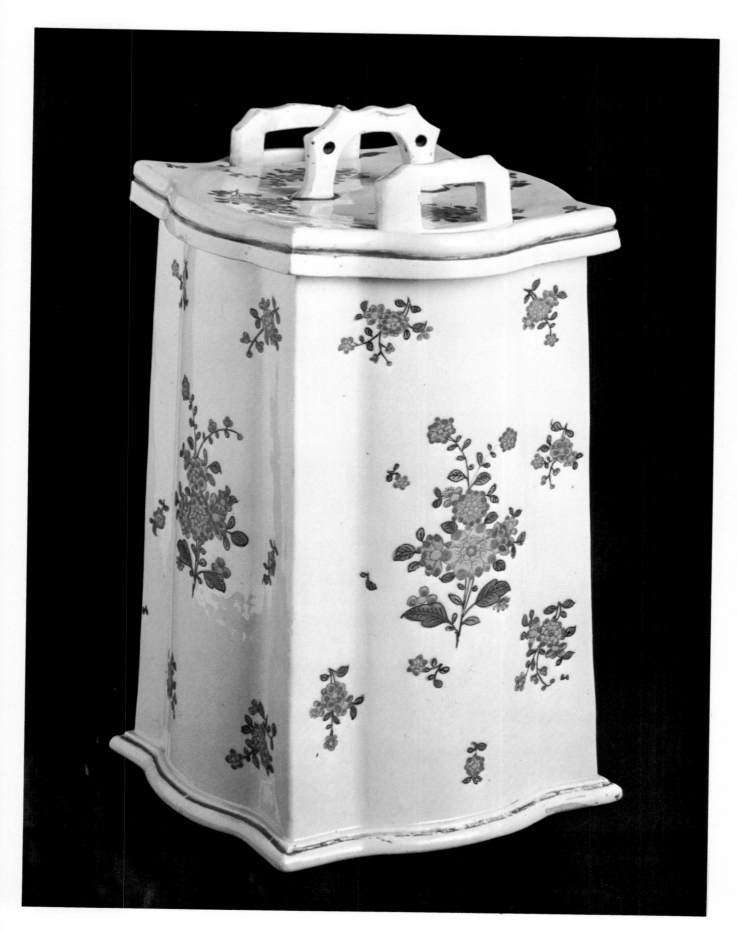

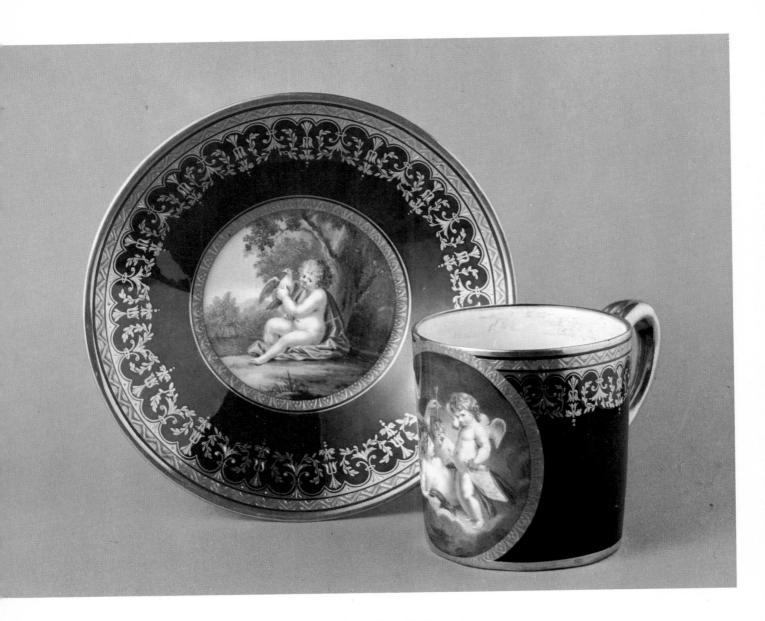

29 Cup and saucer in "Leithner blue" camaïeu,
Vienna, 1795; cup 8 cm high

Eighteenth Century
European Porcelain

European porcelain of the eighteenth century can be classified in two groups, according to the composition of the body and the production techniques used. On the one hand there were factories producing hard-paste porcelain of the Meissen type, mainly in Germany, Central Europe, in Russia, and to some extent in Italy. On the other hand, in France, in some Italian and Spanish factories, and some of those in England, a soft-paste porcelain of the French type was being produced. In addition there was a special type of soft-paste porcelain produced in England and known as bone china because bone-ash was included in the body.

Artistically, the leading role in the production of hard-paste porcelain in Europe was played by the Meissen factory. However unpleasant for the management Stöltzel's desertion to Vienna may have been, it was anything but a loss from the artistic point of view, for while he was in Vienna Stöltzel persuaded the painter Johann Gregor Höroldt to accompany him when he returned to Meissen. Höroldt had been born in Jena, worked as a painter in Strasbourg, and then as a painter of porcelain and wallpaper in Vienna. In mid April 1720 the two arrived in Meissen, and by 14th May Höroldt had prepared samples of his painting on porcelain for a special commission, who received them so favourably that he was offered a contract. According to this agreement Höroldt was engaged as a free artist, to be paid for his work according to the number of articles he painted for the factory; his remuneration was calculated by a three-degree scale of difficulty. As it turned out, Höroldt had been given very favourable conditions, and the Meissen works gained a painter who founded the fame of their porcelain. It was Höroldt's painting that determined the style and character of Meissen porcelain for the first decades of its existence, and created the tradition of European porcelain decoration. His style gave a unified composition to the article, in which the background, the decoration, the figural design and the frame together formed a single whole. In manner and palette Höroldt followed oriental models in some of his work, achieving great mastery in the painting of chinoiseries and "Indian flowers", but he was also an excellent portrayer of harbour scenes, landscapes, hunting scenes, European flowers, and other motifs.

Höroldt set up a large studio in Meissen, where work was very rigorously organized, each painter specializing in a certain type of work and being forbidden to sign it. At first this studio was not in the castle itself, but down below, in the town. "Blaumalerei", decoration with underglaze blue patterns, accounted for a considerable proportion of the work; at first this technique caused much trouble, because of the high temperatures at which it had to be fired, but a formula was devised by the chief kiln-master David Köhler and on 5th March 1720 the first articles with this decoration were shown to the Elector, Augustus the Strong. Köhler jealously guarded the secret of his underglaze blue pigment, however, and when he died in 1725 Höroldt had not won from him the complete formula. The ensuing difficulties were not overcome for another seven years, until 1732. Höroldt succeeded, however, in broadening the palette of colours for firing in the muffle-kiln. It is not possible, today, to determine how far he was indebted to C.C. Hunger and to Stöltzel, with whom he had worked in Vienna; in a letter Hunger complained that Stöltzel and Höroldt had stolen his pigments when they left Vienna for Meissen, while Stöltzel, on the other hand, said that Höroldt knew

nothing of porcelain painting and owed all his later knowledge to him, Stöltzel. However this may be, it is not so much the technical aspects of the decoration that we admire in Höroldt's porcelain painting today, as the high artistic standard he achieved. Nor should we forget the other painters in Höroldt's studio, among them such outstanding artists as Johann Ehrenfried Stadler, who sometimes secretly signed his work; Johann Georg Hintze, whom Höroldt himself considered his best collaborator; Johann David Kretschmar; Adam Friedrich von Löwenfinck, and many others. It the course of time some of these men left Höroldt to spread the fame of Meissen porcelain painting to other European factories.

This first phase of production at the Meissen factory, which was the "painted" phase, lasted until 1733, when the Elector died. The second important phase, which could be called "modelled" because the production of porcelain figures became of more consequence, is linked to the name of Johann Joachim Kaendler. Born in 1706 in Fischbach, Saxony, Kaendler was apprenticed to the Dresden court sculptor, Benjamin Thomä, at the age of fifteen. He became court sculptor in 1730, the following year he was appointed modeller and in 1733 "Modellmeister" at the Meissen works. Before this there had been two modellers there: Johann Christian Ludwig Lücke, who after two years (1728 and 1729) left Meissen for Vienna, and Johann Gottlieb Kirchner. Kirchner had been a mastermodeller in the Meissen

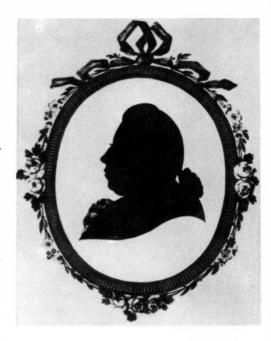

30 Silhouette of Kaendler, c. 1740. VEB Staatliche Porzellan-Manufaktur, Meissen

factory in 1727 and 1728, and was taken on again in 1730, when he won a great reputation for the large porcelain animal figures he modelled for the Japanese Palace. The decoration of this palace was the favourite project of Augustus the Strong, who gave orders to the factory

Eighteenth century jug types:

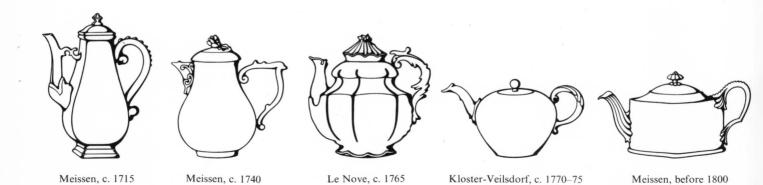

Meissen, c. 1715 Meissen, c. 1740 Le Nove, c. 1765 Kloster-Veilsdorf, c. 1770–75 Meissen, before 1800

31 A page from J. J. Kaendler's sketchbook. VEB Staatliche Porzellan-Manufaktur, Meissen

repairers, and set to work on the Elector's commissions. He modelled large animal figures — a pelican, a monkey, a goat, a golden pheasant — no matter how monumental the task. Together with Kirchner he modelled the large figures of the apostles for the chapel of the Japanese palace, and continued on his own after Kirchner left the works in 1733. Kaendler believed that any monumental figure could be executed in porcelain, so long as it was broken down into the necessary number of smaller parts. In 1755 he prepared a 10-metre-high plaster model for an equestrian statue of King Augustus III, which, however, was not executed in porcelain in the end.

In the 1730s the Rococo style began to predominate in porcelain, finding its ideal form of expression in this plastic medium. Porcelain figures became much smaller, without losing their artistic significance. Kaendler began modelling figurines in 1736, at first taking his subjects from life at the Saxon court. Thus about fifteen "Krinolinengruppe" came into being up to 1750, characterized by the wide and elaborately painted crinolines worn by the ladies. Around 1736 Kaendler also modelled a number of figures from the Italian Commedia dell'arte, starting with Harlequin and followed around 1744 by Pierrots, Columbines and Scaramouches. From the middle of the eighteenth century courtly subjects became fewer and folk types took their place; at this stage Kaendler modelled whole series of craftsmen, miners, peasants and beggars.

In his position as head of the modelling

which could not be executed. On his appointment, Kaendler was also made director of the "Weiss Corps", a team of throwers, mould men, sculptors and

Eighteenth century cup types:

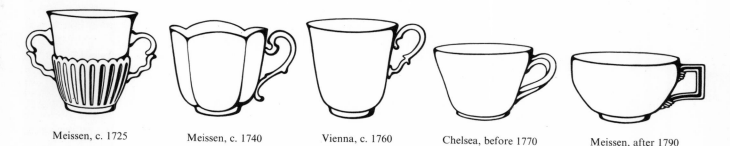

Meissen, c. 1725 Meissen, c. 1740 Vienna, c. 1760 Chelsea, before 1770 Meissen, after 1790

51

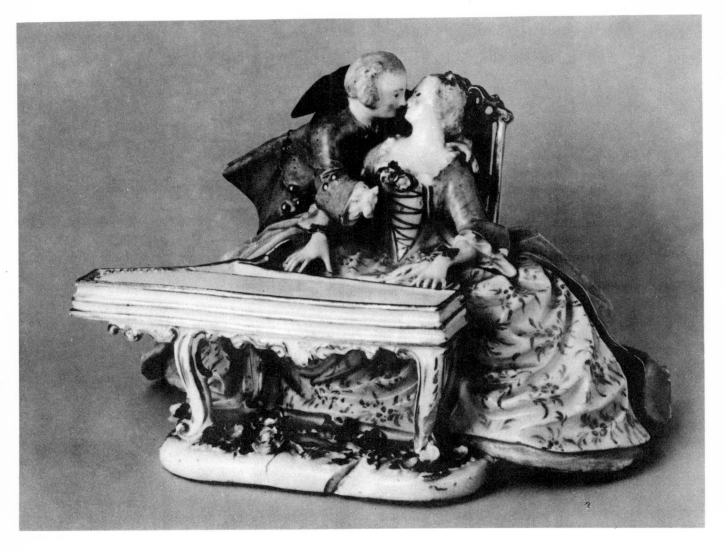

32 Crinoline group (The clavichord), Meissen, modelled by J. J. Kaendler, 1741 (the painting is later); 16 cm high

department Kaendler not only modelled figures, but also designed new shapes and types of services, vases, bowls and other vessels; one of the most famous sets of table ware was the Sulkowski service, designed for Count Sulkowski and his wife. This was the first large Meissen service to be made, and was fired from 1735 to 1737, designed by Kaendler. The dominant motif in the decoration of plates and dishes was the painted coats-of-arms of the Sulkowski-Stein marriage, while the pattern round the edge was in low relief, imitating basketwork interspersed with radial strokes. This motif is known as the "Sulkowski Ozierrelief". Kaendler mod-

elled the tureens, the most demanding pieces of the service, on silver tureens made by the Augsburg silversmith J. Biller (1692–1746) and preserved in Dresden Castle, while figurines in the Zwinger collections, by B. Permoser, also served to inspire him.

Another famous service made in 1737–42 for Count Heinrich von Brühl, an influential minister at the Saxon court, was the Schwanenservice, one of the largest and most elaborately decorated services ever made at Meissen; it was said to comprise 2,200 pieces, and was designed by Kaendler assisted by J. F. Eberlein and later J. G. Ehder. The painted decoration consists of the Brühl-Kolowrat arms (the

Count married a Countess of Kolowrat) on each of the pieces, in a setting of Indian flowers and finely coloured figures, and edged with gold. The principal motif, however, is the swan, either in low relief or relief modelled to bear a cartouche with the coat of arms. Some of the pieces are shaped like swans. The swan gave its name to the service, although other water creatures and flowers also figure in the designs, as well as Greek mythological motifs connected with water.

Kaendler followed the same rule in his workshop as Höroldt in his studio: the work of his assistants remained anonymous. His influence on those who worked with him was a powerful one, and so it is very difficult to distinguish the work of individual artists among them. Then, some figures were the work of more than one artist, like the Polish lady in a crinoline which was begun by Kaendler in December 1744 and finished by J. F. Eberlein in January 1745. Kaendler himself thought most highly of Eberlein, who worked with him from 1735 until his death in 1749. Another artist who was strongly influenced by Kaendler was Peter Reinicke, who worked under him from 1743. On the other hand Friedrich Elias Meyer was already an experienced sculptor when he joined the Meissen works in 1748, bringing with him the true Rococo spirit, which had remained somewhat alien to Kaendler hitherto. Meissen porcelain figures, created under the direction of Kaendler who can be considered the spiritual father of European porcelain statuary, set the tone for the other factories in Europe.

Meissen ware was at the zenith of its artistic development around the middle of the eighteenth century, and never reached such heights later. This was partly due to the disturbances of the Seven Years War (1756–63), but also to the changes taking place in France and England in the sphere of porcelain. The new style which predominated there after 1763, Neo-classicism, began to spread to other countries in Europe too. Kaendler could not adapt easily to these changes in taste, and so in 1764 a French sculptor was brought to Meissen to breathe French charm and "esprit" into the porcelain figures made there. Michel-Victor Acier was given the same authority as Kaendler, and soon the Meissen factory started to produce mythological figures, scenes of bourgeois life, and

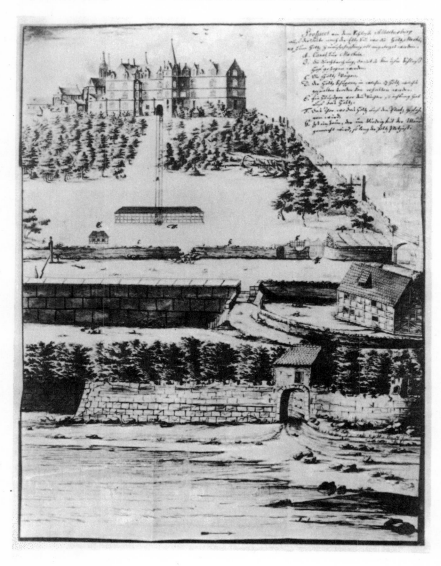

33 The Albrechtsburg fortress, Meissen; the lift needed for timber for the factory can be clearly seen. VEB Staatliche Porzellan-Manufaktur, Meissen

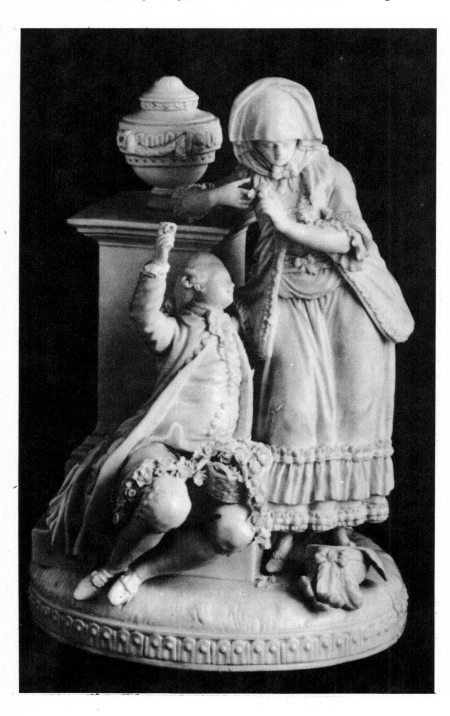

34 Love's Test (Liebesprüfung), Meissen, M. V. Acier, 1774; 23 cm high

child figures. The French spirit could be seen in the painting, too; Höroldt retired in 1765, and soon scenes à la Watteau became popular, figures of children and cherubs à la Boucher and other French painters. Meissen was completely subject to the French influence — but naturally there were also commercial reasons for the change; Meissen wanted to compete with Sèvres, Berlin and other European factories already making French-style porcelain.

At the end of the eighteenth century, when Count Camillo Marcolini (1774–1814) was appointed director of the Meissen works, the main endeavour was to compete artistically with Sèvres, for porcelain production was technically up-to-date. White bisque began to be made, Parian figures in imitation of antique marble statuary; and such popular French pigments as "bleu du roi" were introduced. The world of Baroque and Rococo was left behind. J. J. Kaendler died on 18th May 1775, and Acier retired in 1781. The great era of Meissen porcelain was at an end. Under their successors, Carl Schönheit (1745–94), Christian Gottfried Jüchtzer (1769–1812) and Gottlieb Matthäi (1773–95), and even under Johann Eleazar Zeissig, called Schenau (1773–96) as head of the painting department, Meissen never regained its former significance in the artistic world.

The second oldest porcelain factory producing Böttger's hard-paste porcelain was that in Vienna. It had been founded in 1718 by Claudius Innocentius Du Paquier, who was able through the Austrian ambassador to the court of Saxony to engage the Meissen gilder Christoph Conrad Hunger, and acquired the privilege of making porcelain in Austria. Du Paquier was disappointed in Hunger, however, and the secret of porcelain still eluded him until in 1705 he engaged another deserter from Meissen, Böttger's assistant Samuel Stöltzel. In Meissen Stöltzel had prepared the body and had also taken part in the firing process, and so the first "true" porcelain was made in the Vienna kilns. The volume of production and sales did not come up to Du Paquier's expectations, however, and so he was unable to keep his promises to the two Meissen workers. Hunger fled secretly to Italy in 1720, and Stöltzel returned to Meissen. There were only ten employees at the Vienna factory when

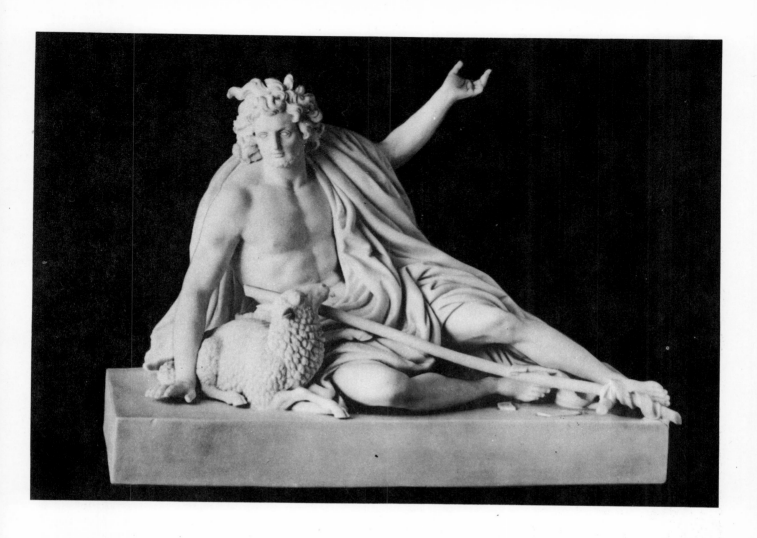

35 St. John the Baptist, Meissen, c. 1800; 20,4 cm high

Stöltzel and Hunger left, but before long this figure was doubled. Even so the factory did not prosper, and so in 1744 Du Paquier offered it to the government. It was bought for 31,500 guilders, the price including the arcanum of porcelain production. Thus ended the first phase of Vienna porcelain production, sometimes called "Wien vor der Marke", because the pieces made during this period bore no mark.

Like Meissen ware, the oldest Vienna porcelain set out to imitate oriental style; it was not until after 1730 that Central European Baroque ornament was in common use. At first the colours were predominantly black and manganese purple, ferrous red and gold; later purple was added, as well as green, yellow and bright blue. It should be noted that the Vienna works evolved some types of vessels which were not known in Meissen, like the trembleuses, or those decorated with modelled figures. The first major commission executed by the Vienna porcelain factory was for the porcelain cabinet in Count Dubský's Palace in Brno, Moravia; it was panelled with 1,458 porcelain plaques, and work lasted from 1725 to 1730. The decoration on the panelling is mainly oriental floral motifs, but European flowers appear on the mantelpiece. It was painting which laid the fame of Vienna porcelain at this time (1718–44), Johann Karl Wendelin Anreiter von Zirnfeld came from Slovakia and founded a numerous line of painters who remained faithful to the Vienna works until it was closed down in the middle of the nineteenth century. Of the other Vienna porcelain painters we should

36 Plate from the hunting service for Prince Trivulzio, Vienna, apparently painted by J. Helchis, 1735–40; diameter 25 cm

mention Joseph Philipp Dannhöfer, skilful at figure subjects, and Jacob Helchis, painter of landscapes and floral motifs who is also accredited with paintings in black (Schwarzlotmalerei).

When the factory was taken over by the state it entered on the second phase of its history, marked by the personalities of two successive directors, Mayerhof von Grünbühel (1747–57), Quiex von Bodenthal (1757–64) and Wolf von Rosenfeld (1764–84). J. J. Niedermayer, appointed head of the modelling department in 1747, remained there until 1784; the other modellers are not known. From the mid 1740s the Vienna works produced single figures and groups which in conception, liveliness and colour from a distinct group in European porcelain. They differ from Meissen work, and although they do not surpass it in quality they nevertheless are of definite artistic value. The Vienna modellers created large allegorical scenes, groups of gallants and crinolined ladies, innumerable types of cherubs, amoretti and folk types like peasants, street musicians, soldiers and so forth. The Meissen series of "Cris de Paris", figures from the streets of Paris, was followed by a series of "Cris de Vienne". By the end of the century the production of porcelain in Vienna was strongly influenced by French Neo-classicism as expressed in Sèvres, through the person of Anton Grassi (1755–1807), who worked in Vienna from 1778 onwards.

Rocaille was much used in plastic decoration, and the shapes were restless in the Rococo manner, with tendrils and twigs to form handles. At the beginning of this period Rococo painting predominated, and European floral motifs reigned supreme, the flowers often painted in bunches; Rococo scenes of gallantry took the place of Chinese scenes, and hunting or battle scenes were painted according to engravings of popular paintings by Boucher, Ridinger or Rugendas; these scenes were often painted in camaïeu technique, and not always in monochrome. During the Rococo period Vienna welcomed a number of artists from Meissen, like Christian Daniel Busch and Samuel Hitzig, or Johann Gottfried Klinger and Philipp Ernst Schindler, driven out of Meissen in the aftermath of the second Silesian War, 1744–5. From the 1770s onwards the influence of Sèvres became stronger in Vienna, and the factory tried to keep pace with its rival. As in Meissen, the Vienna porcelain painters were faced with the problem of imitating the brilliant colours of the French soft-paste porcelain. Realizing that the same effects could not be achieved on their hard-paste porcelain, they tried to develop a finer body, but even after the chemist and painter Leithner succeeded in improving several pigments, one of which, the blue, bears his name, the Vienna factory continued to produce hardpaste porcelain.

37 The Czech Princess Libuše, painted on porcelain, signed A. A. v. Z. (Ant. Anreiter), 1756; 7.4 × 5.5 cm

In 1784 the factory was in such financial straits that the state decided to auction it, but no prospective buyers appeared. The management was then entrusted to the councillor Konrad von Sorgenthal, who had already proved his acumen in running a cloth mills in Linz. Under this management (1784–1805) the Vienna porcelain factory at last prospered and even outshone Meissen. Sèvres Neo-classicism was absolutely predominant in colours as well as in forms; the palette became light and airy, and at the end of the seventeenth century decoration with a metallic gleam was popular, as well as gold encrustation in the manner of Georg Perl (1771–1801). Joseph Leithner was another porcelain painter famed at this time. On the death of Niedermayer in 1784 Anton Grassi became head of the modelling department, specializing in white bisque figures. The Sorgenthal era lasted into the early nineteenth century, when the Vienna school of porcelain painters, in particular, was renowned and often imitated.

Böttger's arcanum spread from Vienna throughout practically all the German regions, and our survey of nineteenth century European porcelain must now turn to Nymphenburg, the nearest of the German factories to Vienna. The arcanist J. J. Ringler, after Hannong found it impossible to overcome the obstacles to porcelain production in Strasbourg, had moved to Bavaria in 1753, but even earlier, in 1729, the Saxon glass-maker E. Vater had attempted to make porcelain, the Bavarian Elector agreeing with his peers that a porcelain factory of his own would add "lustre and honour to his court". It was not until Max III Joseph was Elector, however, that serious experiments were made to set up a factory. In 1747 the Elector put the manor of Neudeck, near Aue, at the disposal of a potter, Franz Ignaz Niedermayr, and he endeavoured to discover the arcanum in his magnificently named "Churfürstliche Porcelaine-Fabrique" there. The Bavarian government took over the works and appointed the "arcanist" and kiln-builder J. J. Ringler in 1753. A year later the first porcelain was fired, and in 1761 the factory was moved to the grounds of the Nymphenburg Palace, near Munich.

From the earliest beginnings in Neudeck, porcelain figures had been an important part of the factory programme; the model-

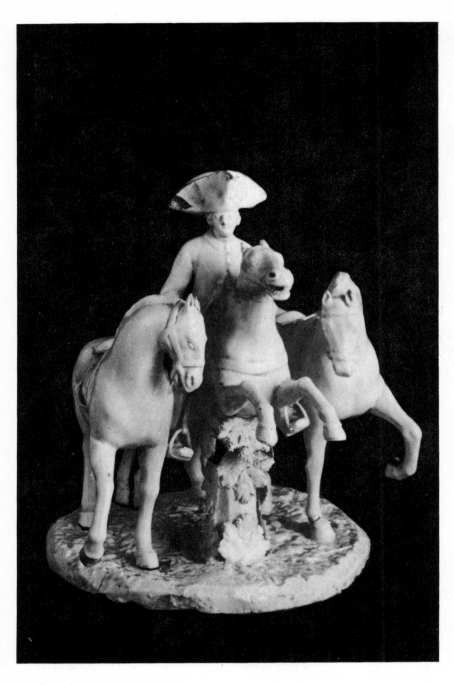

38 Part of the table decoration for Prince Franz Joseph Auersperg, Vienna, 1749; 18 cm high

ler J. Ponhauser, of Vienna, was the first to be able to cope with an order from the Elector for a table-stand one metre high (Tafelaufsatz). The piece was completed by Franz Anton Bustelli, engaged as a figure modeller in 1754. Bustelli played the same role in the Nymphenburg works as, Kaendler in Meissen, becoming famous for his ladies and gallants, single and in groups, his Commedia dell'arte characters and his Chinamen; his figures were full of life, and the hundred or more he modelled during his short term in Nymphenburg (he died there in April 1763) are among the finest porcelain figures ever made. He was succeeded by a Czech sculptor, Dominik Auliczek, a pupil of the Litomyšl sculptor F. Pacák, who was trained in Vienna, Paris, London and Rome, where in 1759 he won the prize of the Academy of S. Luca. The greatest influence on Auliczek's art, however, was that of the sculptor G. Chiaveri, who gave him a good grounding in Classicist theory. The calm, poised elegance of the Nymphenburg figures made by Auliczek after his appointment in 1763 derives from the influence of Chiaveri. Auliczek was not only modeller for the porcelain factory, but court sculptor as well, and as such he worked on the decoration of the manor park. Thanks to the *Augsburgisches monatliches Kunstblatt* of 1772 we know what major works he had completed by that date: 25 models of animals for hunting groups, and such mythological figures as Apollo and Diana, Mars and Pallas, Jupiter and Juno. Auliczek also designed vessels, and was the creator of the famous Nymphenburg "Perl-Service". When he retired in 1797 he was succeeded by Johann Peter Melchior (1742–1825), who came to Nym-

Eighteenth century tureen types:

Meissen, after 1730

Meissen, before 1740

39 Chinaman with a lute, Nymphenburg, modelled by F. A. Bustelli, c. 1760; 16.8 cm high

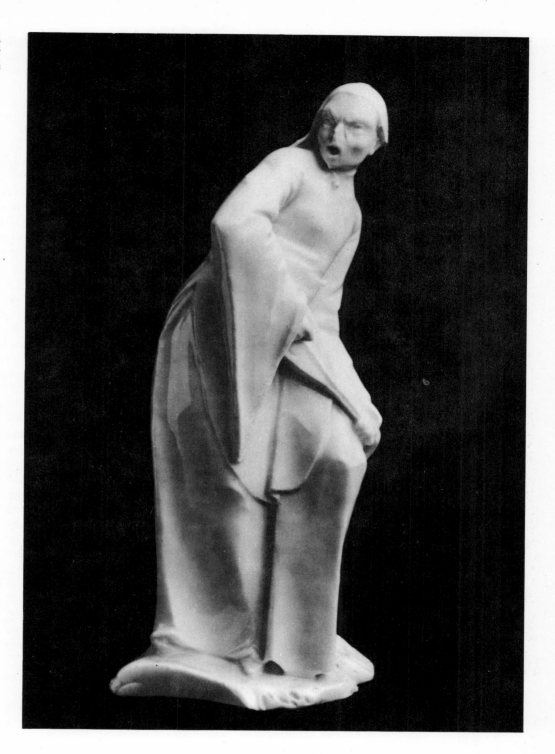

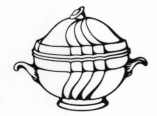

Vienna, c. 1765

Sèvres, 1770–80

Nyon, c. 1790

59

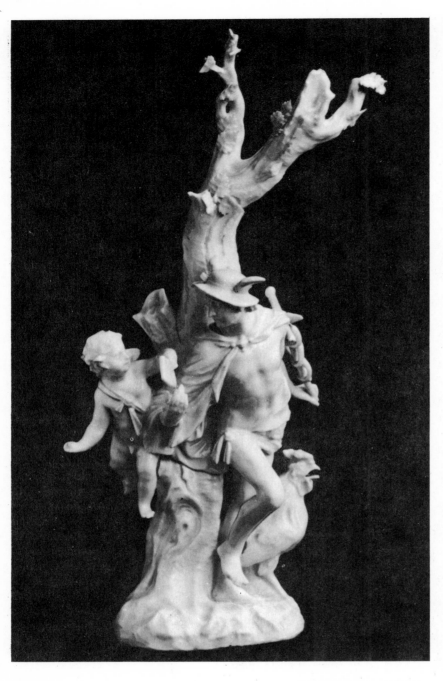

40 Mercury, Berlin, modelled by F. E. Meyer, c. 1763; 34.2 cm high

phenburg with other artists from Frankenthal when the factory there closed down after the French occupation.

In the early phase, Nymphenburg ware was strongly influenced by Meissen in forms (osier, Alt-Brandenstein), but in painted decoration it produced some remarkable hunting scenes, mythological motifs and genre paintings. Rocaille edging in various colours was characteristic of Nymphenburg ware.

Another important porcelain factory in Germany was that in Berlin, where the history of production falls into three parts, according to the owners of the factory. Experiments were already going on in the 1740s, but it was not until 1751 that a factory was set up, by the weaving-mills owner Wilhelm Wegely, with the support of Frederick II of Prussia. As we have already seen, Wegely tried to engage experts from Höchst, in particular the director of the Höchst factory, Benckgraff. Negotiations were promising; Benckgraff visited Berlin, sent Wegely a wooden model of a kiln, and arranged for supplies of kaolin from Passau, but in the end decided to work for the Fürstenberg factory. Wegely managed to start up production, in spite of difficulties, with the help of experienced men from Höchst and Meissen. The porcelain pieces made by Wegely are rarities; they include figures modelled by Ernst Heinrich Reichard, as well as table ware. Painting seems to have presented the greatest difficulties, and part of the production was left white; larger pieces were decorated in unfired lacquer colour. The situation improved when the painter Isaac Jacques Clauce came from Meissen in 1757, but it was already too late to save the factory, and it was closed down for financial reasons in the same year.

Frederick II did not give up so easily, and in his aim of a Berlin porcelain works supported the merchant Johann Ernst Gotzkowsky in his plans to reopen the factory. He not only bought the works, and some of the equipment, but acquired the arcanum from Wegely's modeller, Reichard. The painter I. J. Clauce also promised to co-operate, and the modeller Friedrich Elias Meyer, the painter Karl Wilhelm Böhme, Karl J. C. Klipfel and Johann B. Borrmann all came from Meissen. With these experienced workers Gotzkowsky reorganized the Berlin factory and two years later sold it to the King of Prussia;

by then there were 146 workers employed there. The change of owner did not affect the factory's production, and so it is very difficult to distinguish pieces made under Gotzkowsky from those of the royal factory.

The Berlin porcelain factory was parti-

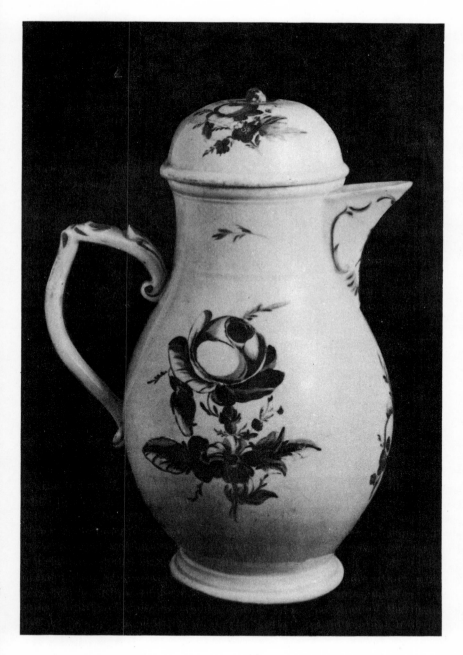

41 Lidded jug with floral design in purple, Wallendorf, c. 1780; 24.7 cm high

cularly renowned for its table ware, which was the finest in all Germany during the Rococo period. At first the decoration (in relief) was derived from Meissen patterns, using the osier, Brandenstein, new osier and new Brandenstein designs. In 1741 Gotzkowsky commissioned Eberlein in Meissen to design relief ornament for a service which then became known as "Gotzkowskys erhabene Blumen" ("Gotzkowsky's relief flowers"), copied in Berlin under the name "Floramuster". The Berlin artists designed their own decoration, of course; a service with relief ornament designed by Friedrich E. Meyer in 1764 was known as the "Radiertes Dessin" ("etched drawing"), later the "Reliefzierat" ("relief decoration"); another variation was the "Reliefzierat mit Spalier" ("trellis"). In the 1760s there was another popular ornament, the "Antikzierat", heralding the Neo-classical style; bunches of twigs tied with a ribbon, interspaced with painted scales (écaille, or Mosaique-malerei). The earlier "Reliefzierat" was also the source for the "Neuzierat" of the 1780s, used especially for services in the English manner, like the "bleu mourant" service of 1784.

The porcelain statuettes made in Berlin could not compare with Meissen ware, even after 1761 when the Meissen modeller F. E. Meyer came over; his predecessor under Wegely was Ernst Heinrich Reichard, whose work in Berlin is dated 1751–64; the rough effect in the latter's figures can be blamed on the unsuitable body. F. E. Meyer raised the level of Berlin production, although he lacked Kaendler's imagination; the reputation of the Berlin factory rested on the floral painting, which was in every way comparable to that of Meissen, and the invention of crimson, which was lacking from the Meissen palette. Naturally the Berlin repertoire included genre paintings in the Sèvres manner, inspired by Watteauesque engravings. By the end of the eighteenth century production at the Berlin works was completely Neo-classical in style, in accordance with the taste of the Prussian court, and the new trend can be seen in the relief portaits executed in bisque, and in the choice of mythological subjects.

The name of Benckgraff, already heard in connection with Berlin, cropped up again at the Höchst factory, founded in 1746 by three partners, the painter Adam

61

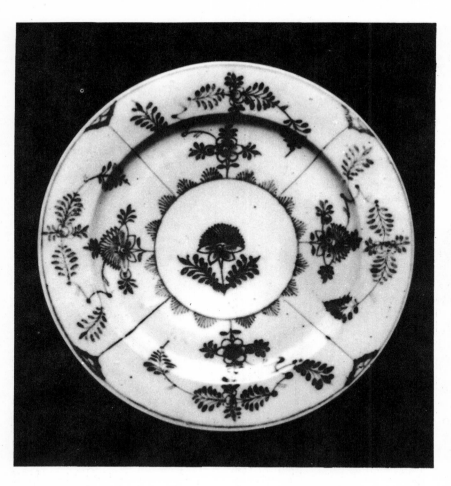

42 Plate with design of everlasting flowers in cobalt blue, Gera, c. 1790; diameter 23 cm

Friedrich von Löwenfinck of Meissen and two merchants from Frankfurt, the brothers-in-law Johann Christoph Göltz and Johann Felician Clarus. Their hopes that Löwenfinck would start the production of porcelain were not fulfilled; his "Fayence-Porzellan" was excellent quality stoneware. The appointment of J. Benckgraff as manager of the factory in 1750 brought a change for the better; he brought his friend J. J. Ringler from Vienna, an expert in the building of kilns, and the Höchst factory then began to produce true porcelain as well as faience. In

1751 Ringler moved on to Strasbourg, to help the faience factory of P. A. Hannong to produce porcelain, and two years later Benckgraff himself left in dramatic circumstances and went to Fürstenberg. The Höchst factory struggled with financial difficulties even after 1765 when it was turned into a limited company, and not even the support of the last two Electors of Mainz, Emmerich Freiherr von Breidbach and Friedrich K. J. Freiherr von Erthal, saved it from closing down in 1796.

The principal artistic contribution of the Höchst factory were the porcelain figures modelled by Johann Peter Melchior, who worked there during 1767–79. They are sensitive reflections of the mood of the time, Rousseauesque love of Nature and sentimental idylls, absorbed during a visit to Paris, and skilfully expressed in the Damm factory near Aschaffenburg, mythological subjects, portraits and relief medallions. When the Höchst factory closed down the moulds were bought by the Damm factory near Aschaffenburg, which made over 300 figures and 8 groups using them, after 1840, in stoneware.

The story of another German factory, at Fürstenberg, goes back to 1747. Duke Karl of Brunswick-Wolfenbüttel was anxious to have his own porcelain factory attached to his court, and a would-be expert, Johann Christoph Glaser, tired in vain to make at least an acceptable sample of porcelain at his expense. It was not until Benckgraff left Höchst for Fürstenberg that things improved. As we have seen, Benckgraff first negotiated with Wegely in Berlin before deciding for Fürstenberg, and his departure was held up by the owner of the Höchst factory, J. C. Göltz, who had him arrested for breaking his contract. The Duke intervened and had him released, so that he arrived in Fürstenberg on 6th May 1753, taking with him the modeller Simon Feilner and three painters, J. Zeschinger, P. Zisler and G. F. Geisler. Porcelain was already being fired in the Fürstenberg factory on 3rd November 1753. The first modeller was Simon Feilner, who created Commedia dell'arte figures as well as fourteen types of miners. He worked until 1768, and alongside him there were Johann Christoph Rombrich (1758–94), Anton Carl Luplau (1759–76) and Desoches (1769–74). The principal fame of the Fürstenberg porcelain, however, lay in the painted ware;

Jug, Venice, Vezzi brothers, 1720–27

this was at its best between 1770 and 1790, and we know about 39 painters who worked there in the second half of the eighteenth century. In 1774 the studio, where bright colours were used ("Buntmalerei"), was moved to Brunswick, where it remained until the 1820s.

The factory was at the height of its fame under Johann Ernst Kohl (1769–90); his successor, Victor Louis Gerverot, a Frenchman, who took over in 1795, had a troubled period as a consequence of the Napoleonic Wars, but this is already the nineteenth century.

Equally important was the porcelain factory in Frankenthal, which like most of the German factories was renowned for its figures. Over 800 different models were

43 Lidded jug with design of everlasting flowers in cobalt blue, Gotha, c. 1795; 16.5 cm high

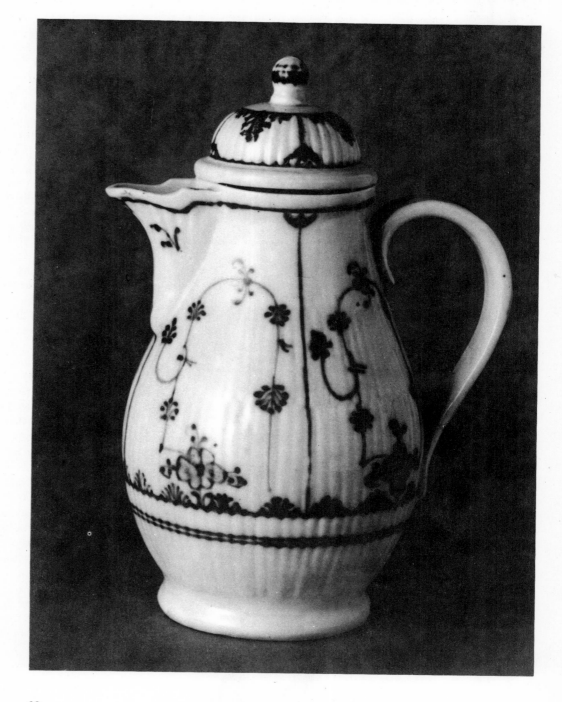

Chinaman, Venice, Cozzi, 1780

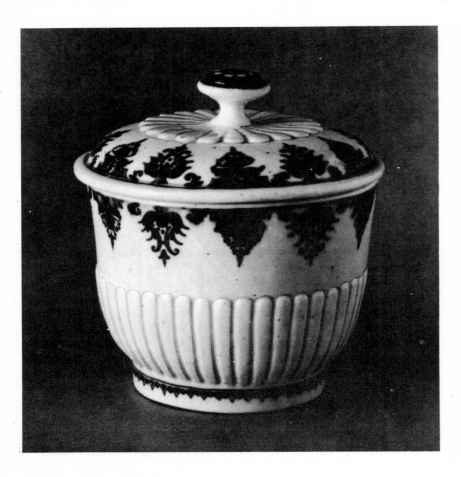

44 Lidded jar with Bérain decoration in blue, St. Cloud, after 1700; 10.3 cm high

it was taken over by his brother Joseph Adam. The factory was not very successful, however, and in the end Joseph Adam sold it to the Elector in 1761. The technical manager was Adam Bergdoll, followed on his retirement in 1775 by Simon Feilner. The French occupation of 1794–5 marked the beginning of the end for the Frankenthal factory; in the spring of 1795 the French authorities rented the factory to Peter van Recum, who again put A. Bergdoll in charge. After a short period from the autumn of 1795 to 1797 when the Elector was again in command, the factory was sold to Johann Nepomuk van Recum in December 1797, under the Campoformio peace terms. He closed down the kilns in the summer of 1799, for financial reasons, and set up a stoneware factory in Grünstadt, to which he brought many of the Frankenthal moulds. The legal closure of the Frankenthal works was signed by the Elector Max IV Joseph on 27th May 1800.

The first porcelain was fired in Frankenthal in November 1755, and was at first strongly influenced by Strasbourg; Hannong seems to have taken Strasbourg workers with him. At first he used Strasbourg moulds for the figures of everyday characters, tradesmen and peasants, as well as ladies and gallants or allegorical figures of the seasons, the continents, and so on. The base of the earlier figures resembles that of Strasbourg faience figures, but later rocaille bases were used, painted in purple or gold. The first modeller was Johann Wilhelm Lanz (1755–61). Later, under Joseph Adam Hannong, the most famous of the Frankenthal modellers Johann Friedrich Lück (1758–64) was active, with his brother Karl Gottlieb Lück (1758–75), who was chief modeller from 1760. The work of the court sculptor Franz Konrad Linck (1762–80), who modelled the allegorical figures of the seasons, was a real artistic achievement. Early Neo-classicism appears in Frankenthal porcelain with the work of Johann Peter Melchior, who came from the Höchst factory in 1779. He was particularly fond of genre groups in bisque, in imitation of white marble, or with a white glaze. Another of the modellers who worked in Frankenthal until the factory closed down was Adam Clair, who followed Melchior to Nymphenburg in 1799.

Frankenthal tableware was both painted

Sauceboat, Weesp, c. 1760–65

made during the life of the works, which was established by Paul Anton Hannong, who had already made hard-paste porcelain in his faience factory in Strasbourg, with the help of the Vienna arcanist J. J. Ringler. Production had to be stopped in Strasbourg, since the Sèvres works had the monopoly for the whole of France, and Hannong turned for help to the Elector-Palatine, Karl Theodor, who granted him the monopoly of the production and sale of porcelain, on 26th March 1755. At first Hannong's son Karl Franz Paul ran the factory, and after his death

(continued on page 73)

64

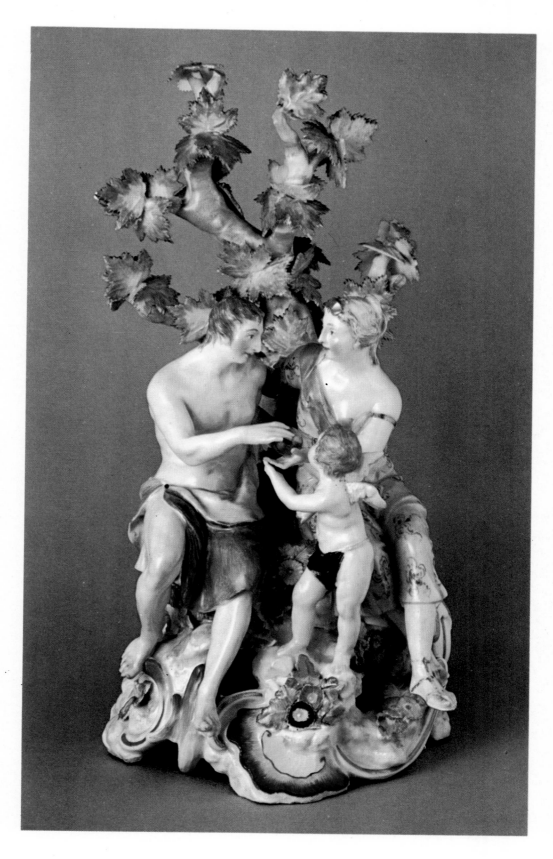

45 Paris and Helen, Vienna, modelled by
J. J. Niedermayer, 1755–60; 28.5 cm high.
Private collection, Prague

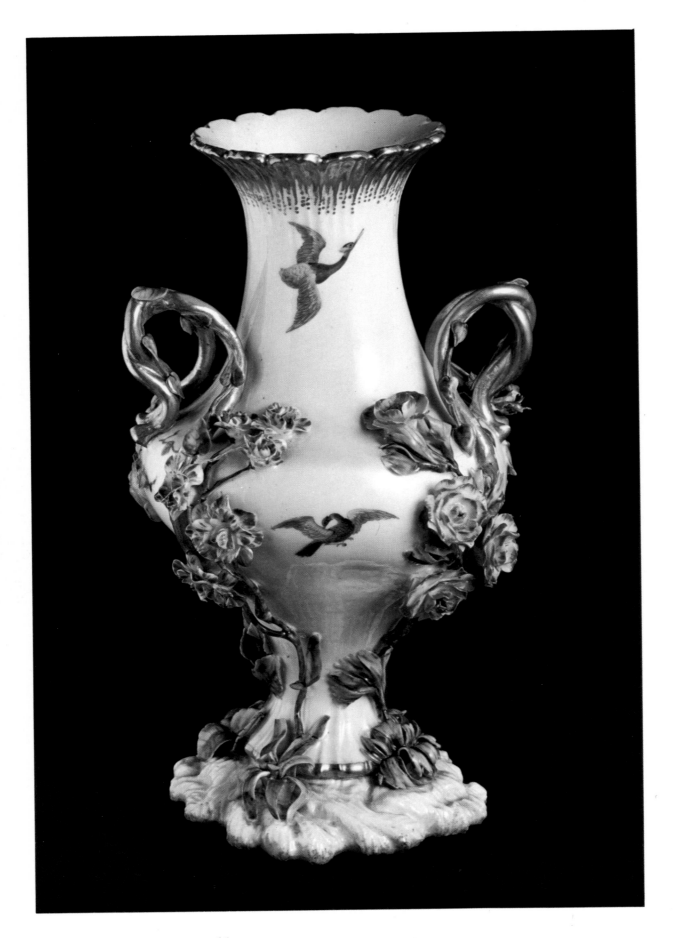

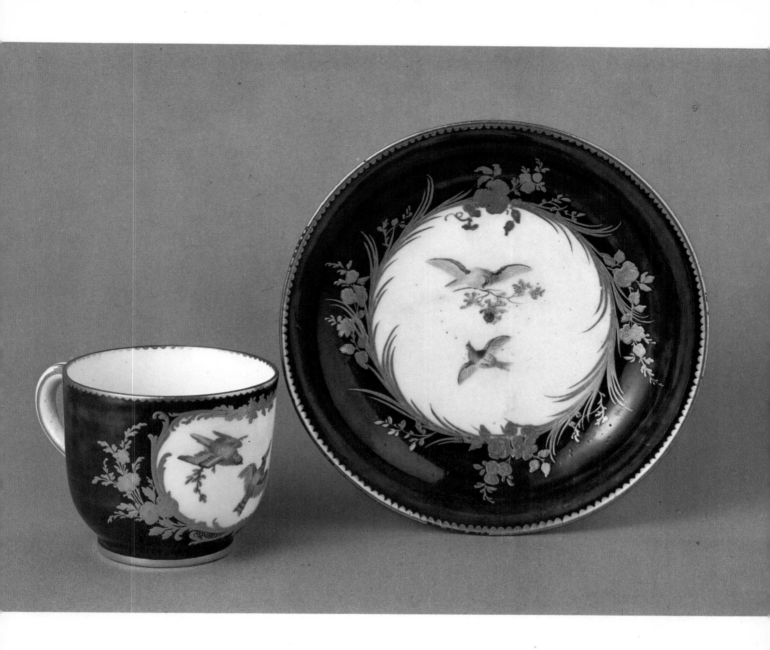

47 Cup and saucer, Sèvres, painted by F. Alon-
cie, "bleu lapis" ground, 1771; cup 5.8 cm high

◀

46 Vase with raised floral decoration ("Vase
Duplessis à fleurs balustre rocaille"), Vincennes,
1752; 22.5 cm high

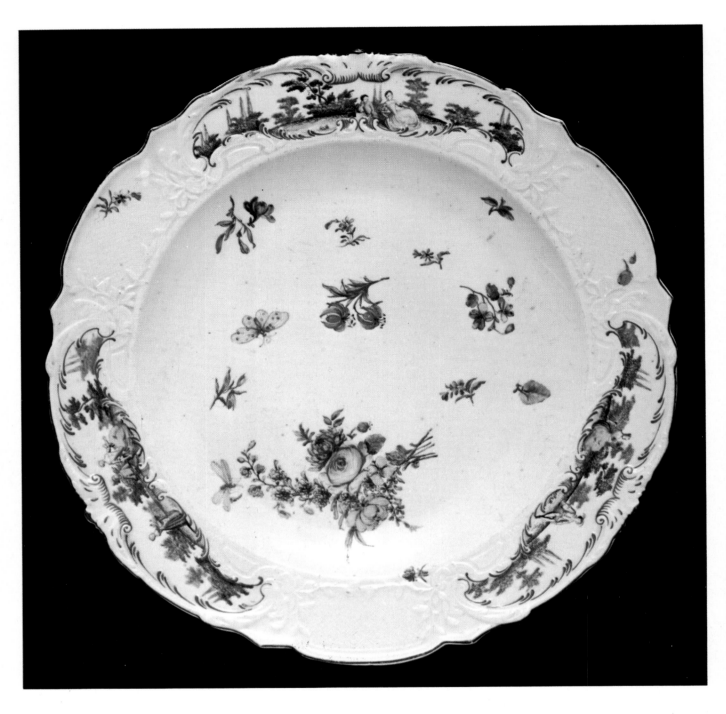

48　Plate with "European flowers" and a gal-
lant scene, Chelsea, after 1760; diameter 28.5 cm

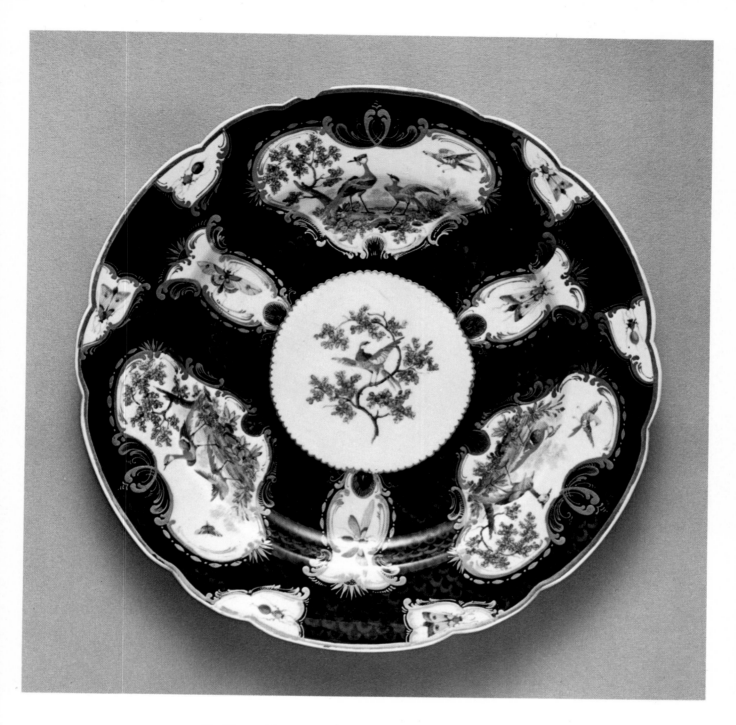

49 Plate with scale background and exotic
birds and beetles, Worcester, after 1760; dia-
meter 28.5 cm

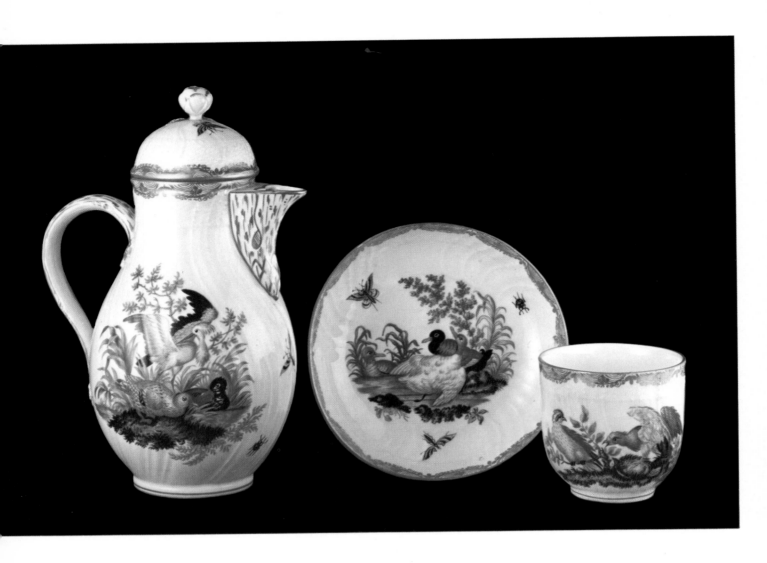

50 Part of a coffee service, Berlin, 1765–70;
pot 21 cm high

51 Allegorical figure of Water, from a set "Die vier Elemente", Berlin, modelled by F. E. Meyer, 1763–65; 22 cm high

52　Mars, from a set of classical gods, Nymphenburg, modelled by D. Auliczek, 1763–67; 41.2 cm high

53 Plate with gay floral pattern, St. Petersburg, c. 1780; diameter 23.2 cm

Ellwangen, and brought the Ludwigsburg factory to its zenith between 1760 and 1767. In the 1770s production began to fall, and after the death of the founder Karl Eugen in 1793 the artistic level of the Ludwigsburg ware fell, too. In 1824 King Wilhelm I of Württemberg closed the factory down.

Figures were the Ludwigsburg factory's best work, but the complete lack of archive material and the fact that the artists did not sign their work makes it extremely difficult to attribute authorship correctly. It is therefore usual to employ such terms as "Meister der Volkstypen", "Meister der Apollo leuchters", and "Meister der Tanzgruppe" when dealing with figures dating from before 1762. The Ludwigsburg figures show very clearly the transition from Rococo porcelain to early Neo-classicism, and it was the first German factory to reveal the influence of the new style. The sculptor Johann Christian Wilhelm Beyer was most concerned; he admired classical art when he spent some years in Italy (1751–9), like the Nymphenburg Auliczek coming into contact for the first time with Winckelmann's theories of the perfect proportions of classical art. Returning from Italy, he was employed as court sculptor, which involved checking the work of the "repairers" in the porcelain factory. Of his many tasks in the factory he is most often recalled for the series "Musiksoli", a convincing example of his endeavour to combine the liveliness of Rococo art with the cooler approach of Neo-classicism. He left Ludwigsburg for Vienna in 1767, and in 1770 was appointed court sculptor and painter. Of the other sculptors who worked with Beyer in Ludwigsburg we should mention Domenico Ferretti (1764–67), the modeller of many mythological subjects, and Pierre François Lejeune, appointed to the ducal service in 1753 and active in the factory during 1768–78. Nor should we forget Jean Jacques Louis, the author of popular animal figures. He worked in Ludwigsburg from 1762 until his death in 1772.

Although the Ludwigsburg table ware was not so important as the figures, it was characterized by first-class painted decoration. The best examples, in the Rococo style, were those of the "Obermaler" Gottlieb Friedrich Riedel (1759–79). Another painter who should be mentioned is the Viennese Joseph Philipp Dannhöfer,

and given relief decoration. Johann Bernhard Magnus (1762–93) was the finest of the painters there. Besides the painting itself coloured grounds were often used, and shades of gold in the French "à quatre couleurs" manner.

The last of the great German porcelain factories was that in Ludwigsburg, established by the Duke of Württemberg, Karl Eugen, on 5th April 1758. J. J. Ringler was appointed manager in 1760, after he had successfully started production in Höchst, Strasbourg, Nymphenburg and

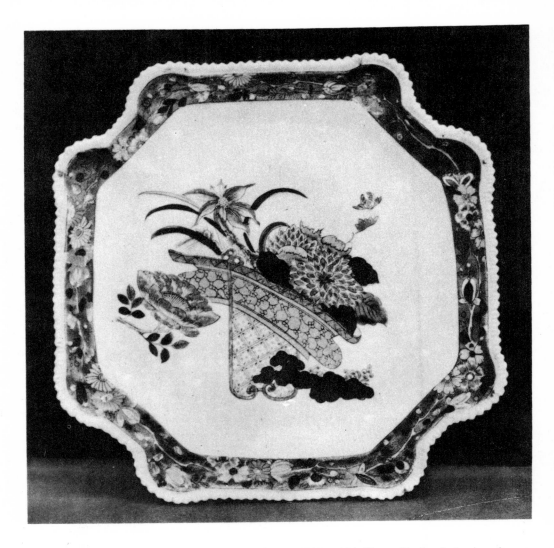

54 A tray with a colourful decoration, St. Cloud, c. 1730; width 23 cm. De danske kongers krono-
logiske samling på Rosenborg, Copenhagen

who worked in various German faience
and porcelain factories like Bayreuth, Ab-
stbessingen and Höchst, to end up in Lud-
wigsburg in 1762, where he remained until
his death in 1790.

An unusual chapter in the history of
European porcelain began in the middle
of the eighteenth century, in the forests
of Thuringia. Not only was there enough
cheap fuel there, but the streams were fast
enough to feed the simple machinery de-
signed to prepare the clay for firing. The
theoretical basis for production was pro-
vided partly by the "inventions" of the
theological student and laboratory hand
Georg Heinrich Macheleid, and partly by
the Greiner brothers and their arcanist

J. G. Dümmler. The body they used dif-
fered from that of Meissen or Vienna, and
the term "Thuringian porcelain" refers to
the products of this local industry. Except
for Kloster-Veilsdorf, where Prince Fried-
rich Wilhelm Eugen von Hildburghausen
established a pottery in 1760, all the fac-
tories were set up by potters, glass-blowers
and merchants on a commercial basis.
Their purpose was not to add to the glory
of princely courts, but to meet the demands
of a broad market among local burghers
and wealthy farmers; porcelain statuettes
were therefore much less in demand than
services and household vessels. This practi-
cal orientation, together with a more sen-
sible management of the trade side, made

74

it possible for the Thuringian potteries to withstand the economic pressures which forced so many of their aristocratic competitors into bankruptcy.

In 1760 G. H. Mecheleid was granted the monopoly of porcelain production in Sitzendorf, but the factory was moved to Volkstedt in 1762. The Greiner brothers founded a factory in Wallendorf in 1762, laying the foundations for the Thuringian production of porcelain. Factories were set up rapidly: Limbach 1772, Ilmenau 1777, Grossbreitenbach 1777, Gera 1779, Rauen-stein 1783, Blankenhain 1790, Eisenberg 1796 and Pössnek 1799. The quality of Thuringian porcelain varied, improving in the course of the eighteenth century, but the impression remains that trade interests were predominant in the policy of some of the factories. The principal inspiration in the decoration of Thuringian porcelain can still be traced to Meissen, e.g. the Brandensteinrelief or the cobalt bird motifs and cliffs with everlasting flowers. It was not until the nineteenth century, when there were 112 factories in Thuringia, that the industry achieved its zenith here.

The development of porcelain production in Thuringia was of great importance for the industry in north-west Bohemia, around Karlovy Vary (Karlsbad), where the real prosperity dates from the nineteenth century, although the foundations of its fame were laid at the end of the eighteenth century by experts from Thuringia. Deposits of kaolin were known here from the middle of the eighteenth century, but the Austrian imperial authorities preferred to favour foreign imports particularly from Thuringia, rather than threaten the prosperity of the porcelain factory of Vienna. The first attempt to set up a Czech porcelain factory, in Rabensgrün, met the same fate. In 1789 Franišek Antonín Habertitzl established a company of 128 shares, and employed the arcanist Johann Gottlieb Sonntag from the Grossbreitenbach factory in Thuringia; the small factory asked for permission to produce porcelain in 1793, but was refused. The company dispersed and the first Czech porcelain was thus cut short. Three years later, in 1792, Jan Jiří Paulus and Jan Pöschl set up the second Czech porcelain factory, in Slavkov, with the aid of the Thuringian arcanist Johann Georg Reumann. Again the request for a patent was refused, and in 1800 he sold the factory to Louisa Greiner, widow of the manager of the Gera porcelain factory. It was not until the nineteenth century that the Slavkov factory flourished, when official policy towards Czech porcelain factories changed. The third Czech factory founded in the eighteenth century was in Klášterec, where Count František Josef Thun gave his support to Johann Nicolaus Weber, who worked with the arcanist Johann Gottlieb Sonntag of the Rabensgrün factory, and fired the first kiln on 15th September 1794. This is also the date of the first known and preserved

55 Designs for porcelain for the Copenhagen Royal Factory, Elias Meyer, coloured pen and ink sketches, c. 1780–90. Den kongelige Porcelainsfabrik, Copenhagen

Czech porcelain coffee cup, with saucer, inscribed "Vivat Böhmen". But it was not until the nineteenth century that the Klášterec factory really flourished; it is still one of the foremost Czech porcelain works.

Böttger's hard-paste porcelain, of course, found its way to other European countries; as we have already seen, in 1720 Christoph Conrad Hunger left Vienna when Du Paquier could not meet his financial commitments, and went to Venice. Here he

56 Vase mounted on gilded bronze, Chantilly, c. 1735; 17.3 cm high

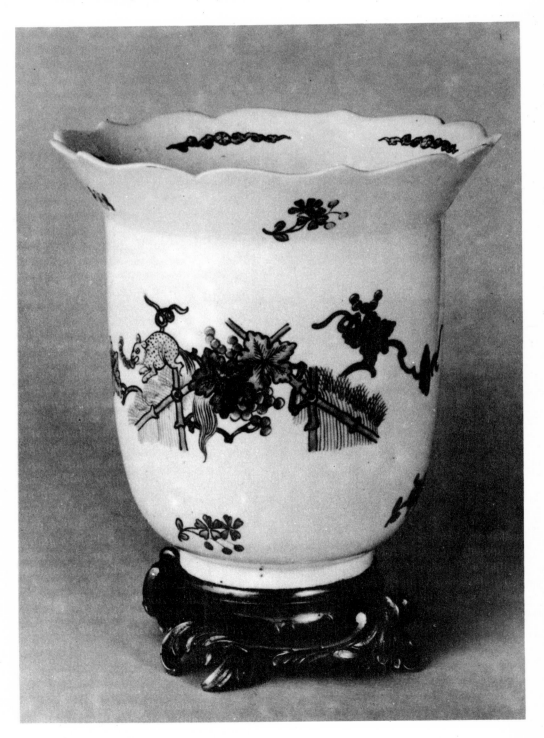

found enterprising businessmen willing to invest in his not too certain undertakings; the Vezzi brothers financed him, and as long as he was able to import Saxon kaolin from Aue, Hunger made hard-paste porcelain. After he returned to Meissen in 1727, however, imports of kaolin ceased and the Vezzi brothers were forced to close down their factory. Another Saxon fleeing from the consequences of the Seven Years War, Friedrich Hewelcke of Dresden, was not too successful in his attempts to start porcelain manufacture in Venice during 1758–63. Although he enjoyed the support of the banker Geminiano Cozzi, his permit

to make porcelain was withdrawn in 1763 and given to P. Antibono of Le Nove. Hewelcke had already used local materials for his porcelain, digging kaolin in Tretto, near Vicenza. Cozzi did not give up his intention of making porcelain, and in 1765 was granted a patent for twenty years, in Venice. He appears to have used the Tretto kaolin, but his body is very grey in colour. The Cozzi factory worked until 1812, but in 1769 the production also included majolica, presumably for economic reasons, and from 1781 English stoneware was also added to the ware produced.

Even before the Hewelcke and Cozzi enterprises, an Italian porcelain factory was opened at Doccia, near Florence. This was the third oldest factory in Europe, founded in 1735 by the Marquis Carlo Ginori, with the help of another Vienna arcanist, Johann Karl Wendelin Anreiter von Zirnfeld. It was not until the late 1740s that porcelain manufacture was really successful here, though; many renowned Italian artists worked here, among them Gaspar and Giuseppe Bruschi (up to 1778). The factory was famous for monumental vases and statues.

Another well-known Italian porcelain factory was that of Vinovo near Turin, founded with the help of another arcanist from Vienna, by the broker Giovanni Vittorio Brodel; in 1776 he acquired the help of Peter Anton Hannong of Strasbourg, notorious for his sale of the arcanum to Sèvres. The two were not very successful, and in 1778 the factory was closed down. Reopened in 1780 by Dr. Vittorio Amadeo Gioanetti, it was more successful, working until the French occupation of 1796 which closed it. Another unsuccessful attempt in 1815 to work the factory ended definitely in 1820.

From Italy we must now turn eastwards, to Russia. In 1744 the Czarist porcelain factory was opened in St. Petersburg, but not even the foreign arcanists invited to work there (including Hunger) brought success. They were followed by a Russian mining engineer, Dimitry Ivanovich Vinogradov, who made his first experimental porcelain early in 1747; these articles were of a very grey body and poor glaze. Good quality products began to come from the St. Petersburg kilns in 1749, decorated with overglaze enamels. In the 1750s of the factory was already catering for the luxury market; characteristic products of the per-

57 A porcelain painter at work, France, anonymous drawing, eighteenth century. Manufacture nationale de Sèvres, archives, Sèvres

iod were snuff-boxes with painted decoration, and services with relief decoration picked out gold and purple. In 1779 Antoine J. D. Rachette was appointed head of the modelling department; he had studied in Copenhagen and Paris, and brought fame to the St. Petersburg factory. The best-known figures from this factory are the series of "Russian street traders and craftsmen" and the "nations of Russia", modelled on the ethnograhical sketches by I. I. Georgi, 1776. The most famous of the table services was the boat service, with arabesques, and the one made for Prince Yusupov. By the end of the century there were 200 workers at the St. Petersburg factory.

Before leaving the sphere of Böttger's hard-paste porcelain, we must look at north-west Europe. The first successful factory was that set up in Weesp, near Amsterdam; founded in 1757 by the Amsterdam merchants Pye and Cruikshank to make porcelain and earthenware, up to 1759 only faience was made there. After the factory was bought by Count van Gronsveldt-Diepenbroik the German arcanist Nicolaus Paul started the production of hard-paste porcelain, and in 1762 produced a glassy white ware. There were constant financial difficulties, and in 1768 negotiations for the sale of the factory to Sèvres were started; production came to an end in 1771. J. de Mol took over some of the equipment for his factory in Oude Loosdrecht.

Somewhat further north, in Copenhagen, attempts at porcelain production are said to have dated from 1731; among the unsuccessful we again find the name of C. C. Hunger, who spent seven years there (1730–7). Johann C. F. Lück from Meissen was no more successful. It was not until 1756 when suitable deposits of clay were discovered on Bornholm that the factory was set up, although it did not at first produce porcelain. Frit porcelain was produced after the engagement in 1759 of Louis Fournier, who had worked in Vincennes and Chantilly. It was only in 1773, under Fournier's successors F. H. Müller and Richter, that the first hard-paste porcelain was made in Copenhagen, from clay imported from Limoges. In 1775 deposits of suitable quality clay on Bornholm were discovered.

The factory acquired an artistic reputation in the 1780s, after it became royal property in 1779. Now known as the "Kongelige Porcelainsfabrik", it employed mainly German artists, so that the production was not markedly individual. Between 1790 and 1802 the famous "Flora Danica Service" was created, painted by Johann Christoph Bayer of Nuremberg. At first the factory produced mainly table ware, but even later did not pay much attention to figural production. It was at the turn of the nineteenth and twentieth centuries that the artistic fame of Copenhagen porcelain was to emerge.

Let us now turn our attention to soft-paste porcelain. France, as we have seen, inherited Italian efforts to find another way to make porcelain, which produced frit porcelain, produced in France by Louis Poterat, even earlier than Böttger made his discovery. Of even greater significance for French porcelain was the discovery by Pierre Chicaneau of a porcelain "almost as perfect as that of China and India", in his faience factory; this was before 1678, and the process was improved by his heirs so that by 1683 the product was described as "véritable porcelaine". The St. Cloud ware was indeed white, with an ivory tinge, and highly polished. When Chicaneau's widow remarried the factory passed to the Trou family, but growing competition especially from Vincennes forced the last owner Henri-François Trou to close down in 1766.

The problem of true porcelain did not cease to concern French producers, certainly not immune to news of Saxon successes after 1700. It is not surprising that the city of Lille gave its support to Barthélemy Dorez and his nephew Pierre Pelissier, when in 1711 they added porcelain to their faience production; the body of their ware was very similar to that of St. Cloud. Production was maintained until about 1730, after which the factory made only faience.

The production of "pâte tendre" in Chantilly was an enterprise undertaken by the highest social circles; Louis-Henri, Duke of Bourbon and Prince of Condé, determined to produce porcelain according to the formula of Sincaire Cirou, whom he naturally entrusted with the management of production, and who worked for him from 1726 to his death in 1751. The works continued under a succession of managers until 1800, when the last, an

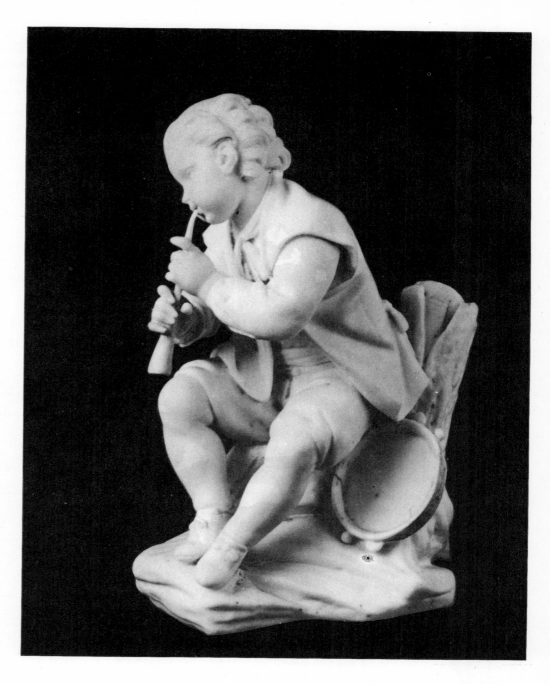

58 Boy with flute and tambourine, Sèvres, E. M. Falconet, 1757–60; 12.5 cm high. Private collection, Prague

Vase, Buen Retiro, c. 1760–65

Englishman, Christopher Potter, declared the firm bankrupt.

We do not know who was responsible for spreading knowledge of frit porcelain production in France; no such personality as the German arcanist J. J. Ringler has been discovered. Some part was played by the brothers Robert and Gilles Dubois, who were engaged by the Marquis d'Orry de Fulvy to make porcelain in the uninhabited royal castle of Vincennes, near Paris. The brothers, who came from Chantilly, were not successful, and after three years' work they were dismissed; in 1750 they turned up in Tournai, where Robert was named manager of a new porcelain factory. After the Dubois brothers left Vincennes, their assistant François Gravant continued with their experiments, and after some years succeeded in 1745 in mixing the "pâte tendre" which was suitable for porcelain manufacture. A limited company was formed the same year, under the name of C. Adam, with a capital of 90,300 livres.

This was the factory which under the name of Sèvres, its later locality, was to become as famous as Meissen in Saxony. There was a difference between the two, however, in style; Meissen employed outstanding artists, painters and sculptors, who impressed their individuality on the products of the factory. The historian who wants to trace Meissen porcelain produc-

59 Cup and saucer with raised plant design, Capodimonte, 1745–50; cup 6.3 cm high

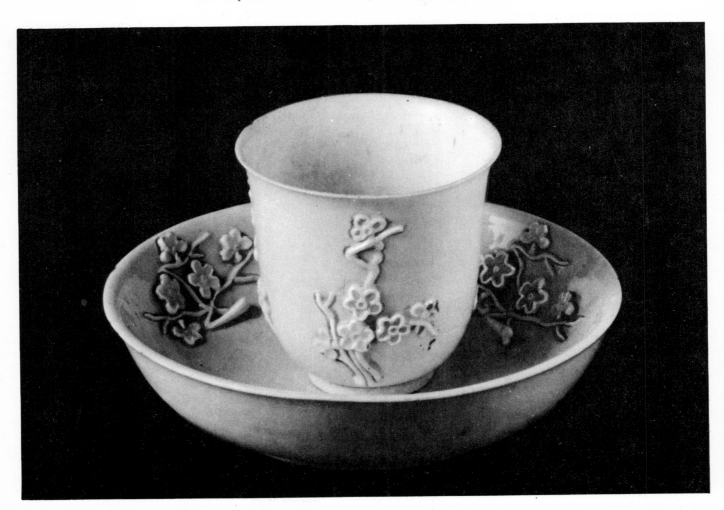

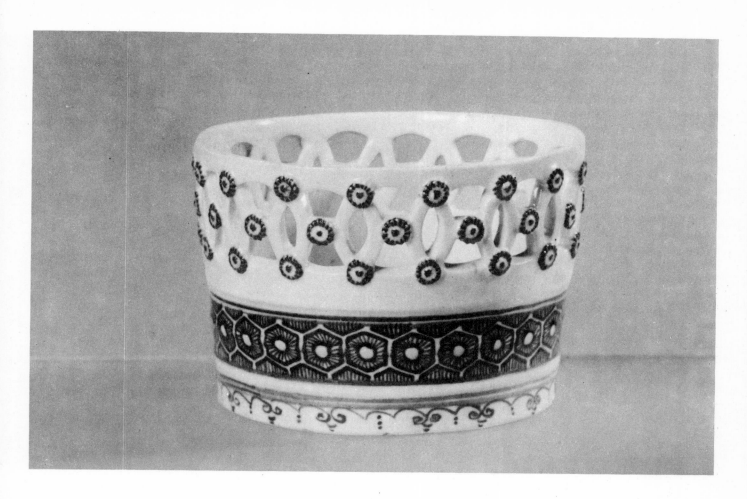

60 Basket decorated in underglaze blue, Philadelphia, Bonnin & Morris, 1771–2; height c. 6.3 cm. Yale University Art Gallery, New Haven

Covered cup, Alcora, c. 1790

tion must consider the work of these individual artists. At Sèvres the situation was different; a particular French style was evolved to which the artists working for the factory had to submit. The only artists who imprinted a personal touch on Sèvres ware were the sculptor Etienne Maurice Falconet and the painter François Boucher.

The company was granted a royal monopoly for the production of porcelain "de façon Saxe", i.e. painted, gilded and with plastic decoration. No other factory was allowed to produce the same ware, and the workers were not allowed to move and work elsewhere. In 1747 this patent was extended, and even stricter control of the workers was instituted. The technical manager at time was Jean Hellot, the manager

Boileau and the art director Hulst, followed in 1751 by Jean-Jacques Bachelier. In 1752 a new company was established, with the king holding one-third of the shares; the new patent included the use of the title "Manufacture royale de porcelaine", and the monopoly of all porcelain manufacture, gilded or not, white or coloured, smooth or with relief decoration, as well as porcelain figures and flower designs; the monopoly was valid for twelve years and three months from October 1752. The official mark was an "L" ("chiffre royal") with its mirror image, which had already been in use. Naturally a monopoly of this extent hindered the development of the industry elsewhere in France; both St. Cloud and Chantilly suffered, and as we have already seen, Paul Hannong

was forced to move his factory from Strasbourg to Frankenthal in Germany. At this time the move to Sèvres was already being considered, and took place in 1756, at the instigation of Madame de Pompadour, who was a sympathetic patron of the Vincennes factory. In 1759 the factory passed directly into royal hands, where it remained until the French Revolution. On 25th of Floréal VIII (14th May 1800) the outstanding chemist and geologist A. Brongniart was appoint-

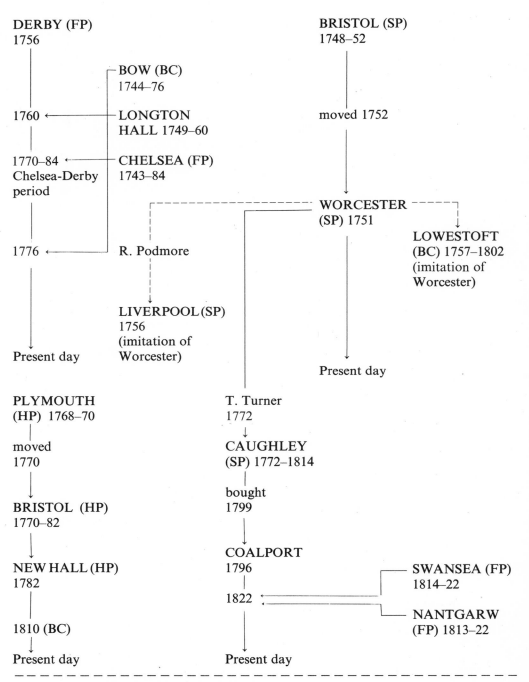

HP = hard porcelain; FP = frit porcelain; BC = bone china;
SP = soapstone porcelain

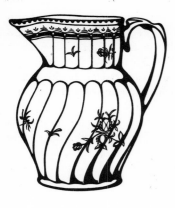

Jug, New Hall, c. 1790

ed director of the Sèvres factory, and in 1805 it regained its privileged position as the emperor's personal property.

The exceptional standing of the Sèvres factory, from the time it was founded at Vincennes by the king, was reflected in the technical and artistic achievements. J. Hellot, a chemist and member of the Académie Française, invented new ground colours, such as the "rose Pompadour", the "bleu lapis" or "bleu céleste", their gleaming translucence accenting the qualities of the body and glaze of the frit porcelain. White patches left in the coloured slip were painted in the kakiemon style with European flowers and fruit, or scenes taken from the paintings of Watteau or Boucher. A famous speciality of the Sèvres factory were porcelain flowers, modelled and painted from nature, and used to decorate lamps, clocks ets., or gathered in long-stemmed bunches. A bunch of porcelain blooms in this style was sent to Augustus III by his daughter Maria Josephine, in a white porcelain vase mounted in gilded bronze. The artistic standards of the factory did not suffer when it was moved to Sèvres; new ground colours were developed, like the "rose" (1756-7) and new patterns designed, like the "vermiculé" (irregular worm-like lines on a coloured ground), the "oeil de perdrix" (points arranged in circles), and the irregular gold oval network on a dark blue ground known as "caillouté". The supreme achievement of the Sèvres factory was the 744-piece service ordered by the Czarina Catherine II. In the 1780s Sèvres became the leading force in the art of porcelain manufacture in Europe, replacing Meissen itself.

The soft frit porcelain was particularly suitable for figures; the first modeller was the royal sculptor E. M. Falconet, modeller of the well-known group "Annette et Lubin", 1764; his disciple Duru modelled the "Pygmalion" group (c. 1765) and in 1771–2 J. F. Le Riche was the author of mythological groups. Both figures and painted decoration at Sèvres were influenced by the painter François Boucher, of Rococo fame. Although he did not model figures himself, he designed them for Sèvres throughout his life, and some of his designs, like the well-known "Flute Lesson" ("La leçon de flageolet"), were copied by other European porcelain factories right up to the middle of the nine-

teenth century. An important innovation at Sèvres was unglazed bisque with a surface imitating marble, which was introduced by Bachelier at the Vincennes factory in 1751 and which became very popular for figures during the Neo-classical period, for hard-paste porcelain production as well as frit.

In 1772, after deposits of kaolin were discovered in St. Yrieix near Limoges, "pâte dure" porcelain was also made at Sèvres, although the production of soft frit porcelain continued up to 1804.

This French type of porcelain also became popular in other European factories during the eighteenth century, particularly in Italy. From 1741 Charles II of Bourbon encouraged experimental porcelain production at Capodimonte, where in 1743 the chemist Livio Ottavio Schepers succeeded in composing a suitable frit body. That year the factory started production, and the table ware which was the main product was among the best in Europe in the eighteenth century. Up to about 1757 the shapes were inspired by the Baroque vessels of Meissen and Vienna, but with very delicate painted decoration. The modeller Giuseppe Gricci was very well-known, his figures — often quite large — being among the finest made in Europe. When in 1759 Charles Bourbon was called to the Spanish throne, he did not hesitate to dismantle the Capodimonte factory and transfer it by boat to Spain, re-establishing it in the summer residence of Buen Retiro, near Madrid. The workers and artists were taken to Spain along with the equipment, and in 1760 the first porcelain made on Spanish soil was already being made there. Naturally in style it continued the Italian tradition.

Frit porcelain was made again in Naples after 1771, when King Ferdinand IV established a new factory at first in Villa Portici (until 1773) and later in Naples itself. The factory worked until 1834, and the ware made there was the equal of the best French and German porcelain.

In Buen Retiro the proper factory style developed only in Classicism, the ware being dated after the year 1780. The factory began to make hard-paste porcelain in 1804, when the Sèvres arcanist Vibien was summoned cup. During the Napoleonic Wars (from 1808 to 1812) the factory was destroyed.

A Frenchman, Pierre Cloosterman,

managed to make hard-paste porcelain in Spain in 1786, at an old faience factory in Alcora, after his compatriot François Haly (1751) and a German Christian Knipffer (1764) had failed. The porcelain made by Cloosterman was of a yellowish body; small scent bottles and snuff-boxes are well known. In style the ware was inspired by Parisian models; a blue ground with panels framed in gold Rococo scrolls or Neo-classical designs was very popular. The factory closed down in 1858, but it seems that porcelain production had already ceased there earlier.

In England there had been attempts to make porcelain for a long time, and the first factory in Chelsea used the French "pâte tendre" when it opened in 1743. John Dwight (in 1671), the Elers brothers and Francis Place (died 1728) only succeeded in making stoneware, although Dwight called it "mouse-coloured porcelain". The success of Meissen led to interesting experiments in England, one of the few countries to develop its own porcelain body, and where several types of different composition were produced from the very beginning. At first frit porcelain of the French type was made in Chelsea, Derby and at Longton Hall. Bone china (or bone porcelain) was an English invention, which Thomas Frye patented in 1744 and 1748. He founded the Bow factory, called New Canton. At the end of the eighteenth century Barr in Worcester and Spode in Stoke-on-Trent improved the bone china body, and it became the standard porcelain body used in England, still being made today.

Another English invention was the admixture of steatite (soapstone or soaprock) to the body; this formula was used in Bristol in 1748, perhaps devised by William Cookworthy. Soapstone china was also made in Worcester (founded 1751), Caughley (founded 1772) and Liverpool (founded 1756). The making of hard-paste porcelain is associated with the name of the chemist W. Cookworthy, who discovered deposits of kaolin at St. Austell in Cornwall. Granted a patent in 1768, he set up a factory in Plymouth, along with several partners. Hard-paste porcelain using the formula of Cookworthy was also made in Bristol (founded 1770) and New Hall (founded 1782), but New Hall went over to bone china in 1810.

Technically, then, English porcelain is very varied, but we shall now consider eighteenth century English porcelain from the artistic point of view. The Chelsea factory was founded in 1743, after a French Huguenot called Thomas Briand had successfully made a suitable body the previous year. Two Frenchmen utilized his discovery: Charles Gouyn, a jeweller, and Nicholas Sprimont, a silversmith; the latter managed the factory until 1769, while Gouyn left the partnership earlier. In 1769 the firm was bought by James Cox, who sold it the following year to William Duesbury, one of the partners in the Derby firm. The Chelsea factory was in production up to 1784, and the periods are distinguished by the different marks used: the triangle (up to 1749), the raised anchor (1750–3), the red anchor (1753–8) and the gold anchor (1758–69). The period during which Chelsea was linked with the Derby factory is known as the Chelsea–Derby period. Each of the periods is distinct in style. At first (triangle period) the forms were close copies of silver vessels, while during the next two periods oriental models were followed (Arita, Blanc de Chine), and some Meissen styles. During the raised anchor period figures were introduced, inspired by Meissen ware. Meissen was still the model for European porcelain, as indeed we read in the patent granted to the Vincennes factory in 1745. And according to a report from Vincennes, around the year 1745 the porcelain made in England was "much finer than that of Saxony". Soon, however, during the gold anchor period, the influence of Sèvres predominated in Chelsea, not only in the colouring but after 1770 in bisque ware too. It was the red anchor period that marked the greatest achievement of the Chelsea factory, and indeed of English porcelain altogether.

The factory at Bow, which made a type of bone china based on Thomas Frye's patent from 1748, was not as important artistically as Chelsea, although some of the Bow figures are remarkable. Most of the modelling is attributed to one "Tebo" (perhaps a French Huguenot named Thibaud) and to the sculptor-modeller John Bacon. The table ware made at Bow was modelled on the Chinese "famille rose", from Arita and Blanc de Chine, as indeed is proclaimed by the manufacturer's choice of a name: New Canton.

In 1750, two years after it was founded, Thomas Frye left the factory to his partners Crowther and Weatherby, he himself

remaining art manager until 1759, when he went back to painting. After the death of Weatherby in 1762 the Bow factory found itself in difficulties and in 1763 Crowther declared the firm bankrupt and reduced production. In 1776 William Duesbury bought it, and had some of the equipment taken to his Derby factory after closing Bow down.

Thomas Briand, who was the arcanist concerned in the setting up of the Chelsea factory, had tried to make porcelain in Derby in 1745. Nothing is known of the factory he set up there with James March-and, and which seems to have lasted only a short time. In 1756 William Duesbury, the porcelain painter, put together a company and set up a factory in Derby for the manufacture of a porcelain similar in composition to the Chelsea frit porcelain. The arcanist was a Frenchman, André Planché, while the banker John Heath provided the capital. The company expanded rapidly, acquiring the Longton Hall factory in 1760, Chelsea in 1769 and finally Bow in 1776. This concentration of resources made Derby one of the most important porcelain works in eighteenth-century Europe.

Figures, strongly influenced by Meissen models, were a major part of Derby production, and Duesbury himself said that they were made "after the finest Dresden models", and called them the "Derby or Second Dresden". This was due to both modellers and painters, among whom John Bacon, from the Bow factory, was important, and Jean-Jacques Spengler of Zurich. Of the painters working at the time we should mention Zachariah Boreman of Chelsea and William Billingsley. During the Chelsea-Derby period (1770–84) Neoclassicism on the Sèvres model prevailed in Derby porcelain.

The Worcester factory was one of the most important where soapstone was included in the paste. Its immediate predecessor was the small Bristol factory founded in 1748 by Benjamin Lund and William Miller. Lund seems to have been told of the advantages of soapstone for porcelain manufacture by the chemist William Cookworthy and was granted a patent for the quarrying of soapstone at Gew Gare on 7th March 1748. His factory produced both table ware and figures.

In 1751 the Worcester Porcelain Company was founded, with William Davis as manager and Dr. John Wall, a chemist and physician, playing a leading part. The following year the company bought the Bristol factory and transferred the production to Worcester. William Davis managed the firm until his death in 1783, when before that in 1772, it was bought by Thomas Vernon. In 1783 the Flight family became its proprietors, and in 1791 the name Barr was added, after another proprietor, the Barr family.

The soapstone porcelain paste made by Robert Podmore and John Lyes could be worked very thin, which made it very suitable for table ware; this was also the principal product of the Worcester factory. Figures are attested from 1769 onwards, when Tebo came to Worcester. A new print technique was also used there, introduced by Robert Hancock in 1757, after it had proved successful at Bow.

Worcester porcelain was very popular on the market and was imitated at other factories (e.g. Lowestoft and Caughley) in the eighteenth century.

We must still take a short look at Plymouth, where the chemist William Cookworthy had discovered deposits of kaolin at St. Austell in 1758. After the granting of a patent in 1768 he began to make a hard-paste porcelain, thus adding yet another type to those being made in eighteenth century England. Cookworthy's patent was also used at the Bristol factory (1770–82) and at New Hall (1782–1810), before it went over to the production of bone china). Cookworthy made both table ware and figures at Plymouth, but it was not technically faultless. The modeller Tebo worked for him, and is said to have brought moulds from Bow. "Monsieur Saqui" of Sèvres was an excellent painter, particularly of landscapes in bright colours. Most of the Plymouth ware was simple, with underglaze blue decoration in the Chinese fashion. In 1770 Cookworthy transferred the works to Bristol.

In the second half of the eighteenth century North America also entered the field, but the early history of porcelain there is not quite known. Around 1730 a French Huguenot, André Duché, experimented in Savannah (Georgia), where he had discovered "unaker", the Indian name for kaolin. Nor is much known of another Savannah porcelain factory said to have been founded by John Bartlem in 1766. It was not certain whether Bonnin and

Morris, of Philadelphia, produced stoneware or porcelain, until excavations on the site by Graham Hood (published in 1972) showed it to have been soft-paste porcelain. Spectrographic analysis showed that the body contained bone ash, so that the ware was similar to that made in Bow or Lowestoft in England. The factory had been founded by Gousse Bonnin and George Anthony Morris, the latter in a purely financial capacity. Built in 1770, the factory began production in 1771, but could not compete with large-scale imports of oriental ware and Wedgwood earthen ware. Bonnin's experiments with hard-paste porcelain did not save the situation, and the factory closed down in the autumn 1772. In style the Philadelphia porcelain closely copied English wares, which is only natural since the foremen appear to have come from England, although there are reports that both Frenchmen and Germans were employed there. It was not until the nineteenth century that large-scale porcelain production began in North America.

Porcelain in Europe in the Nineteenth and Early Twentieth Centuries

The nineteenth century was one of revolutionary changes in Europe, not only in political and economic life, but in culture, too. A century before, porcelain had been the privilege of a small upper class, but now it was within the reach of ever broadening circles. Not that this happened overnight; after the blockade of Europe collapsed in 1812 British stoneware, represented mainly by Wedgwood products, flooded the market at such a reasonable price that practically all classes could afford to buy it. This was dangerous competition for the porcelain factories of Europe, especially when innumerable factories producing stoneware in flagrant imitation of the English sprang up all over Europe, while the purchasing power of their former customers had been drastically affected by the Napoleonic Wars.

Only those porcelain factories whose management was up-to-date and flexible could hope to survive. The time when such a factory was the boast of aristocratic courts had gone for good; the court sculptor gave way to the anonymous designer, the painter could be dispensed with, too, after the invention of printed decoration, patented in England in the mid eighteenth century, but not widely used on the Continent until the early nineteenth. What had been a strictly guarded secret, the arcanum, was a generally known industrial process by the nineteenth century, and new factories were springing up on a purely commercial basis. New deposits of kaolin were discovered, one of the largest and finest in the vicinity of Karlovy Vary (Carlsbad) in Bohemia. By mid century European hard-paste porcelain could already compete commercially with the cheaper stoneware, until it won back the market almost completely. By the second half of the nineteenth century one can speak of a porcelain industry; it was centred in Bavaria, Saxony and Thuringia, in Germany; in Staffordshire, in England; around Karlovy Vary, in Bohemia; and around Limoges, in France. In Bohemia alone, by way of illustration, there were 38 porcelain factories by the end of the century, employing a total of 6,739 people.

The style reigning in European art at the beginning of the nineteenth century is now generally called "Empire"; it was in fact the last phase of the Neo-classical period, and again it was France that set the fashion, consciously turning to classical antiquity for themes and models. The Empire style lasted up to the end of the 1820s and was the official art of Napoleonic France. From the middle of the previous century classical forms and subjects had been a source of inspiration for artists, but now they became a binding programme; ornament was based on a faithful reproduction of classical Greek and Roman art. Napoleon's Egyptian expeditions broadened the mythological background and helped to create an inexhaustible source of figures and ideas from the world of the ancient gods.

The standard shape for Empire porcelain vessels was a simple cylinder, for jugs, cups and sugar basins; dishes were fairly deep, with straight edges. These were forms that left the painter a wide field, and in addition to mythological scenes landscapes became popular, townscapes with great attention paid to correct detail, and of course genre scenes, including idyllic country scenes. Allegories and symbolical designs of all kinds were also frequent, in keeping with the spirit of the times; a piece of porcelain was a welcome gift, one which could express friendship, love, and other emotions. Flowers and the language of flowers were favourite subjects; the painters usually took as their models prints, book illustrations, or accepted pattern books.

About 1820 the classical shapes of Em-

pire porcelain began to give way to more pretentious forms, in keeping with the mood of the late Empire period; barrel and half-barrel shapes were favoured, and bell-shaped cups with a softly rounded upper rim. The surface was no longer smooth, but treated with relief patterns, or swollen drop-like patches, or imitations of the shape and surface of shells. Cups no longer stood firmly on a flat base, but were given feet of all sorts of shapes, from lions' paws to circular stands. Decoration tended to imitate classical vessels, particularly vases. The large expanse of white porcelain gave the painter a great deal of liberty in his work.

Once again it was the Sèvres factory that set the fashion. In May 1800 the well-known Parisian professor Alexandre Brongniart became manager there, and remained in office until his death in 1847. He introduced hard-paste porcelain, and in 1804 the soft-paste ware was no longer made Brongniart developed new muffle-kiln pigments which were used particularly for copies of well-known paintings between 1815 and 1850. The imperial mood was of course reflected in porcelain decoration; Napoleon I himself and his circle were portrayed, landscapes through which the victorious armies had marched were painted on porcelain vessels, and art treasures brought home from the conquered lands either influenced or directly inspired European porcelain (like the "vase étrusque à rouleaux" decorated by Béranger). Miniatures were often painted on the centre of plates, with a gold ornament round the edge. Napoleonic themes disappeared after the fall of the Emperor in 1815, but admiration for classical antiquity remained unabated, as can be seen from the "Greek world" service. Instead of Napoleon it was now Louis XVIII and Charles X whose portaits appeared on porcelain, while fruits and flowers were ever more popular. The production of the Sèvres factory at this time, elegant and well-made, was the model for porcelain makers all over Europe. The Vienna factory was perhaps the most successful, after the sculptor A. Grassi followed Niedermayer in 1784 as chief modeller. Grassi was a devotee of classical art, and introduced scenes from the frescoes at Pompeii to decorate his porcelain. Piranesi's engravings alternated with scenes of home life in antiquity. The greatest popularity

was achieved in the early nineteenth century, however, with paintings of scenes in Vienna, landscapes and portraits. Painted porcelain from the Vienna factory during this period is among the finest ever made in Europe; of the painters working for the factory at this time we should name at least A. Kothgasser, G. Perl, and J. Leithner. At the end of the eighteenth century Sèvres became the model for Vienna porcelain figures, too; statues copied from classical works in white bisque, imitating marble, were the main type. A. Grassi with his disciples and assistants J. Schaller and E. Hütter were the principal artists. The Russian porcelain factory in St. Petersburg also reached a high standard at this time; we may mention the Guriyev service of 1809–17, designed by the sculptor S. Pimenov.

Around 1830 there was quite a sudden change in artistic expression in the porcelain made in Europe; the symmetrical, geometrical forms gave way to vessels of a heavier, restless and over-mannered style. Relief ornament covered the entire surface, leaving little scope for painting which was now limited to decoration; there was little for the painter to do but flower patterns in pseudo-Rococo cartouches in relief, in scrolls and asymmetrical rocaille work. The new trend drew boldly on mid eighteenth century Rococo and came to be known as Revived Rococo. Although the style originated in France, the work of the Sèvres factory was little influenced by it; it took root early in England, so that by 1830 Rockingham, Davenport and Derby, to name but a few factories, were producing only Revived Rococo pieces. Around 1833 even Meissen turned to its old moulds, often, alas, altered to suit contemporary "taste", and again made the popular Rococo figures.

The young porcelain factories in Bohemia played a large part in this Revived Rococo period, perhaps because Baroque art had such strong roots in the country and made it easier for the designers to adapt to the demands of this market. The period covering the second third of the nineteenth century saw the greatest prosperity of the Czech factories and the height of their technical achievement. They catered for the renewed interest in porcelain figures and offered a wide selection of subjects; their figures were not slavish imitations of Rococo originals, but a broad

(continued on page 97)

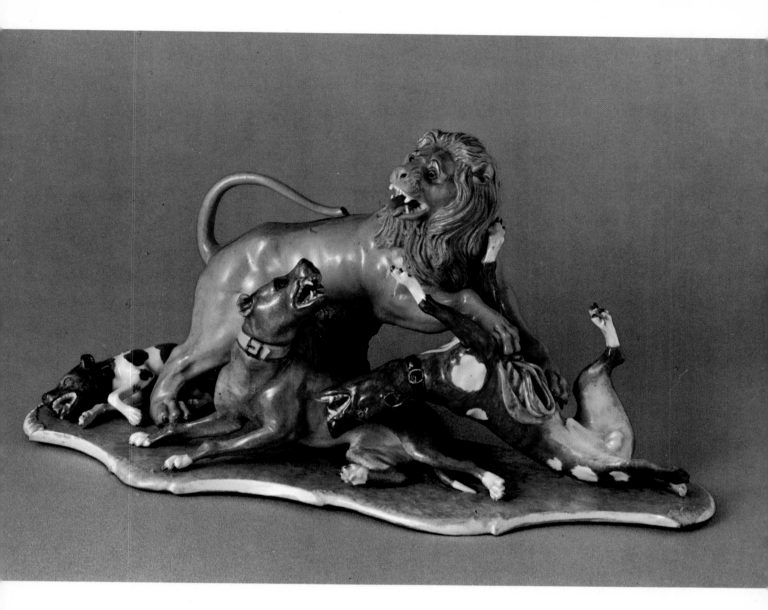

61 The lion hunt, Nymphenburg, modelled by
D. Auliczek, 1765; 11.7 cm high

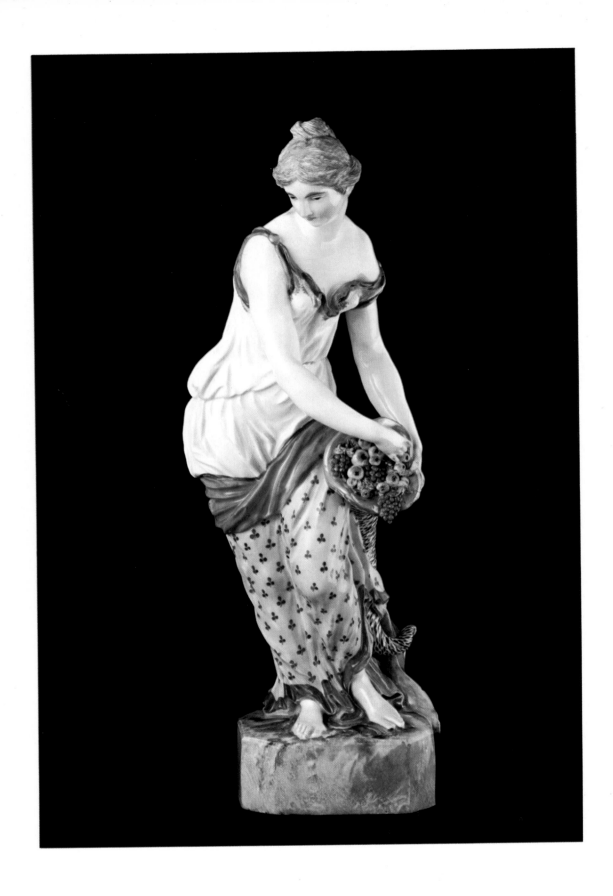

62 Abundantia (Plenty), Ludwigsburg, modelled by J. C. Bayer, 1766; 25.5 cm high

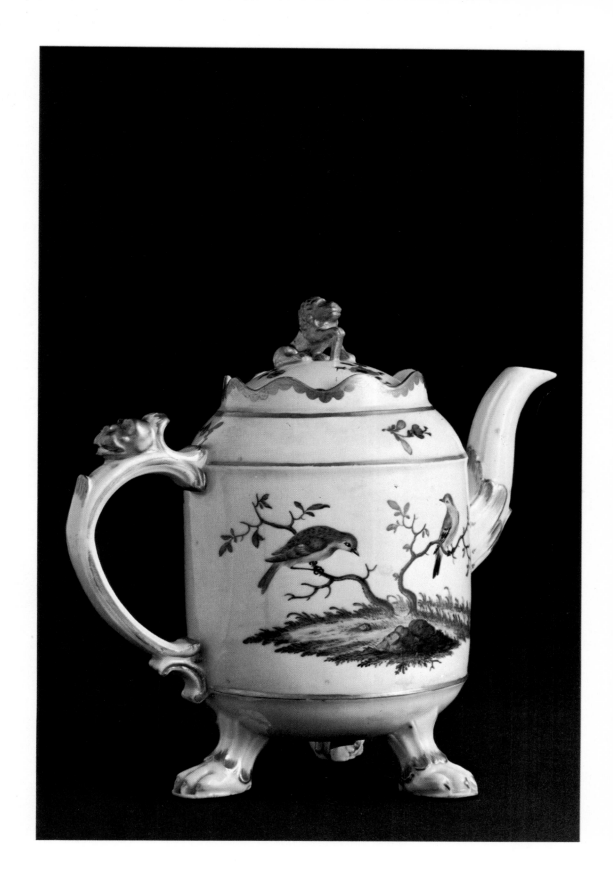

63 Pot from a coffee set, Ludwigsburg, c. 1770;
height with lid 15.8 cm

64 The family, Frankenthal, modelled by
K. G. Lück from the painting by J. B. Greuse,
1770; 17.6 cm high

65 Boy at the dog-kennel, Höchst, modelled
by L. Russinger, 1760–65; 17.4 cm high

66 Gallantry in an arbour, Ansbach, after 1760; 25.8 cm high

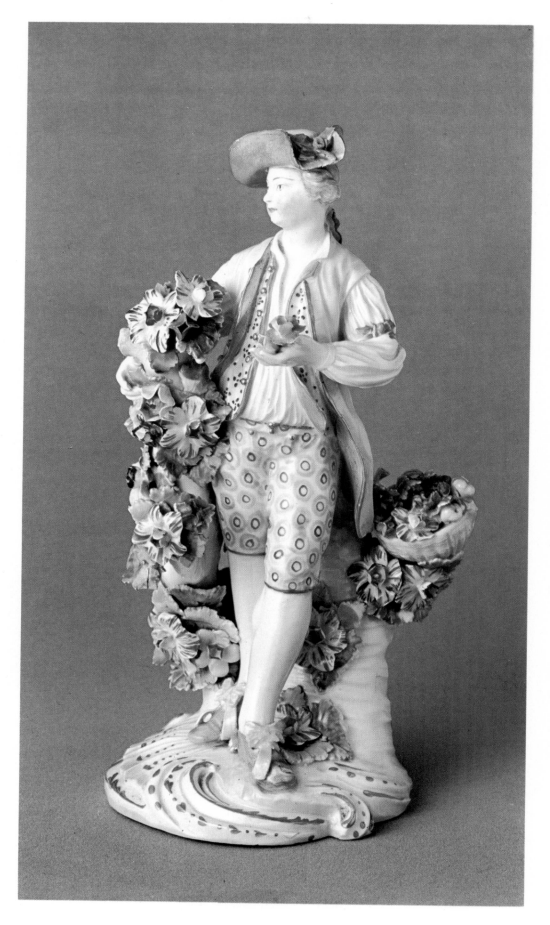

67 The gardener, Chelsea, c. 1756; 25 cm high

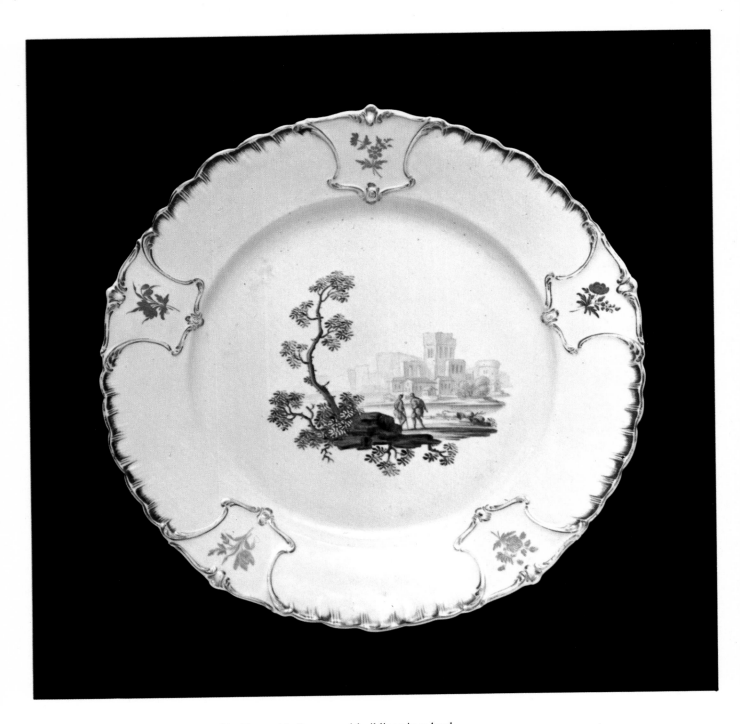

68 Plate with figures and buildings in a land-
scape, in purple, Tournai, before 1770; diameter
23.7 cm

69 Cup and saucer, St. Petersburg, 1830; cup 9.2 cm high. Private collection, Prague

variety of new ideas. The Slavkov factory was perhaps best known for this Revived Rococo porcelain, but Klášterec on the Ohře and Loket were not far behind.

There were some small factories specializing only in figures like one in Prague which kept up production well into the second half of the century. When the fashion changed the firm got into difficulties and had to close down production.

Naturally this Revived Rococo, particularly in Central Europe, tried to follow its great model as closely as possible, and imitate "vieux Saxe", the work of the Meissen factory. Elsewhere, as in England, it was Sèvres that was the ideal; Stoke-on-Trent, Minton and Coalport bone china, for example, in the 1840s was imitating the Sèvres porcelain of the 1750s and 1760s.

The Revived Rococo period was really the expression of contemporary Romanticism in the decorative arts, a Romanticism whose roots go well back into the eighteenth century. The porcelain of this period should not be disdained, for at its best it introduced new ideas and new treat-

70 Allegory of Night, modelled after the relief by B. Thorvaldsen of 1815, Copenhagen, Royal Factory, after 1867; diameter 35.8 cm

ment in figural work. On the other hand it cannot be denied that when the style predominated in the forms and expression of all the crafts around the middle of the century, it was taken over by industrial production with catastrophic results. "Kitsch" in the sense that we use the word today was born then.

In London H. Cole and a circle of friends were preparing an exhibition which was to present to the world examples of "good design". Opened on 1st May 1851, it was called "The Great Exhibition of the Works of Industry of all Nations". This early world exhibition showed how the unlimited use of technical progress led to the decay of aesthetic standards in the arts, a claim that shocked public opinion and produced a healthy reaction, especially in England. The way out of the crisis seemed to be a revival of the skills and artistry of the craftsmen, and for this purpose collections of the finest examples of the old crafts were to be opened to the public, in a programme of art education. The first such institution was the Victoria

and Albert Museum in South Kensington, London, opened in 1852. The British example was followed in 1863 by Vienna, in 1867 by Munich and Berlin, in 1874 by Hamburg, and so on. These museums of decorative arts and crafts were one of the strongest factors in the rise of the historicism of the second half of the nineteenth century, a trend which has long been maligned. It was not until the 1950s

71 Psyché, modelled after a statue by B. Thorvaldsen of 1811, Copenhagen, Royal Factory, after 1867; 31 cm high

that research into this period has become more systematic, showing that the trend itself has repeatedly appeared upon the cultural scene, and that every major period has had its historicism — the Renaissance, Neo-classicism, etc. The historicism of the late nineteenth century was thus only one specific instance of a universal phenomenon.

There were other influences at work in the revival of the crafts; there were significant theoretical studies, mainly by archi-

72 Rudolph I of Hapsburg, after the statue on the tomb of Maximilian I in Innsbruck dating from the first quarter of the sixteenth century, Prague, before 1852; 25.8 cm high

73 Cup and saucer with pseudo-Gothic ornament, Meissen, before 1850; cup 6.1 cm high

tects, aimed at an all-round approach to man's surroundings. One of the leading minds in this movement was the German architect Gottfried Semper, who proclaimed his principles in the 1860s: "The style of a work of art does not lie in conscientious or even slavish imitation of the forms and decoration of past ages; if a work of art is created according to the laws which governed art at the time the artist is trying to follow, it must be as appropriate to the modern age as were the works of art created in that past age whose aesthetic laws the artist has adopted."

Semper instigated the establishment of museums and similar institutions to spread knowledge and encourage the new trend. Few works met Semper's high standards, most artists being content to copy some work of the period that attracted them. But the enthusiasm aroused for the craftsmanship of past ages led to a wave of collecting zeal; anything and everything that was "antique" was worth collecting. The influence of this fashion on the art of the later nineteenth century should not be underestimated; the vast antique market could not be met by genuine works of art

74 Cup and saucer in Neo-renaissance style, Paris, J. Brianchon the Elder, 1878; cup 7 cm high

Nineteenth century jug types:

Slavkov, 1810–20

from the past, and soon copies were being made. On the one hand this led to a revival of all-but-forgotten skills and craftsmanship, but on the other hand to the mechanical production of substitutes. It is important for the collector of porcelain to realize that historic pieces were faked on a large scale at this period.

New ideas and impulses were transmitted by the world exhibitions which followed rapidly on each other in different parts of the world. After the Great Exhibition in London in 1851, there was one in Paris in 1855, another in London in 1862, one in Dublin in 1865, and so on. From 1904 up to the outbreak of the Great War there was an exhibition of this type almost every year. The arts and crafts were always the most significant aspect, and the artists were carefully chosen, for the standard of craftsmanship was an all-important criterion of the cultural level

Meissen, c. 1825

Meissen, c. 1870

Slavkov, c. 1885

Prague, after 1890

102

Nineteenth century cup types:

Klášterec, 1810

of the country concerned. The role of intermediary played by these exhibitions in the revival of the crafts has led to the term "Exhibition Period", sometimes used to describe the products of the craft at this time.

The makers of porcelain had to react to all these influences, and so "Renaissance" and "Gothic" decoration made their appearance, often (and still) severely criticized. The key to understanding this

"fall from grace" in the matter of style must be sought in Semper's principle set out above. Scholars have now done much to clarify the evolution of the crafts in the second half of the nineteenth century, and porcelain takes its place in this context.

In the 1850s European craftsmanship was under the spell of Revived Rococo; a change began in France, still the leading force in the arts, under the Emperor Napoleon III, in the early 1860s. The

Meissen, c. 1820

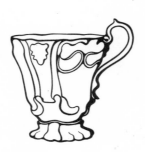

Loket, 1837

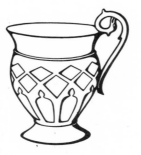

Meissen, c. 1855

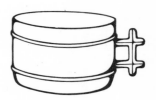

Klášterec, c. 1890

103

Renaissance became the recognized ideal both in architecture and in the decorative arts. At first only Renaissance decorative elements were incorporated into ornament, but as Revived Rococo lost its popularity and came to be seen as undisciplined and unbalanced, the influence of the Renaissance became so strong in the second half of the 1860s that Renaissance works were copied in their entirety. This trend was not obvious in porcelain, however, appearing mainly in the use of figural stems, usually in bisque, and in painted ornament where a typical motif was the meander. The porcelain designers were still captivated by the eighteenth century, clinging in conservative prudence to the style that had brought them their greatest successes in the past.

The 1870s were marked by the Franco-Prussian War, and the defeat of France led to the loss of her leading position in the arts. The focus of artistic life moved further eastwards, to Central Europe, and one of the main centres was now Vienna. Rudolf von Eitelberger was the director of the Museum of Applied Arts at the time, and with a group of artists and architects they turned to the early Italian Renaissance for their models, to the fifteenth and sixteenth centuries. The Viennese exhibition of 1873 displayed a unified artistic approach in all the crafts, and aroused admiring interest throughout Europe. Success was particularly marked in glass, gold and bronze. Porcelain was represented by Bohemian ware from Klášterec, Slavkov (Schlaggenwald) and Březová near Karlovy Vary. This new renaissance was slow in changing the style of porcelain, however, first influencing painted decoration and later bringing with it more delicate shapes and thin-walled vessels. Thus Revived Rococo still survived in porcelain manufacture throughout the 1870s, especially since it brought commercial success overseas as well.

The Austrian attempt to introduce a unified style for all the arts and crafts was welcomed by its contemporaries as a success to be followed, but before long artists began to feel their freedom unnecessarily curtailed by the formal bonds it imposed; the new renaissance was not a springboard for further development, but an isolated peak from which there were no new creative paths to follow.

Meanwhile there were several important events which had their consequences for the art of Europe. In 1857 the Americans forced Japan to open some of its ports to trade, and in 1860 Anglo-French forces captured Peking, looting the treasures of the Summer Palace. The works of art that thus found their way to Europe were greeted with fascinated admiration. Japanese art came to Europe by more peaceful means, appearing at world exhibitions. From 1862 onwards no such exhibition lacked its display of Japanese art, and Europe appreciated in particular the force of inspiration the Japanese artist drew from his close bonds with nature. French painters, in particular, were influenced by the artistic principles of the Japanese, and Japanese art stood by the cradle of Impressionism, which was even sometimes called the "Japanese school". Thanks to Impressionism, a new style came into being in the Sèvres porcelain works, for which the main credit goes to the French potter Théodore Deck, who was artistic director of the factory during 1887–91. His work was particularly successful at the Paris Exhibition of 1878, where he was awarded the Grand Prix. The French example was soon followed elsewhere in Europe, and particularly in Copenhagen; the artistic director Arnold Krog studied the Sèvres style while on a European tour of porcelain centres in 1885. The Japanese inspiration he brought back from Paris was transformed into a very individual style, and his work won the Grand Prix d'honneur at the Paris Exhibition in 1889. Krog's successes led to his style being adopted elsewhere in Europe, in Meissen, St. Petersburg and Berlin, among other factories.

Japanese inspiration was of course not the only influence on art in Europe at the end of the 1870s and during the 1880s. Devotees of the European tradition turned to Baroque and Rococo, finding there the same freedom of interpretation as in oriental models. It would not be entirely true to impute this revival of Baroque and Rococo to lack of courage in following new paths; the emotional and historical ties with the past were particularly strong in Central Europe, which made for the long persistence of Revived Rococo there.

By the end of the century the crafts could draw on a well-studied and explained system covering all the European styles, but porcelain was in a difficult position. Now based purely on commercial principles, the craft also lacked the ancient tradition of

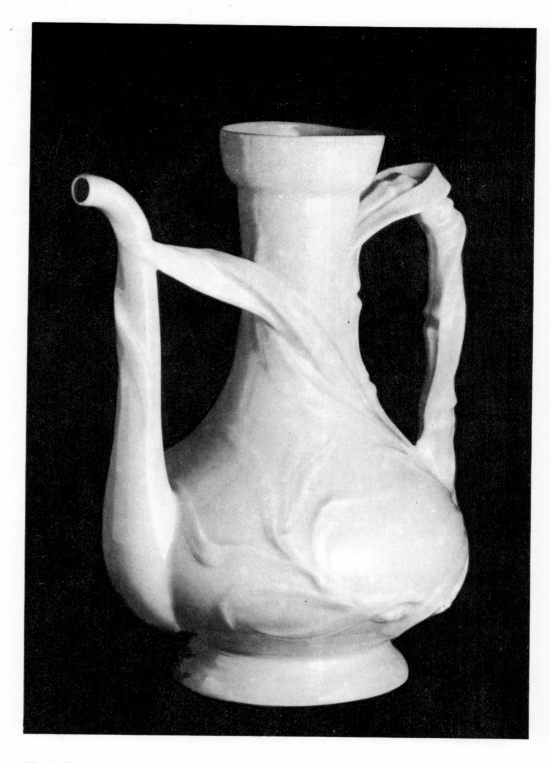

76 Coffee-pot, early Art Nouveau period, Březová, c. 1895; 26 cm high

Jug, designed by H. van de Velde, Meissen, c. 1908

other branches, and artists took up the new ideas whose involved history we have just been following, with hesitation rather than bold enthusiasm. They are traceable in painted decoration only, and even then only in the ware issuing from more progressive firms. Elsewhere producers still clung to traditional forms and designs, which covered not only the European market but overseas customers as well, until late in the nineteenth century.

In contrast to the creative artistic problems besetting producers of porcelain, great advances were being made at this time in the techniques of production and decoration. In 1854 Henri Victor Regnault, a well-known chemist and physicist, became manager of the Sèvres factory, while another scholar, A.–L. Salvevat, was technical manager. They developed a new range of high-temperature colours and new glazes ("pâte japonaise"), a new type of soft-paste porcelain known as "pâte tendre regnault", and improved the technique of cast porcelain, producing a very thin body and also making it possible to create large pieces such as the "Neptune" vase, over two metres high. In the 1860s Sèvres discovered the "pâte-sur-pâte" technique, a brush relief decoration inspired by Chinese porcelain. Under G. Vogt (1880–1909) the value of zinc white in crystal glazes was discovered, as was his

"new hard porcelain", of such a body as to permit new decorative techniques like copper oxide lustre glaze. The Sèvres factory was very forward-looking, and under Deck a new type of felspathic soft-paste body was introduced, which was easily modelled and also took bright colours well.

German porcelain producers were not idle. The Royal Porcelain Works in Berlin set up a research institute in 1878, under H. A. Seger, whose name survives in connection with technical improvements such as the Seger cone but who also invented new glazes (iridescent blue, sang-de-boeuf) and an overglaze enamel inspired by Japanese ware. Porcelain production had left the realm of empirical practice and acquired a sound scientific base. All the various historical styles of the nineteenth century had exhausted their élan, and over-reliance on convention and reliable models had ended up in inspirational fatigue. It was clear, as 1900 approached, that England had achieved considerable success in attempts at aesthetic reform, after following its own ways from the middle of the century. The Arts and Crafts Movement inspired by Ruskin and William Morris in the 1860s was already celebrating its first successes in the 1880s (e.g. A. H. Mackmurdo's book designs). In the 1890s Glasgow became the centre for the new ideas, when the Four formed

Nineteenth century tureen types:

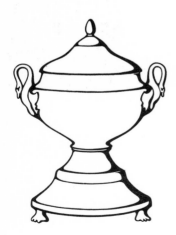

Korzec, 1815–20

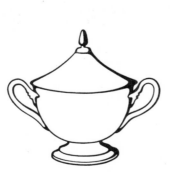

Slavkov, 1833

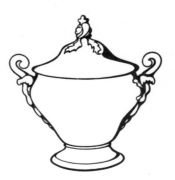

Prague, c. 1850

Kláśterec, after 1884

round C. R. Mackintosh. Exhibitions and periodical publications helped to spread new ideas to Belgium, Germany, France and the rest of Europe. By the turn of the century the new style had conquered Europe, known in France and England as "Art Nouveau", in Germany as "Jugendstil", in Austria as "Sezessionstil", and in Russia as "Modern style". It grew from the need for a new style which would express the need felt by artists at the turn of the century to influence the whole surroundings in which modern man lived. This style then affected not only the arts and crafts, but architecture, sculpture and painting. It was a conscious stand against

77 Vase with Art Nouveau ornament, Meissen, c. 1910; 40 cm high

78 Venus, Meissen, modelled
by Paul Scheurich, c. 1920;
34.8 cm high

79 Part of a tea set in functionalist style, Loket, designed by L. Sutnar, 1928–32; pot 17.7 cm high

historicism; in the crafts, and therefore in porcelain design too, it cleared the way for liberated forms, while the change was most remarkable in porcelain decoration; instead of traditional designs treated strictly historically, we find plant motifs, mostly in stylized form. Nature was the only source of inspiration for the modern style, and functionalism in design was demanded; nevertheless Japanese woodcuts had a considerable influence, as did Islamic (Moorish) pottery ornament. The discovery of the lost Minoan civilization also contributed new themes, and plant motifs in Late Gothic woodcuts in Europe were another source of inspiration.

Porcelain itself was regarded only as an accessory which should not be allowed to interfere with unified style of interior decoration, and so the foremost designers of the movement turned their attention to this craft, too. After 1900 there was no doubt that Art Nouveau had conquered all along the line, both small workshops and large porcelain factories adopting the new style until a new danger emerged — that it would become a mere superficial aping of fashion. The foremost artists realized this menace, and again dealt with it in the English fashion: in 1903 the Wiener Werkstätte ("Vienna Workshop") was established in Vienna to produce not only single

80　Covered jar in Art Déco style, Karlovy Vary, c. 1925; 20.2 cm high

objets d'art, but everything that pertained to complete interior decoration, and even to build whole houses. Porcelain thus came within their sphere; Jutta Sika, Joseph Hoffmann and E. J. Margold, for instance, designed ware to be made in the Czech porcelain factory at Slavkov, while J. Böck's Vienna factory made tea and coffee services designed by them. Germany passed through a similar stage, the Vereinigte Werkstätten für Kunst und Handwerk ("United Workshop for Art and Craft") being founded in 1897 by leading Munich artists inspired by William Morris. In 1901 the Grand Duke invited Henry van de Velde to Weimar, to set up the "Seminary of Decorative Arts", which in 1918 became the famous Bauhaus. This seminary exercised considerable influence on the porcelain factories of Thuringia and van de Velde himself made some designs for

Meissen. The famous works also contributed to Art Nouveau porcelain by the "pâte-sur-pâte" technique and some crystal glazes. Of the painters working for Meissen at this time we should mention R. Hentschel, while T. Schmuz-Baudiss was outstanding in Berlin, his best-known work being the "Ceres" and "Pensée" services. His delicate underglaze painting was charasteristic of Berlin porcelain at this time.

After the short-lived attempts by Bonnin and Morris to make English porcelain in Philadelphia in the 1770s it was not until 1826–38 that production was seriously undertaken again, by William Ellis Tucker of Philadelphia. He made household wares strongly influenced by European models in both shape and ornament. "Revived Rococo" reached America in the 1840s, and in the work of Christo-

81 Jug; Philadelphia, W. E. Tucker, before 1832; height 24.2 cm. Collection of the Newark Museum, Newark

pher W. Fenton struck an original American note; his "corn pitcher" is typical. The Fenton factory, set up in 1849 in Bennington, Vermont, also made parian figures and table ware of excellent quality although still in the English style. During the nineteenth century a number of factories were producing porcelain, particularly in Pennsylvania, Vermont, New York, Ohio and New Jersey, and their work clearly leant heavily on European models; in the second half of the century France was a strong influence.

The First World War brought the Art Nouveau period to an end, although the first signs of change had already been visible before 1914. After the war the crafts received a new impulse from the Paris Exhibition of 1925, with the catalogue subtitle "Arts Décoratifs" setting the new direction. "Art Déco" was to solve for good the conflict between the interests of art and those of industrial production. At the same time functionalism spread from architecture to other arts and crafts, including porcelain; the functionalist creed that "form follows function", based on scientific analysis, led to clean, functional forms in porcelain, free from applied or painted decoration.

82 Cup and saucer (the oldest surviving Bohe-
mian porcelain), Klášterec, 15th September
1794; cup 5.6 cm high

83 Cup and saucer, Sèvres, signed by the woman painter J. Denois, 1820; cup 9 cm high. Private collection, Prague

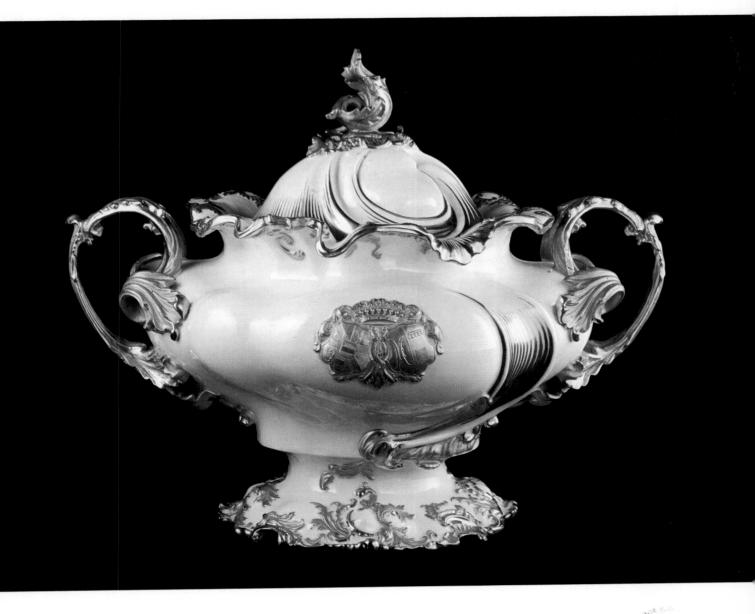

84 Large tureen from the Thun service, Kláš-
terec, 1856; height with lid 33.8 cm

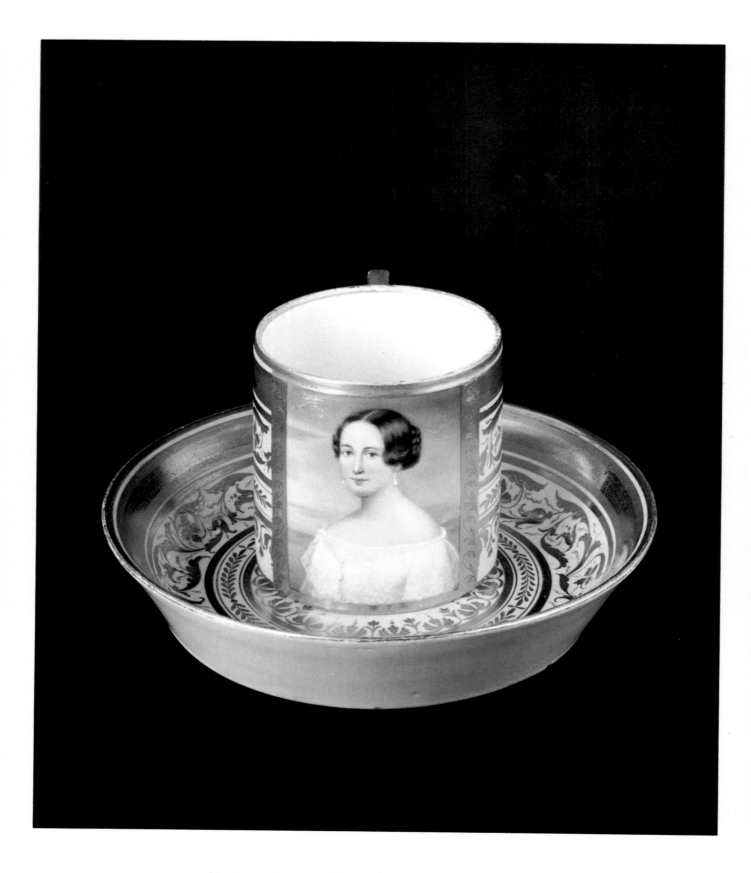

85 Cup and saucer, Vienna, signed by the
painter Daffinger, early nineteenth century; cup
5.9 cm high. Private collection, Prague

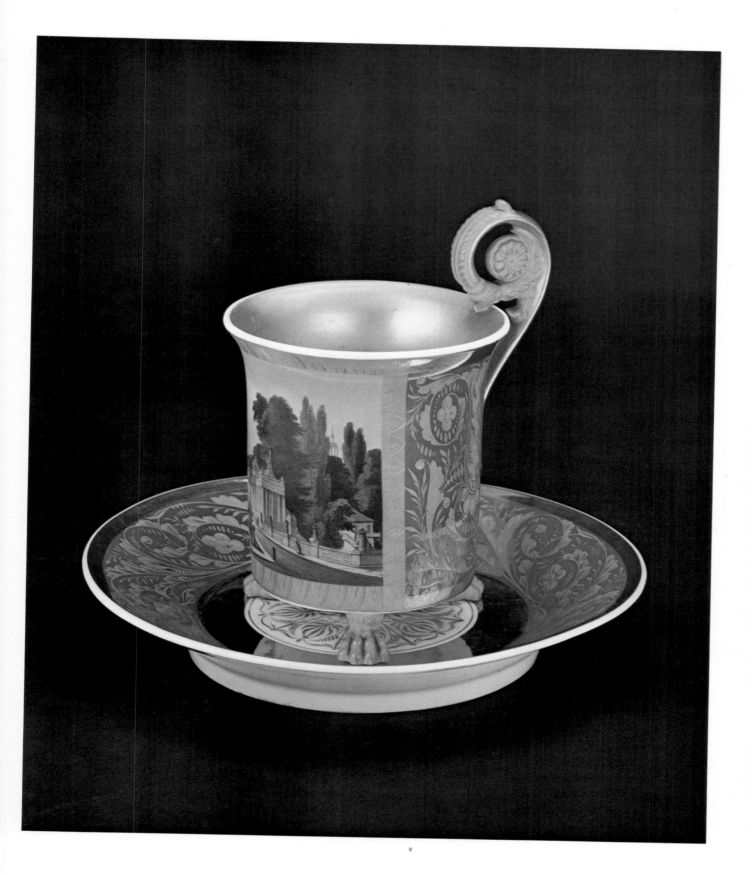

86 Cup and saucer, the cup bears the inscription "Die Königsbrücke in Berlin", Berlin, c. 1835; cup 13.4 cm high

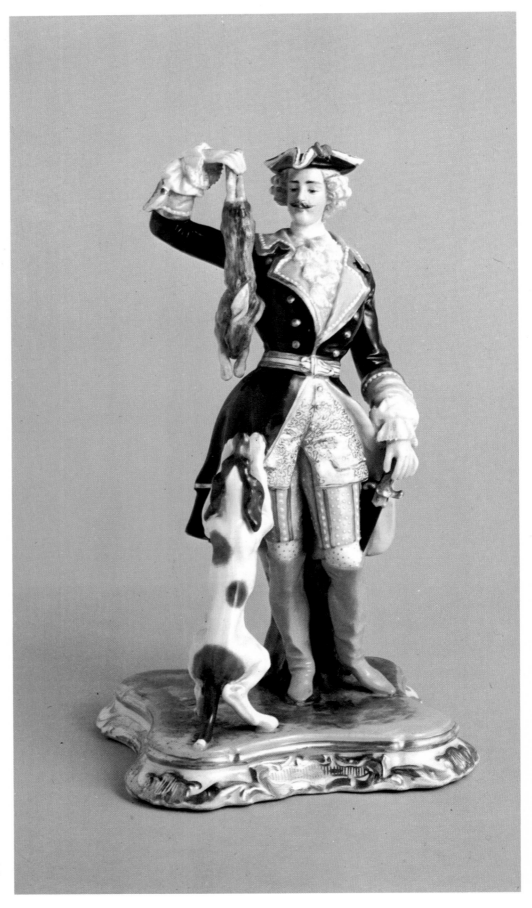

87 The sportsman, Prague, modelled by E. Popp, after 1852; 23.4 cm high

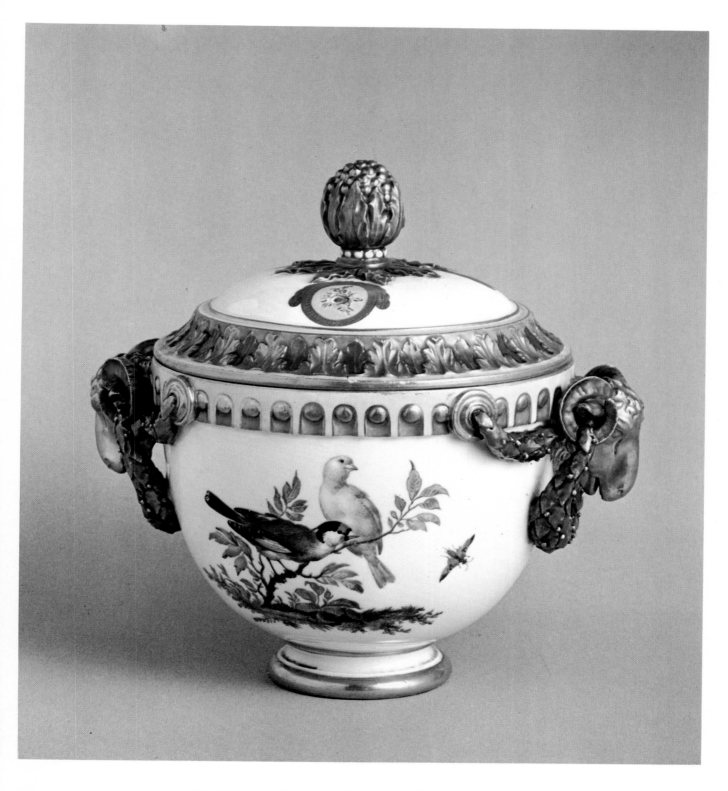

88 Lidded jar, Meissen, c. 1780; height with
lid 16.9 cm

89 Cup and saucer, the cup with a portrait
of the Emperor Franz Joseph I, Vienna, 1858;
cup 13.7 cm high

A Collector's Guide

Techniques

Marks

Fakes and Forgeries

Techniques

Up to the end of the nineteenth century the term "porcelain" was used in a very broad sense, with no regard to the technical composition of the body. All the attempts to make porcelain in Europe had one single aim: to imitate oriental porcelain. Since porcelain making in China was a closely guarded secret, the techniques employed were long unknown to European potters, who had to try out their own ideas. The result was several different types of material, not one of which was techni-

90 Grinding mill (Fig. 1) and Sieving the ground clay (Fig. 2). From F. J. Weber, *Die Kunst das ächte Porzellain zu verfertigen*, Hanover 1798

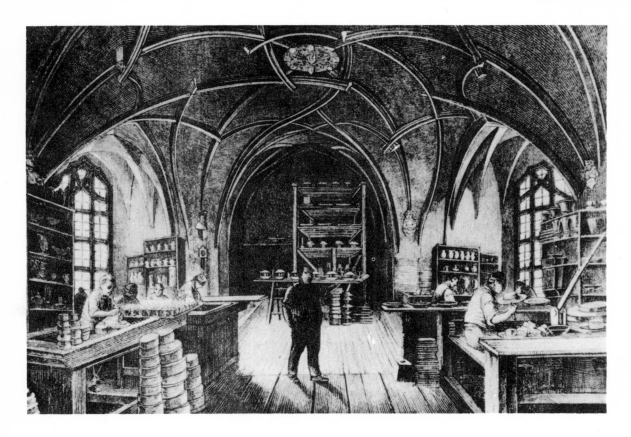

91 The shaping shop at the Albrechtsburg works, Meissen, in 1850. VEB Staatliche Porzellan-Manufaktur, Meissen

Moulding figures: a) half of the mould; b) cross section of a mould ready for pressing; c) a closed mould (after P. Rada)

cally identical with the porcelain body used in China. What, then, is the composition of European porcelain? It is not easy to answer this question, and we must bear in mind the evolution of European porcelain production, and not categorically exclude those bodies which are not strictly speaking porcelain, and yet are an inseparable part of the art of porcelain.

Technically speaking, European porcelain can perhaps be defined as fused ceramic material, the finest of all ceramic products. It is usually white and, when thinwalled, translucent. There are two types of porcelain: hard-paste, with a high percentage of kaolin, felspar and silica in the composition; and soft-paste porcelain, which contains either very little kaolin or none at all. The principal ingredient is frit. These two types of European porcelain are also fired at different temperatures, the dividing line being at 1,350°C; most hard-paste porcelain is fired at temperatures of from 1,380° to 1,460°C, while soft-paste porcelain is fired at 1,100° to 1,350°C.

It follows from this that European porcelain is classified in two basic types, and that this is decided by the temperature at which it is fired. This in turn depends upon the composition of the body, for the two types call for different treatment. Let us now consider how each of the two types is made.

Hard-paste porcelain resulted from Böttger's experiments in his laboratory in the fortress in Dresden. His first formula did not include felspar, which did not become an ingredient of the Meissen porcelain body until 1724. The main ingredients are kaolin, felspar and silica, in the classical German formula in the proportions 50%, 25% and 25% respectively. The quality of each ingredient is decisive, however, and so the proportions vary from one factory to another. The well-known Karlovy Vary

124

92 Bull and dogs, fired clay, modelled by D. Auliczek for the Nymphenburg factory, 1765; 12.9 cm high

Tools for making plaster moulds

porcelain, for example, contains 49 % kaolin, 29 % silica and 22 % felspar; the earliest body used by the Berlin factory was composed of 49 % kaolin, 28 % silica and 23 % felspar, while in the eighteenth century the Copenhagen porcelain works used 47 % kaolin, 20 % silica and 33 % felspar.

Kaolin is the technical name for a clay deposit composed principally of kaolinite, quartz, mica and various clay substances. It is formed by the decomposition of felspar beds from which other substances have been washed away while the kaolin has remained; in the natural state kaolin is a soft, plastic earth in which the chief element is the white clay-like kaolinite (silicate), whose lamellar structure is the

cause of the plasticity of kaolin. Some of the kaolin beds important for porcelain production are Colditz and Seilitz-Löthain near Meissen, in Germany; Oberzell and Griesbach in Austria; Sedlec near Karlovy Vary in Bohemia; St. Yrieix near Limoges, in France; Bornholm in Denmark; and others.

Felspar (orthoclase) helps to fuse the porcelain body during firing, but has the disadvantage of increasing shrinkage. Deposits of felspar suitable for porcelain manufacture exist in Scandinavia, Yugoslavia and Bulgaria. Meissen used Scandinavian felspar in the past, particularly for glazing.

Silica reduces the plasticity of the body, but it also reduces the rate of shrinkage

125

93 Fig. 1. Cross-section of a Vienna kiln
 Fig. 2. Lay-out of a Vienna kiln
 Fig. 3. Lay-out of a French kiln
 Fig. 4. Cross-section of a French kiln
From F. J. Weber, *Die Kunst das ächte Porzellain zu verfertigen*, Hanover 1798

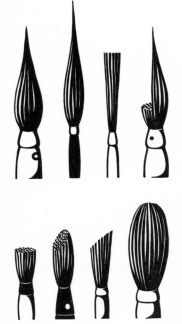

A porcelain painter's brushes:
1) for painting; 2) for fine hatching; 3), 4) for writing and drawing; 5) for stubbing; 6) for thick lines; 7) for flat work; 8) for dusting (after P. Rada)

while increasing the fusibility of the clay. Silica must be pure, and free from impurities which would colour the body during firing. For this reason flint is preferred to sand; Norwegian flint is remarkable for its purity.

The preparation of these three components is a complicated business; the hard materials are ground in rotating cylinders, with a certain quantity of water, until the required fineness is achieved. The material is passed through a fine sieve, which determines the degree of fineness achieved and retains hard remnants. A body which has been too finely ground does not keep its shape, and cracks; at the other extreme, hard particles insufficiently ground cause trouble. Kaolin is mixed with water in a blunging machine, and cleared of impurities; the kaolin slip is then mixed with the finely ground flint and felspar, and particles of iron are removed by magnetic separators. The liquid clay then passes into a filter press which removes excess water and forms stiff "cakes"; when the material is of the right consistency, air bubbles are removed in a de-airing pug-mill, after which the body is ready for shaping.

This is how the porcelain body is prepared in a modern factory, but for a long time the machinery used was primitive, and almost up to the end of the eighteenth century the only motive power was water or horse-power — or man. Steam-driven machinery was a great step forward, but it was only slowly introduced into porcelain factories; the first to be installed in Meissen, for instance, came as late as 1853. An important invention of the mid nineteenth century was the ball or pebble mill, in which metal balls rotating in a cylinder crushed the raw material to the required degree of fineness. Up to this time stamping mills were used. One of the most important stages in the preparation of clay bodies is the removal of

126

Jollying a plate

Jiggering a dish

water from the slip. The filter-presses of today were preceded by a system of canvas bags which were filled with slip and then pressed to remove excess water. The body was then treated to get rid of air bubbles, and homogenized by kneading or treading. This job, too, was gradually taken over by machines. The high-point of mechanization in modern times was the introduction of the vacuum press invented by American, Raleigh Staley, at the turn of the century.

Thus prepared, the clay has to be shaped; there are several methods, beginning with the traditional potter's wheel; originally the thrower gave the desired shape to each piece with his hands, but today the majority of porcelain shapes are turned on the wheel with the help of plaster moulds and jollies. This method was first used at Sèvres in 1855; the clay is cut into pieces of a size appropriate to the article being made, and each piece flattened to a cake. The cake is placed on a plaster mould fixed to the wheel and shaped like the inside of hollow article; the outer wall is then shaped as the wheel revolves, by a jigger-arm profile corresponding to the desired shape. The contrary method, by which hollow ware is made, uses a plaster mould giving the outer shape (e.g. of a cup); the clay is placed in this mould and the tool simultaneously presses it against the mould and shapes the inside wall. Plaster moulds can absorb moisture from the clay; as it dries the porcelain comes away from the plaster mould.

Sectioned plaster moulds were used for porcelain figures, and the separate parts of the figure were then joined together by an expert known as a "repairer". Figures made from the same set of forms may show slight differences according to how the "repairer" joined them together. Today porcelain figures are usually cast; this is another important shaping process, made possible by the realization that additional water, and the addition of soda or isinglass, give the right consistency for casting while the soda or isinglass prevent a sediment forming, the slip retaining its viscosity. The slip is poured into the mould, where it forms a hard shell of clay as the plaster absorbs the water; when the desired thickness is reached, the remaining liquid is poured off. After drying, the mould is opened and the article taken out. This method was first used in Tournai in 1780, but kept a close secret. It only became widely used in European factories after Goetz introduced casting with the use of soda at the Karlovy Vary factory in 1891.

The factories make their own moulds; since there is a 15—17% shrinkage during drying and firing, the moulds have to be larger than the finished article. The plaster moulds do not absorb all the moisture from the clay, and there must be a drying stage before the ware can be safely placed in the kilns.

The firing is the most important stage in the whole process of porcelain making, and is indeed the centre of ceramic art. For porcelain to attain its exceptional qualities and appearance, it has to be fired more than once. The raw ware is prefired at about 950°C, to harden it, and the result is a porous unglazed body. During pre-firing the ware is placed in fireproof saggers to protect it from dirt and damage, and from direct contact with heat and smoke. If underglaze decoration is intended, the ware is now painted; then, cleaned and touched up, it is dipped in the prepared glaze and then fired at a high temperature for the second time. The temperature is determined by the kaolin and felspar content of both body and glaze, but can generally be said to lie between 1,370° and 1,460°C. Oxidation of the iron present in the body must be prevented, because it would lead to a yellowish tinge and the precious white of porcelain would be spoiled. Oxidation is prevented by reduction firing, at a temperature of 1,100°—1,300°C, i.e. by reducing the amount of oxygen in the kiln. At the correct temperature the body and glaze fuse firmly together, the glaze forming a vitreous, trans-

lucent and gleaming surface. It is the finished porcelain product that comes from the kilns.

Further firing is a matter of decoration; where underglaze painting is used, with colours which stand high temperatures, the range is limited practically to cobalt blue, chrome green, uranium black, and copper red. The palette of overglaze colours is much wider, and today all shades can be applied. The base of these overglaze enamels is flux of glass with a low melting temperature, usually a lead or borax compound, mixed with metal oxides for colour. The colour is usually applied with pen or brush, on the glaze, and a third firing is carried out to melt the glass and fuse the colour with the glaze; this firing is done in a muffle-kiln at a temperature of 800–900°C. If gold is used in the decoration a fourth firing is necessary, at a temperature varying from 560° to 740°C according to the technique used. Overglaze colours are less durable than those fused under the hard glaze, which cannot be scratched.

As industrial porcelain production developed new mechanical ways of decorating ware were adopted, making decoration easier and cheaper, without the need for painters or specialists. The oldest of these methods is transfer-printing, by which the design is engraved on metal, printed on paper in ceramic colours, and transferred to the glazed porcelain, which is then fired. The method was invented in England about 1733 and used at Bow by Robert Hancock, and at Worcester between 1757 and 1774. Like most other investions there are several claimants for "first" place: among them G. Green and J. Sadler, owners of the "Printed Ware Manufactory", applied printed decoration to various types of pottery from about 1756 to 1799. At the turn of the eighteenth to nineteenth centuries transfer-printing spread to other English factories. The process came to Germany from Sweden, where the Marieberg factory produced successful printed ware 1769–88, and was first used in Frankenthal in 1769–70. In the early nineteenth century it spread all over Europe, and was extended to include coloured transfers which were applied to ceramic wares in the same way as children's toy transfers today. The cheapest and artistically least demanding form of decoration is the use of a rubber stamp to apply the colours.

Let us now turn to soft-paste porcelains; as we have already seen, in Europe this is taken to cover all bodies which do not need a higher firing temperature than 1,100°–1350°C. The first is French frit porcelain; the composition of the frit, which is the basis of the French "pâte tendre", is very different from that of porcelain bodies, and really derives from old glassmaking techniques. This was how it was made in Sèvres around the year 1760 (according to P. Rada): a frit was mixed of 22% potassium nitrate, 7.2% sodium chloride, 60% silica, and 3.6% each of aluminium-potassium sulphate, sodium carbonate and calcium sulphate. To 75% of this frit 17% washed chalk and 8% chalky clay was added. The result had very little plasticity, and so soft-soap and tragacanth gum were added in sufficient amounts to make the body plastic. Plaster moulds were generally used to form the ware, and after drying it was fired until the body fused completely, at about 1,250°C. This frit paste suffered from severe shrinkage, and so the moulds were sprinkled with ground quartz to prevent collapse. Once fired, the frit porcelain was given a low-temperature glaze containing litharge, calcined lime, potassium and soda. The glaze also needed a high proportion of viscous material, to fuse with the absolutely non-absorbent body. Compared with the glazes used for hard-paste bodies this low-temperature glaze (700°–800°C) had the advantage that during firing the colours mingled with the softened glaze and thus acquired a gleam that hard-paste porcelain decoration can never have. The low temperature also meant that a wide palette of delicate tones could be used.

Another type of soft-paste porcelain is bone china, invented in England in 1744 and 1748 by Thomas Frye. His formula is not known, but bone china has been constantly improved by English firms. As an illustration we may quote P. P. Budnikow on the composition of bone china: 20 to 45% kaolin, 8–22% felspar, 20–60% bone ash, 9–20% silica. Like frit porcelain, it was fired in moulds dusted with ground quartz at a temperature of 1,250° to 1,300°C, i.e. until the body was completely fused. A glaze of lead or borax was applied before the second firing at 900–1,000°C. A speciality in bone china was the table ware with a very thin body, i.e. very thin-

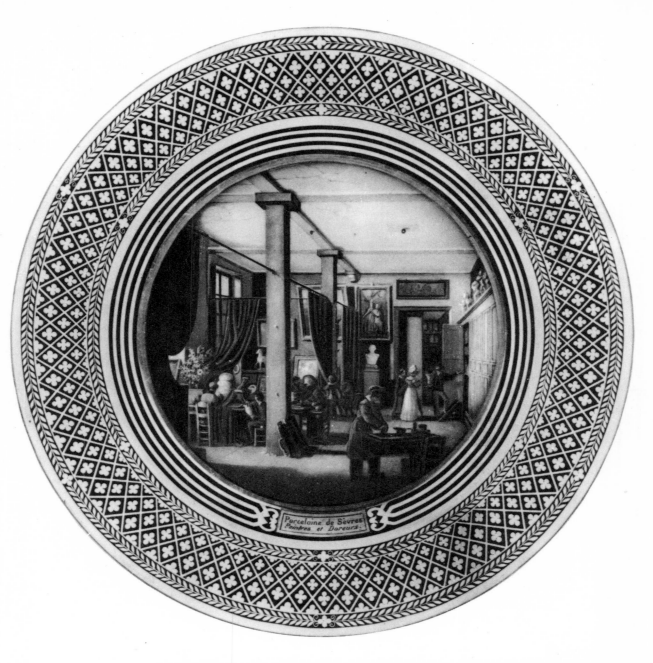

94 Plate from the "service des Arts Industriels" with a painting of an artist's and gilder's studio, Sèvres, painted by C. Develly, 1823. Musée national de céramique, Sèvres

walled, which was made by turning the dry body on a lathe until it was only half thickness. A special type of bone china was evolved in England for figures and, characteristically, it was fired unglazed; it was known as Parian, because of its resemblance to Parian marble. Parian was fired at 1,280° − 1,320°C.

In the second half of the nineteenth century oriental porcelain was very much admired because it combined the qualities of both hard-paste and soft-paste European porcelains — it was equally resistant to changes of temperature and mechanical damage to the surface, and it was decorated in magnificent colours. Other types were therefore evolved in Europe, like Seger's porcelain made of 25% plastic clay, 45% silica and 30% felspar, and fired at 1,250° − 1,300°C. In 1881 the Sèvres factory introduced a "pâte nouvelle" composed of 45% kaolin, 35% felspar and 25% silica, fired at 1,280°C.

The porcelain factories of today bear little resemblance to the manufactories of the eighteenth century. The enormous strides made in technical progress have had their influence in this field of human endeavour, too, although not always to artistic advantage.

Marks

95 The "Mercury's staff" mark on Meissen ware, used c. 1721–2 to c. 1731, underglaze blue

K. P. M. from 1722

Marks on porcelain serve a very different function from those on precious metal in the interests of the purchaser; hallmarks on gold and silver articles are and always were official marks guaranteeing the proportion of precious to common metal in the interests of the purchaser; in the case of pewter the ratio of lead to tin is controlled for health reasons. No such official and sensible control of por-

celain products was needed. The original purpose of porcelain marks was commercial, and that is still true today, whether the reason for their introduction was advertisement or fiscal considerations. Apart from the sporadic imitation of the marks on Chinese and Japanese porcelain, the first mark to be adopted in Europe was that of the Meissen factory — the famous crossed swords. O. Walcha has given a detailed account of how this came about: the story of the Meissen crossed swords began in 1722, when Inspector Steinbrück insisted on the need to protect Meissen ware against undesirable competition by local decorators and especially by the newly founded factory in Vienna. The far-seeing inspector suggested a mark, but the archives reveal hesitation about how and to what extent the marking should be carried out. At the beginning of October 1722 it was decided that in every breakfast service the coffee-pot and sugar basin should be marked with the letters M. P. M. (Meissner Porzellan Manufaktur), and a report later in the month shows that this was indeed kept to. Other abbreviations were also put forward, however, like K. P. M. (Königliche Porzellan Manufactur) and K. P. F. (Königliche Porzellan Fabrique). On 8th November 1722 Inspector Steinbrück proposed that part of the Elector's coat of arms should be used as the Meissen mark — the crossed swords — which would eliminate all confusion. It is impossible to find out today why it took two years before this mark was finally used, and it is clear that marking was not systematic, since in June 1731 the employees of the factory were reminded to mark their products as they had been ordered to. 1731 is thus the earliest date from which we can assume regular use of the crossed swords mark on Meissen porcelain. So much for O. Walcha. It would seem that the way of marking adopted by Meissen inspired

the other recent porcelain works, and it is not to be wondered at, for in this early stage it was the ambition of all of them to come as close as possible to their model — Meissen. Marks more or less resembling the crossed swords of Saxony began to appear — but we shall return to this when discussing fakes.

As we have seen, most factory marks were inspired by commercial motives of advertisement, but in the Austrian Empire the situation was somewhat different, because of the government's protective tariff policy. Towards the end of the eighteenth century the line was to employ local labour in the factories that were springing up, and to make the most effective use of local raw materials. By this time Vienna no longer insisted on the monopoly of the government porcelain factory in the capital, but began to encourage production in other parts of the realm, although hesitantly at first. Thus new factories were started up in north-west Bohemia, around Karlovy Vary, close to the large deposits of kaolin discovered there. The Czech regional office — the supreme civil authority up to 1848 — decided that much of the porcelain imported especially from neighbouring Thuringia purported to have been made in the new Czech factories, and that this practice damaged the economic interests of the Austrian state. The regional office therefore proposed to the Vienna directorate *in cameralibus et publico* that porcelain articles should in future be marked so that it would be clear that they had come from Bohemian factories. When the directorate accepted the arguments of the regional office it was decreed (in 1793) that each factory must mark its products.

We have thus seen the two main reasons why European porcelain was marked almost from the start of production. These reasons are naturally less important for collectors than the technical and graphic aspects of factory marks. Changes occurred in the course of time, providing one of the bases for reliable dating; thus the producers' marks not only reveal where the article was made, but also have something to say about its antiquity.

From the point of view of technique we can divide porcelain marks roughly into three groups: painted, printed and impressed. We must of course bear in mind that all three may be found on one and the same piece of porcelain. Painted marks are usually underglaze, in order to prevent forgery. Yet even on the earliest examples this need not be true. We have only to turn to Meissen for illustration: we know that regular marking of their products can only be dated from 1731; the mark was painted in cobalt underglaze blue. But at that time there were earlier pieces of unmarked porcelain in store, which were then marked — overglaze — with the light blue crossed swords. Another frequent type of mark is the impressed mark on unfired clay; this was usually made by a wooden stamp before glazing, when the body was still soft. Often these marks are so casually imprinted, or so flooded with glaze, that it is very difficult to distinguish them. The third type, the printed mark, is common on modern porcelain figures and table ware.

The marking technique may be a combination, so that one part of the mark is painted and another printed or impressed, or simply scratched on the porcelain body. The Strasbourg factory of Joseph Hannong can serve as an example: the Strasbourg mark is sometimes part impressed, part scratched, and executed in different colours, e.g. blue, grey or a combination of the two.

The mark itself is very varied in form, from national coats of arms, and municipal crests, to local symbols and the monograms of the owners of firms; as a rule, when the firm changed hands the mark was changed, too. The fact that the mark was entrusted to apprentices (as we know that it was in Meissen) meant that the execution of the mark was often unsure, as the unskilled hand held the brush. It is therefore dangerous to judge the date of an article by the "hand" of the mark. It is obvious from what has been said that there are thousands of porcelain marks from European factories, and that many have still to be deciphered. Every would-be collector therefore requires a reliable handbook of porcelain marks.

Up to now we have been talking about factory marks, but porcelain often bears other marks or signs. These were used for internal purposes, either for technical reasons or for checking on and rewarding the work of individuals. Once again these marks may be painted (usually overglaze), impress stamped, or merely incised. These marks indicate the painter or "repairer", the type of vessel or service

132

96 An impressed mark, Vienna, 1744–9

97 The AR mark on Meissen ware, used about 1723–36 on porcelain for the king or for royal gifts

Initial letters of the princedom of Hessen-Darmstadt, Kelsterbach, 1767–8

concerned, or the composition of the body and hence the quality. In many cases these additional marks enable us to determine the exact year in which the article was fired or decorated. The Sèvres factory, in France, for instance, marked its products with letters, signs, or numbers indicating the year of production. Every painter had his own mark, too, usually made up of letters from his name. The Strasbourg factory of J. Hannong, too, marked every coffee service with impressed or incised letters "A" or "C"; relief porcelain was marked "GR", vases "V", while the letters "A" and "B", incised, together with numbers from 1 to 16, documented the composition of the body. Unfortunately there are not many cases where these auxiliary marks are known in such detail. Often the principal and even the only guide is the mark of the factory.

Sometimes the collector finds a well-known mark apparently defaced by a ground incision or by a stroke of a different colour. The factories sometimes used this method of marking an article which did not come up to their standard; this method was used both in Meissen and in Vienna. It is obvious that fakes often "repaired" marks thus devalued by the original makers.

The factories tried to mark their products in such a way as not to spoil the artistic effect, so that we are likely to find their marks on the base of plates or dishes, or under or inside the base of the figures. There are of course exceptions, especially where the artist's signature is concerned. The Prague factory which was making porcelain figures during 1837–94, for example, placed the factory mark underneath the base, but Ernst Popp, the sculptor designing their models, usually incorporated his signature into the terrain

98 The Meissen factory mark combined with a "D" in gold; the gold letters seem to have been used to mark all the pieces of a given set

on which the figure stood, or placed it in some less conspicuous spot on the figure itself. The situation was different for those painters working for Höroldt in Meissen, who were strictly forbidden to sign their work; nevertheless Johann Ehrenfried Stadler, one of Höroldt's painters, succeeded in placing his monogram on some of the works he executed, hidden in the painted decoration.

Often, however, we come up against unmarked pieces of porcelain. We know how long it was before Meissen began to mark its work, and we have seen, too, that porcelain from some of the Thuringian factories was deliberately left unmarked in order to pass for the product of the new Czech porcelain works. Yet even after the marking of porcelain became general practice, not all pieces received the factory mark. From O. Walcha's report quoted

earlier it is clear that only the coffee-pots and sugar basins were marked in Meissen breakfast services. The practice of marking only the more important pieces in a service spread to other firms, although it was not necessarily the rule. It explains, nevertheless, why we often find unmarked pieces, especially the less individual pieces of table ware, which were originally part of a larger set.

We have given some examples of the manner of marking porcelain which the collector may come up against, what can be understood from such marks, and how great the variety in marking is. The collector must approach each mark with a certain degree of caution. His best defence against deception is a well-founded knowledge of the ways in which various factories used their marks — which then become an invaluable aid.

Fakes and Forgeries

The faking of works of art is an ancient device, and fake porcelain appeared in Europe as early as the Renaissance period. It was one of the consequences of the fashion for collecting, which brought with it the financial approach to art values. The connoisseurs created a demand for artefacts which often could not be met. Surveying the wide field of art we see that works of all periods and all disciplines were counterfeited. Fake prehistoric objects have been exposed, forged masterpieces of glass, painting, enamel, sculpture, textiles, drawings, gold and silver work, ivory carvings, furniture, weapons, armour, coins and medals and so on and so forth. The faked classical antiques made for Duke Jean de Berry about the year 1400 are notorious, as is the golden tiara of Saitafernes which stirred the world of art collectors and historians in 1895.

The usual reason for art forgeries is financial gain — undeserved — for the perpetrators. Yet there were times in European history when fakes — for lack of the originals — were intended to prove the high level of culture attained by the region, people or society concerned. Most of these forgeries, which date from the first half of the nineteenth century, were romantic affairs not aimed at private enrichment but at political goals. They were often the work of experts and were technically and even artistically perfect.

Fake porcelain cannot be considered in this context; these pieces never aimed so high, but had and have only one goal: to deceive the collector and thus achieve the greatest possible profit for the counterfeiter. Unlike other art forgeries, fake porcelain appeared on the marked relatively late; the most important period was the second half of the nineteenth century. This must be seen in the context of fashion, decreeing that the nouveau-riche must furnish his salon, his dining-room or his smoke-room in the antique manner, including all accessories. Porcelain was very important in this context, and old pieces made by famous factories were suddenly able to command high prices. Soon the antique market could not meet the demands made on it, and forgers had their heyday. The new "connoisseurs" were happy with their "Meissen", "Sèvres", "Nymphenburg" or "Vienna" porcelain — and it was not only individual forgers, working to commission, but whole factories that were involved, perpetrating series of fakes bearing the mark and imitating the style of the famous porcelain factories. Let us consider for the moment the practices of individual forgers, and their results.

Naturally the forgers were not equipped with elaborate machinery and could not produce complete works, as the forgers of pictures or statues could. They had to rely on a porcelain object which was accessible, and which determined the methods they chose. These methods can be classified in three groups, although the methods involved in each might be combined:

1. a white, undecorated piece bearing the factory mark might be painted;

2. genuine marked porcelain, already decorated in the factory, could have its decoration "enriched";

3. the mark of a less famous factory might be removed or covered, and replaced by the forged mark of a better known factory. Let us now consider these ways of faking in greater detail.

1. In the second half of the nineteenth century antique dealers had large quantities of relatively cheap white, undecorated porcelain from many different factories, because even such renowned firms as Meissen or Vienna would put their wares up to auction or dispose of them by lottery, espe-

cially if in temporary financial difficulties. Frederick II even decreed — in order to further the economic prosperity of his Berlin porcelain factory — that all Jews wishing to marry had to prove the purchase of a certain quantity of porcelain. Thus the forger had only to buy suitable ware and decorate it — with greater or less artistry — in the style featured at the most valued period of the factory concerned. It goes without saying that fakes of this type are of very varying quality, from excellent painting to dilettante daubs.

2. In the second case, porcelain bearing the genuine mark but insufficiently decorated, or in a less valued style, was "improved" by the forger, who roused no suspicions because the shapes and the mark were genuine.

Fake pieces of both these categories, if they are the work of a skilful and experienced forger, present the collector with the most difficult puzzles to solve. Superficial knowledge is not enough; it is necessary to know the production methods and the style of each factory at the given period, to know the colours used in the factory from which the article comes, the way in which those colours were applied, the chemical formulae, etc. R. Seyfarth has given a vivid description of fakers at work with green pigment on Meissen porcelain, for instance. Up to the early years of the nineteenth century all shades of copper oxide green were used at the Meissen works; it is characteristic of these colours that after a time they become lustrous. On the other hand, chromoxide green, invented by Kühn at the beginning of the century, does not have this characteristic and remains unchanged. Naturally experienced fakes knew this and went on using copper oxide green for their forgeries. The new colour lacked the lustre which is one of the marks of age of the porcelain, and so the fakers used hydrofluoric acid to produce the desired effect. This, however, had the disadvantage of affecting the glaze as well as the colour, particularly if the solution was too strong. It would leave opaque marks on the clear glaze. Another sign that hydrofluoric acid has been used is a dull quality in the green.

It is clear from these examples that the collector must be acquainted with the methods of production, the materials used and the way they were applied; intuition is not good enough.

Besides these technical aspects, the decoration must also be considered from the point of view of subject and style. Among the one-time successful forgeries of Viennese porcelain were pieces with signed paintings by Angelica Kauffmann, the well-known Swiss painter (1741—1807), who never painted porcelain! It was rare for a forger to be a creative painter, capable of interpreting the spirit of the time to which his fake was supposed to belong. Most of them slavishly copied models, even while sometimes trying to work changes in the composition. A good knowledge of the original usually soon shows up mistakes and illogical features in the composition of the decoration and thus exposes fakes.

3. The mark is always important for deciding the origin or the date of a piece of porcelain, and naturally it has always attracted the skill of forgers. For commercial reasons most smaller porcelain factories copied or at least tried to work in the style of the famous and highly valued firms. This gave the forger a fairly wide choice of suitable material. His troubles began when he tried to get rid of a less desirable mark. He had the choice of two methods: to cover the original mark, which was most easily done with gold, while the desired mark was painted alongside. This was a fairly simple swindle which only an inexperienced buyer would fall for, however. Gold wears off fairly easily, so that today we find pieces that bear two marks, one with traces of the gold used to cover it. The products of the Czech factories in the late nineteenth century were particularly suited to this sort of faking, because they produced large quantities of "Alt-Wiener-Styl" porcelain.

It was much more difficult and required much greater technical skill to remove the unwanted mark entirely, particularly when it was fired underglaze or impressed on the body. The forger had first to remove the original mark by mechanical means, which meant grinding, and then to paint a new mark over the abrasion and repair the glaze. For this he used a colourless flux and fired the piece at a moderate temperature. He might be thought to have achieved his goal, since the glaze and flux would have fused, but careful examination will reveal where the flux has been added. Particularly in early fakes the difference between the colour of the original glaze

99 Large decorative vase in Revived Rococo style, Březová, before 1846; height 48.8 cm

(continued on page 145)

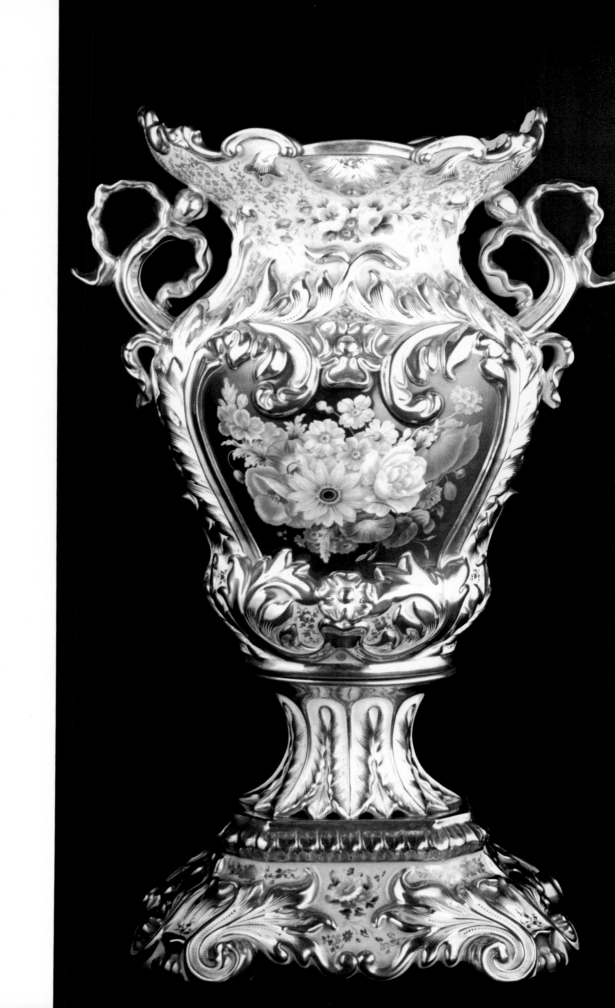

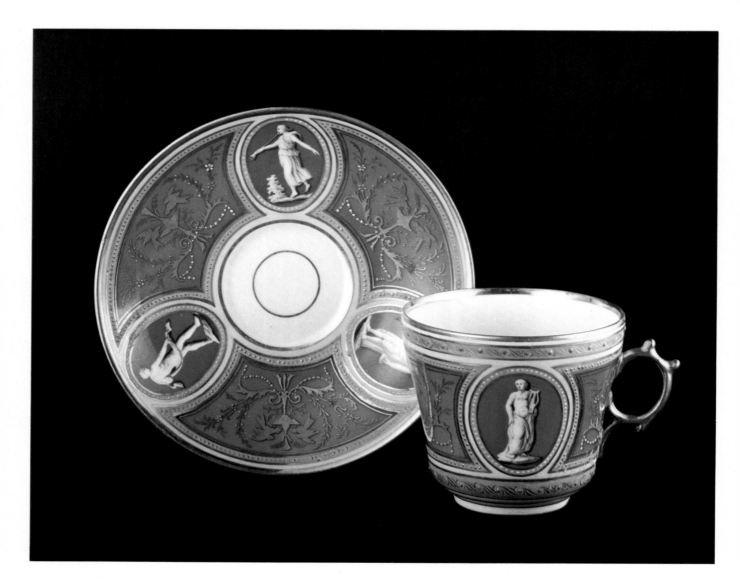

100 Cup and saucer with pseudo-classical decoration, Březová, after 1853; cup 7.1 cm high

101 Dancing girl, pâte-sur-pâte technique, painting signed "FP" (Paul Albert Fournier), Paris, before 1878; 17 × 9.4 cm

138

103 Plate in Neo-baroque style, with a view
of the Chiemsee, Meissen, c. 1885; diameter
26 cm

◄
102 Vase in Neo-renaissance style, Meissen,
perhaps painted by Gross, c. 1878; 57 cm high

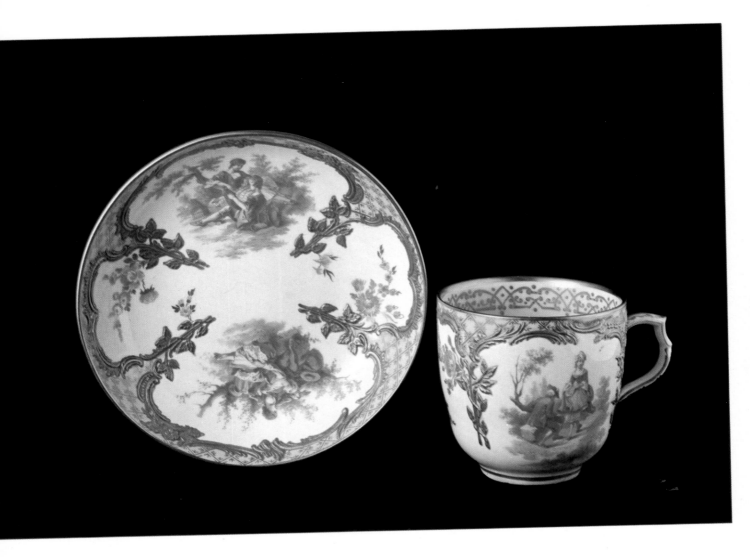

104 Cup and saucer in the third (neo) Rococo
style, Berlin, late nineteenth century; cup 7 cm
high

105 Jug of Parian ware, Bennington, United
States Pottery, c. 1855; height c. 18.4 cm.
Metropolitan Museum of Art, New York

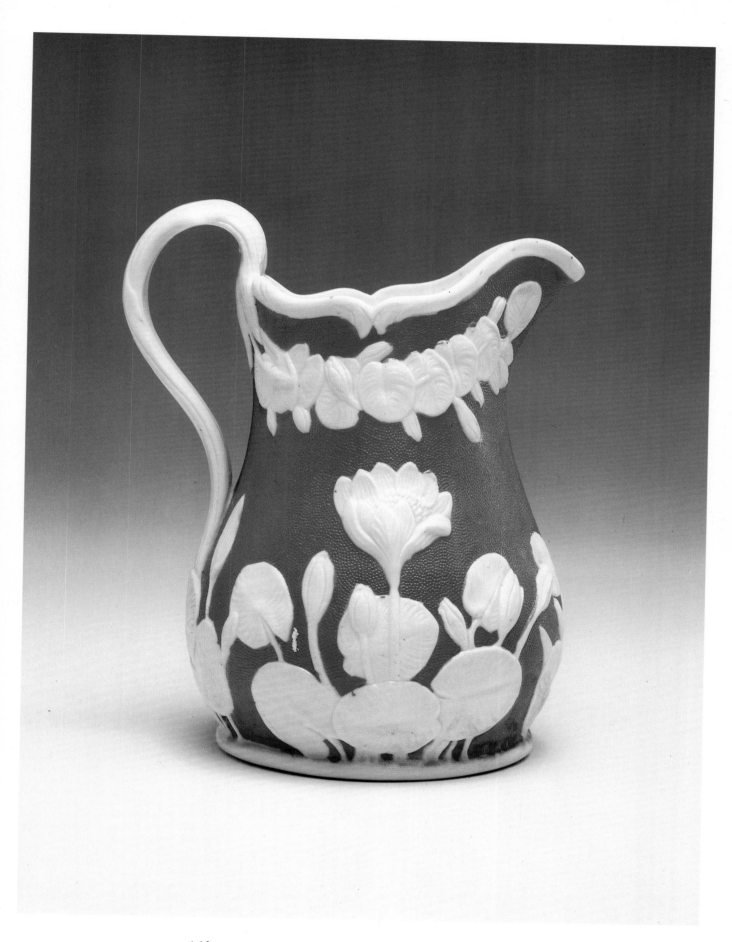

143

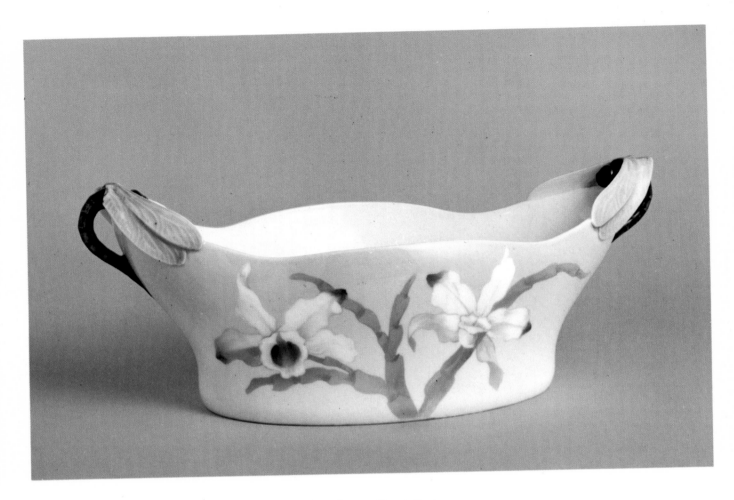

106 Fruit dish, Copenhagen, Royal Factory,
1905–10; 12.1 cm high

and that of the flux is noticeable. Another guide when looking out for fakes is the hollow or flat patch that must be left after the original mark has been ground away; the forger cannot hide this, and the experienced collector will recognize it. The forger had an even more difficult task with impressed marks; their removal left a deep groove which had to be filled in with paste, and the new mark impressed. It was very difficult to find paste of the right colour and consistency to merge with the original body; yet although this method was rarely successful it was also used.

So far we have been discussing fakes made by individuals, but even firms did not hesitate to imitate or forge marks. The simplest trick was to imitate the mark of a successful firm, without actually copying it. The most frequent victim was the Meissen factory, because its wares were in demand all over Europe; the crossed swords were copied in eighteenth-century Germany by factories in Volkstedt, Wallendorf, Limbach, Rauenstein and elsewhere; in England by the Bristol works, Caughley, Chelsea, Worcester and others; in Holland by the Weesp factory, and by Tournai in Belgium. In France the Parisian works in Rue de la Roquette and Rue Fontaine-au-Roy both succumbed to the temptation of using a mark for their ware which was easily taken for that of Meissen. Sèvres was not without its imitators, too, and marks resembling that of Sèvres ware were used at Derby and Worcester in England, and at Limbach in Germany.

In the nineteenth century there were many factories which not only imitated other firms' marks but blatantly forged them. In the context of this chapter the case of "old Vienna" traced by W. Neuwirth is particularly interesting. At the end of the nineteenth century there was a great demand, particularly overseas, for porcelain in the "Vieux Vienne" style made under Sorgenthal's management (1784–1805). This was seized on not only by Austrian and French firms, but primarily by the Czech factories round Karlovy Vary; their task was all the easier since the Vienna mark was no longer protected by patent after the Vienna factory was shut down in 1864. Tons of "Old Vienna" were made in Bohemia for export, about twenty factories making this heavily decorated ware and employing over five thousand workers. This Karlovy Vary ware was so popular overseas that whereas in 1893 export to the United States was to the value of 250,000 dollars, in a few years the figure had risen to 750,000 dollars. It is understandable that such large-scale production, with purely commercial aims, had a bad influence on both technical quality and artistic standards. It was being said by 1900 that "therefore 'modern Vienna' has become a byeword for overdecorated, richly gilded and generally badly painted china".

Even the famous factories of Revived Rococo fame returned to their erstwhile moulds; in the nineteenth century Meissen again used the old moulds, some of which were "improved" in the spirit of romantic historicism, thereby causing irreparable damage to the originals. It would be easy, but wrong, to condemn this period of porcelain production outright. We must remember that in the nineteenth century the porcelain factories were purely commercial ventures whose existence depended on a favourable bank balance. Aristocratic patrons ready to make up financial deficits for reasons of prestige or ambition no longer existed.

The collector, however, especially if he is not yet experienced, finds himself embarrassed by some pieces. We have outlined some of the troubles that may beset him, and it is clear that no reliable guide to recognizing forgeries of the products of any single factory can be given. Experience so far can, however, be summed up in the following general guidelines:

1. A healthy scepticism is desirable when approaching any piece of porcelain; it is wise not to rely on such recommendations as "my grandfather was a student in Meissen (Vienna, Berlin, Copenhagen etc.) when he bought it". It is of course important to know the "pedigree" of the piece, for a reliable and well-catalogued collection is one of the best criteria of authenticity. Today the collector rarely finds such pieces — and if he does, they are likely to be far beyond his financial horizon.

2. It is advisable to seek the most exact knowledge of the porcelain made in the factory from which the piece is supposed to have come. In this those collectors who devote their interest to one single firm are at an advantage. It is advisable to know not only the historical facts,

but also the production process, the subjects dealt with and the decoration technique. It is most helpful to visit museums and other good collections and study their exhibits in detail, from the palette and polish of the glaze and the body to the painter's brushwork. The collector must have "an eye" for pieces from his favourite factory.

3. This does not mean, of course, that the collector can rely on his intuition; such rapid judgements are usually betrayals. The great thing for collectors is never to be in a hurry! Impressions must be confirmed according to guideline 2., and then a decision may be made. It must be borne in mind that forgers — the skilful ones — were well acquainted with the production and decoration techniques employed at the factories whose ware they were faking.

4. When judging a piece of porcelain it is necessary to consider each element step by step. The following approach can be recommended:

a) The body; no two porcelain bodies are alike. This is a matter of the raw materials used, which may have come from different sources and therefore show different characteristics and different colouring. Meissen ware is known, for example, to be relatively heavy; Parisian forgers therefore had to reduce the volume of forged pieces, to achieve approximately the weight a Meissen piece would have had.

b) The glaze. Here it is not only a question of the colour of the glaze, but the surface, because earlier producers had various difficulties in this respect. The glaze may be as smooth as glass, or it may show a crackle, or bubbles, or be rough to the touch. Some English bisque pieces, for instance, have a "smear glaze" which can be barely seen as a matt surface.

c) The colour. The different factories had their own characteristic types of colours, special shades, or individual combinations of colours. For example, connoisseurs recognize the dark brown used by Höroldt in Vienna, because no forgers ever succeeded in reproducing it exactly.

d) Painting. There are two approaches to painted scenes and painted decoration altogether. In the first place, the style or manner of the painting must be seen to correspond to historical reality; we have already mentioned the supposed paintings by A. Kauffmann on Vienna porcelain. Style must be very carefully judged. In the second place, iconography is very significant, and here again, the greatest help is a profound knowledge of the porcelain made by the collector's "own" factory.

e) Marks. A knowledge of porcelain marks is one of the basic requirements for the collector. There are many specialized publications which can help him, but the forger had (and has) the same opportunities. It is essential therefore to know exactly where each factory placed its mark, what colours were used — the shade of colour may be enough to betray a fake. Where the artists signed their work in the factory, this may help us to confirm an attribution.

In general it can be said that no forger could cope with all aspects of his task, either because of technical difficulties, or because of lack of knowledge. To expose fakes is thus a matter of knowledge and experience on our side.

A Concise
Encyclopedia
of Porcelain

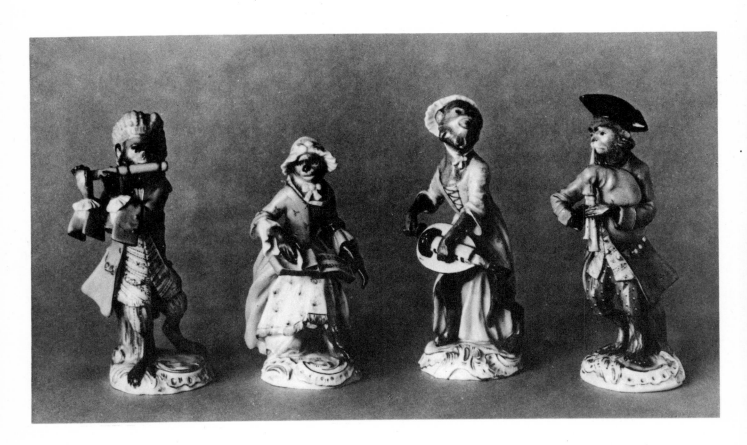

107 Affenkapelle, Meissen, modelled by P. Reinicke, 1765, cast in mid nineteenth century; height of the tallest figure 15 cm

Alt-Brandenstein

Affenkapelle (Germ.), a series of monkey figures, dressed in period costume, playing various instruments, or singing. About 22 subjects are known. First modelled in Meissen by J. J. Kaendler (1747), later by Kaendler and Reinicke (1765–6). Most of the surviving examples belong to this second series. The figures were often imitated, e.g. in Vienna, Fürstenberg, Derby, etc. Five figures were being offered by Chelsea in 1756. Kaendler was probably inspired by Watteau and Huet. The figures were frequently copied in the nineteenth century.

Alcora, a Spanish factory, 1786–before 1858. In the faience works which had been operating since 1727 the Parisian Pierre Cloosterman succeeded in making hard-paste porcelain in 1786. The factory was closed down in 1858, but had not been producing porcelain for some time before that. Table ware in the fashion of Paris was made, and small scent bottles and snuffboxes are known.

Alt-Brandenstein (Germ.), a type of modelled porcelain decoration used in Meissen, of woven basket pattern, alternately straight and slanting. Used from the 1730s and called after the Saxon Elector's chef, F. A. von Brandenstein.

Alt-Ozier (Germ.), a modelled decorative motif

148

Alt-Ozier

used in Meissen, representing thick oiser weave interrupted by straight strokes. It was first used in the mid eighteenth century and often imitated by other factories, e.g. Berlin.

American China Manufactory, U.S.A., a factory producing hard-paste porcelain in Philadelphia, founded in 1825 by William Ellis Tucker. The factory produced household ware up to about 1836; A.C. Walker, J. Morgan, C. Frederick, W. Hand and Vivian were among the modellers.

American Porcelain Manufacturing Company, U.S.A., a factory making soft-paste porcelain 1854–7, in Gloucester, New Jersey. In 1857 the name was changed to "The Gloucester China Company", and in 1860 it was closed down. The ware was white, without decoration.

Angerstein service, a service made in the Coalport factory (Salop, c. 1805) for the banker J. J. Angerstein; each of the 98 pieces is decorated with child figures in silhouette.

Anreiter von Zirnfeld, Johann Karl Wendelin, b. 1702 Banská Štiavnica, Czechoslovakia, d. 1747 Vienna; painter on porcelain, specializing in ornament, landscape and Chinese figures. Employed by the Vienna factory (1724–5, 1737 and 1746–7) and in Doccia (1737–46). He also worked as an independent decorator, painting Meissen and oriental wares.

Ansbach 1757–1860

Ansbach 1757–90

Ansbach c. 1765

Ansbach, a German factory, 1758–1860, established by the Margrave Christian Friedrich Alexander in a faience works which had been operating since 1710. In 1763 the porcelain factory was moved to the shooting lodge of Bruckberg, sold by auction to C. F. Löwe in 1807 and finally closed down in 1860. From the foundation to 1791 it was managed by J. F. Kaendler, nephew of the Meissen Kaendler; later it was run by the painter Melchior Schöllhamer. Ansbach table ware was well decorated, and the figures included such exotic types as Tartars, Indians, Turks, etc.

Antikzierat (Germ.), a raised decoration used in the Berlin factory. The ware was edged with a band of sticks in relief, tied with ribbons, alternating with scale ground (écaille) surrounded with rocaille and tendrils. Dates from the 1760s.

Arcanum, the eighteenth century term for the formulas used in the making of porcelain, i.e. the composition of the paste and its preparation, firing, painting, etc. The arcanist possessed knowledge of all stages of the complete process.

Artifical porcelain *see* Pâte tendre

Auliczek, Dominicus, b. 1734 Polička, Bohemia, d. 1804 Nymphenburg. A sculptor, apprenticed in Polička, years in Vienna, Paris, London and Rome. Succeeded Bustelli (1763) at Nymphenburg, where he led the modelling department until retirement in 1797. From 1773 he was also manager of the factory. Famous for his hunting groups, of which about 25 are known, for allegorical figures of the gods of classical antiquity and relief portraits.

Bachelier, Jean-Jacques, b. 1724 Paris, d. 1806 ibid. Art director at Vincennes and Sèvres 1751–93, previously employed there as a painter (from 1748). In 1751 he introduced a new material for porcelain figures — bisque; in the Neoclassical period it was popular in almost all European factories. Bachelier laid the foundations of the fame of Sèvres porcelain.

Baranówka 1804–5

Baranówka, a Polish factory (today U.S.S.R.), operating from 1804 to the early twentieth century; founded by Adam Waleski, who entrusted it to Michal and Franciszek Mezer. They brought in workers from the Korzec factory, so that at first the wares of the two factories are difficult to distinguish. The peak period was round 1820. Mainly tableware was produced until 1895, when the factory went over to stoneware for technical reasons.

Belleek ware, a type of porcelain made in Belleek, Ireland, from 1863, famous for its very thin body and an iridescent glaze obtained by the use of bismuth. It was soon being made also in U.S.A. in Baltimore (Maryland) and Trenton (New Jersey). Lotus ware was an imitation of Belleek ware made in East Liverpool (Ohio).

Bell-toy pattern, a type of decoration used in the Caughley factory, in Shropshire; the central motif is a Chinese woman with a child, who

holds four bells on the crossed arms of a long stick; c.1776.

Benckgraff, Johann, b. 1708 Mellrichstadt, d. 1753 Fürstenberg. An arcanist who worked with J. J. Ringler and introduced the making of porcelain in the Höchst factory, where he was manager 1750–3. In 1753 he started production at the Fürstenberg factory.

Berlin: Wegely 1751–7

Berlin: Gotzkowsky 1761–3

Berlin: Royal factory
1763–70 and 1790s

Berlin, Germany, factories:
Wegely, 1751–7. Wilhelm Caspar Wegely, a woollen cloth manufacturer, was granted a monopoly of porcelain manufacture by Frederick II, and also land on which to build a factory, near the former Königstor in Berlin. After unsuccessful negotiations with the Höchst arcanist Benckgraff, he started production, but the ware had many faults — cracks, bubbles in the glaze, uneven glazing and trouble with colours. In 1757 production ceased, for financial reasons.
Gotzkowsky, 1761–3. The second Berlin factory was established by a merchant, Johann Ernst Gotzkowsky. in 1761, on Leipziger Straße. He employed two arcanists from Wegely's factory, the modeller E. H. Reichard and the painter I. J. Clauce. J. G. Grieninger was the manager. The factory gained considerably when the Meissen modeller Friedrich Elias Meyer and the painters K. W. Böhme, J. B. Borrmann and K. J. C. Klipfel were taken on. Kaolin was brought from near Passau; the ware has a yellowish tinge and the body is greyish. As early as 1763 Gotzkowsky sold the factory to the king.
Royal Porcelain Factory, 1763 to the present day. Gotzkowsky sold the factory to Frederick the Great for 225,000 thalers because it was in financial straits. The important goal set was the production of pure white porcelain; this was not achieved until after the discovery in 1771 of kaolin deposits in Prussia, at Sennewitz and Morl. After the death of Frederick II the factory was run by a "Königliche Porzellanmanufaktur-Kommission", which modernized the equipment (circular kilns, steam power). Even after the Napoleonic Wars the factory maintained its high standards, particularly in the painting (views and landscapes, etc.). In 1878 a chemical-technical institute was established for the factory, run by Hermann Seger, a well-known technologist. After the Romantic historical period, "Jugendstil" (Art Nouveau) prevailed around 1900 and placed Berlin at the head of German porcelain production. The director at that time was Theo Schmuz-Baudiss.

Berlin transparency *see* lithophany

Beyer, Johann Christian Wilhelm, b. 1725 Gotha, d. 1806 Schönbrunn. Painter and sculptor trained in Dresden; 1759–67 he was court sculptor to the Duke Karl Eugen of Württemberg, after spending some years in Stuttgart, Paris and Rome. In 1768 he went to Vienna. While in the services of the Duke he was in charge of the repairers working in the Ludwigsburg factory and himself modelled many figures (classical themes and folk types). His set of seven musicians, the "Musiksoli", of 1765–6, is well known.

Billingsley, William, b. 1758 Derby, d. 1828 Coalport. English porcelain painter. He worked at Derby 1775–96, where he served his apprenticeship. He founded several factories (Pinxton 1796, Brampton-in-Torksey 1808, Nantgarw 1813). He had a workshop in Mansfield where he painted both French and English porcelain; he was one of the best flower and landscape painters in England.

Billingsley roses, the flower painting style of W. Billingsley, particularly his roses. The petals were treated with a thick coat of paint, and lighter patches in dry brushwork. This style can be traced from 1784 and had many imitators in England.

Bisque, biscuit (Ital. biscotto, twice-baked), unglazed matt porcelain imitating marble or alabaster. It was introduced in Vincennes by Bachelier in 1751, and later produced in many European factories, but of varying quality. Vienna, Sèvres and Thuringian bisque ware is yellower and softer, while that of Berlin and Meissen is hard, with a bluish tint. Bisque was very popular for figures, particularly antique subjects during the period of Neo-classicism.

Blanc de Chine, Chinese porcelain with blue and white or ivory glaze, made in Te-hua, Fukien province; the most frequent themes are figures of Buddhist or Taoist holy men, genre figures, and table ware with a plum-blossom design in relief. This porcelain was imported to Europe from the mid seventeenth century onwards and

exercised a strong influence particularly on early soft-paste porcelain designers (St. Cloud, Chantilly, Mennecy, Vincennes) as well as on some hard-paste designs (Böttger, both porcelain and stoneware). In the mid eighteenth century Blanc de Chine was imitated in both Bow and Buen Retiro.

Bleu céleste (bleu nouveau, bleu de Sèvres, Fr.), an azure blue invented in 1752 by the chemist J. Hellot at Vincennes and used from 1753. It is sometimes wrongly called "bleu turquoise".

Bleu de roi (bleu royal, Fr.), a deep blue ground colour invented at Vincennes about 1749 and much imitated by other factories.

Bleu lapis (bleu de Vincennes, Fr.), a clear blue imitating the appearance of lapis lazuli, with veins that are sometimes picked out in gold. It was used in Vincennes in the 1750s.

Body, the material formed by the firing process; the type and quality of ceramic wares is determined by such criteria as hardness, density, translucence, porosity etc. of the body.

Boizot, Louis-Simon, b. 1743 Paris, d. 1809 Paris, sculptor, pupil of Slodtz. He joined the Sèvres factory in 1774 and was chief modeller 1774–1820. He worked in the Neo-classical idiom, among his principal works being a number of portraits, an allegory of the coronation of Louis XVI and Marie Antoinette (L'Autel Royal, 1775), an equestrian statue of Frederick the Great (1781), etc.

Bone china, English china, a soft-paste with a bone ash content, made in England. The patent for bone china was granted to Thomas Frye of Bow in 1744 and 1748. The composition of bone china was improved by Josiah Spode about 1794, in Stoke-on-Trent, and by Barr in Worcester. It was very popular in nineteenth century England and is still being produced today. Although bone china has not the disadvantages of French soft-paste china, it is not of such good quality as hard-paste ware. It is composed of kaolin (20–30%), felspar (20–30%), bone ash (40–50%) and silica, and is fired at 1,250–1,300°C. Outside England it was made in Sweden (Gustavsberg, Rörstrand) after the middle of the nineteenth century.

Bonnin and Morris, U.S.A., a factory founded in 1770 in Philadelphia, to make bone china of the English type. Gousse Bonnin and George Anthony Morris made the first true porcelain in America, in shapes copied from English ware. The factory was closed down in the autumn of 1772.

Botanical ware, decorated with floral designs taken from botanical manuals. Introduced in Meissen after 1735 (J. W. Weinmann, *Phylan-*

thus Iconographia, Augsburg 1737), the manner was copied throughout Europe. In mid eighteenth-century England the flowers were copied in Chelsea from P. Miller's *Gardener's Dictionary*, 1752. The greatest achievement in this style was the "Flora Danica Service" made by the Copenhagen porcelain factory 1790–1802, painted after the book by Georg Christian Öder *Flora Danica* of 1766.

Böttger, Johann Friedrich, b. 1682 Schleiz, d. 1719 Dresden, inventor of European hard-paste porcelain. Apprenticed to the Berlin apothecary Zorn from 1698, he tried to make gold by alchemy, but was forced to flee from the territory of Frederick I of Prussia and took refuge in Wittenberg, in Saxony (1701). Here he was arrested on orders from the Elector, Augustus the Strong, and taken to Dresden. After further alchemist experiments had failed he began in about 1706 to work on porcelain, guided by E. W. von Tschirnhaus; the experiments took place in Albrechtsburg, Meissen, then from 1707 in the fortress in Dresden. At the end of 1707 he invented the red stoneware known as "Jaspisporzellan", and on 15th January 1708 he fired the first successful samples of true white porcelain. He reported to the Elector of Saxony on his work on 28th March 1709, and the Dresden porcelain factory was established by decree on 23rd January 1710. On 6th June of that year it was moved to Albrechtsburg in Meissen. Böttger worked as "administrator" of the factory until his death, improving both the production and the decoration of Meissen porcelain.

Böttgerporzellan (Germ.), the ware produced at Meissen in Böttger's time there. At first the body was opaque and yellowish and the glaze greenish, sometimes marred by bubbles. From 1717 onwards the body was whiter and the glaze colourless. At first the shapes were those of Böttger's stoneware, and the painted decoration was sometimes unfired. Not many figures were made (e.g. Chinese figures, and "Callot" dwarfs). The ware was unmarked.

Boucher, François, b. 1703 Paris, d. 1770 Paris, painter and engraver, one of the leading Rococo artists. 1734–65 he was in charge of the royal Gobelins workshops, and was a member of the French Academy from 1734. He designed Sèvres models all his life. Engravings of his work were used as models in many European porcelain factories (cherubs, rustic idylls, fêtes champêtres and pastoral scenes of which two were used for the famous Sèvres groups, "Les mangeurs de raisins" and "La leçon de flageolet", 1753).

Bow, London, an English porcelain factory, 1744–76. It was here that Thomas Frye set up production of bone china after being granted patents in 1744 and 1748. In 1750 the factory

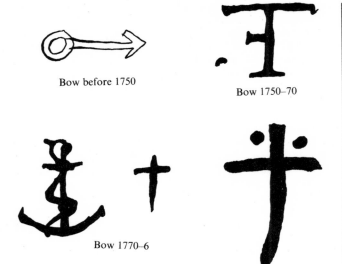

Bow before 1750

Bow 1750–70

Bow 1770–6

Bow 1770–6

was taken over by Weatherby and Crowther and called "New Canton", but Frye managed the works until 1759. In 1776 it was bought by W. Duesbury, who took the Bow moulds to Derby. The most interesting items of Bow ware were the figures.

HK

Březová 1803–10

F & R

Březová 1811–46

Březová (Pirkenhammer), a Bohemian factory 1803 to the present day. Founded in 1803 by F. Höcke, it was not until 1810, when it was purchased by J. M. Fischer and K. Reichenbach, that production assumed greater proportions. From 1857 the owners were Fischer & Mieg. The period of greatest fame was from 1810 to the middle of the century, when the porcelain made there was considered the finest in Bohemia for its translucency and the high standard of taste in form and decoration. It was the first factory to introduce transfer printing in Bohemia, in 1829.

Bristol, England, factories:
Lund, 1748–52. Benjamin Lund and William Miller seem to have set up a factory to pro-

Bristol: Lund 1748–52

Bristol: Cookworthy 1770–82

duce soapstone porcelain in 1748, a small concern making wave with decoration influenced by oriental models; figures modelled on Chinese patterns and marked "Bristol" are known. Cookworthy and Champion, 1770–82. This second Bristol factory was founded by W. Cookworthy when he moved here from Plymouth. He made a hard-paste porcelain patented by himself and passed to Richard Champion in 1772. From 1774 Champion was sole owner of the factory, which closed down in 1782.

Brühl, Heinrich, Count von, b. 1700 Gangloffsömmern near Weissensee, d. 1763 Dresden, a leading statesman at the court of Augustus III of Saxony, where he was First Minister from 1747. In 1735 he was entrusted with the running of the Meissen factory; it was he who commissioned the "Schwanenservice", modelled by J. J. Kaendler.

Brühlsches Allerlei-Muster (Germ.), a type of pattern on Meissen table ware. Bunches of flowers, shells and palmettes alternate in low relief, with an osier-weave in between. It was designed in 1742 by J. F. Eberlein for a service commissioned by Count von Brühl.

1760–1803 1760–1803

Buen Retiro

Buen Retiro, a Spanish factory, 1760–1808,

152

continuing the work of the Capodimonte factory, which Charles of Bourbon dismantled and took with him to Madrid when he ascended the Spanish throne in 1759. The artists and porcelain workers were also taken to Buen Retiro, so that the Capodimonte tradition was not broken. Buen Retiro made soft-paste porcelain up to 1804, when Vibien, from Sèvres, introduced a hard paste. The factory was destroyed in the 1808–12 Peninsular War.

Buontalenti, Bernardo, b. 1536 d. 1608. Florentine sculptor and architect, who worked as a chicf artist together with F. Fontana in the workshop making Medici porcelain, set up by Francesco de Medici in Florence in 1576.

Bustelli, Franz Anton, b. around 1723 Locarno (?), d. 1763 Nymphenburg, figure modeller in the Nymphenburg (Neudeck) factory from 1754.

He is one of the most individual artists in eighteenth century porcelain. Little is known of his life, but he may have studied in Munich under the sculptor J. B. Straub. His best work includes a series of sixteen figures from the Commedia dell'arte, in characteristic poses. He also modelled folk types, craftsmen, portrait busts, etc., and his groups modelled on French subjects are well known, e.g. "Der Lauscher am Brunnen" and "Der stürmische Galan".

Caillouté (Fr.), a Sèvres pattern used around 1752, usually in the form of a network of gold ovals on a dark blue ground. It was often copied by other factories, especially Worcester and Derby.

Callot dwarfs, small figures of dwarfs and cripples, caricaturing contemporary types, trades and social classes. They were frequently model-

Brühlsches Allerlei-Muster

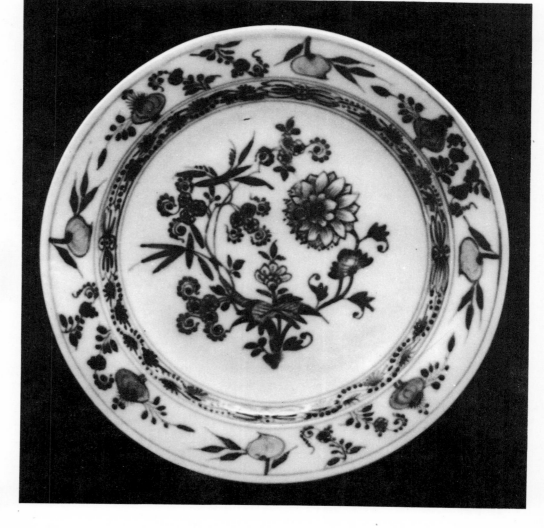

108 The onion pattern, plate, Meissen, 1740, diameter 26 cm. Private collection, Prague

153

led in Vienna, Chelsea and Venice, where the Cozzi factory was still making them in 1770. All these dwarf figures were modelled after engravings by the French artist Jacques Callot (1592–1635).

Camaïeu, painting on porcelain in which various shades of the ground colour are used to build up the scene. The style appeared in Meissen before 1730. Favourite colours were sepia, purple, and green; camaïeu painting in grey was known as "grisaille".

Capodimonte

Capodimonte, an Italian factory, 1743–59, founded by Charles of Bourbon. Production started in 1743 under the chemist L. O. Schepers and the painter G. Caselli. In 1759 the factory was transferred to Buen Retiro in Spain. The main production was table ware, up to 1757 following the fashion of Meissen and Vienna, but large figures were also modelled, by Giuseppe Gricci. Capodimonte porcelain is among the best produced in the eighteenth century.

1772–83 1783–99

Caughley

Caughley, an English factory, 1750–1814, founded in 1750 by Browne, bought in 1754 by Gallimore, and taken over in 1772 by Thomas Turner of Worcester. In 1799 Turner sold the works

to a former apprentice, J. Rose, who then produced only white ware which he had decorated in his Coalport factory. Caughley works closed down in 1814; the wares, known as Salopian china, followed the style of Worcester.

Chantilly

Chantilly, a French factory, 1725–1800, founded by Louis-Henri de Bourbon, Prince de Condé, in his Chantilly palace, and based on the discovery of a formula for frit porcelain by S. Cirou. There were many managers after the death of Cirou, the last of whom, the Englishman C. Potter, went bankrupt. The factory then closed down. Up to the middle of the eighteenth century Chantilly ware was modelled on oriental porcelain, after that on Vincennes-Sèvres ware. A technique characteristic of the factory was a faience tin glaze.

Chelsea 1752–69

Chelsea 1769–84

Chelsea, London, an English factory, 1743–84. Founded by C. Gouyn and N. Sprimont, the Chelsea works made frit porcelain perhaps according to the formula of Thomas Briand. The factory was bought in 1769 by J. Cox and a year

later by W. Duesbury, who united it with his Derby factory. Chelsea was closed down in 1784. The wares are divided into four periods, according to the marks; the triangle period, up to 1749, raised anchor period, 1750–3, modelled on oriental porcelain; red anchor period, 1753–8, modelled on Meissen; gold anchor period 1758–70, modelled on Sèvres porcelain. From 1770 to 1784 is the Chelsea-Derby period. The red anchor period marked the artistic peak of Chelsea porcelain and English china altogether.

Chelsea toys, the term used for the small Chelsea wares such as scent bottles, powder boxes, needle cases, seals, etc., in the shape of tiny figures, animals, cherubs, and so forth.

Chicaneau, Pierre, b.?, d. before 1678, French potter, who began to make frit porcelain in his St. Cloud faience workshop, before 1677. After his death the factory was owned by the Trou family until it was liquidated in 1766.

China, the term which became common in England in the mid eighteenth century for all forms of porcelain; it was an abbreviation of "china ware", i.e. imported Chinese porcelain.

Commedia dell'arte (It.), an improvized comedy in the tradition of Italian popular farce, which originated in the thirteenth century and enjoyed its peak from the seventeenth century until about 1760 in Europe. There was no written dialogue, and the actors improvized according to a set story (scenario). The characters were set types, always dressed in the same costume; best-known were Pantalone the merchant, Harlequin, Brighella the cunning servant, Pierrot, Columbine, Isabella, etc. The characters were a favourite subject for modellers in porcelain, the earliest known being a Harlequin made in Böttger's stoneware about 1710. Kaendler made similar figures in Meissen about 1740. The Nymphenburg figures modelled by Bustelli probably 1755–60 are considered to be the finest. Series were made during the eighteenth century in Germany (Frankenthal, Höchst, Fulda, etc.), in England (Chelsea and Bow) and in Italy (Doccia). The modellers most frequently used as their models the illustrations to L. Riccoboni's *Histoire du théâtre italien depuis la décadence de la comédie latine* (Paris 1728–31).

Cookworthy, William, b. 1705, d. 1780, a chemist and apothecary, one of the inventors of porcelain in England. He began experimenting in 1745, and found that steatite (soapstone) could be used in porcelain paste. Lund used this knowledge in Bristol, 1748–52. In 1768 Cookworthy set up a factory for hard-paste porcelain in Plymouth, after finding deposits of kaolin near St Austell in Cornwall in 1758. In 1770 he moved his factory from Plymouth to Castle Green, Bristol, and ran it until 1773.

Chelsea toys: needle-case

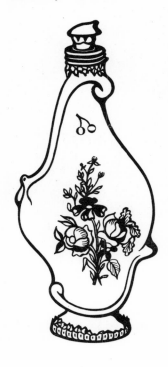

Chelsea toys: scent bottle

Copenhagen: Royal Factory 1760–6

Copenhagen: Royal Factory 1775–1801

Copenhagen: Bing & Grøndahl from 1853

Copenhagen, a Danish factory, 1759 to the present day. Experiments had been carried out in Copengahen as early as 1731 by Elias Vater of Dresden, but it was not until L. Fournier was brought in from France, that production of frit porcelain began in 1760. In 1773 hard-paste porcelain was introduced, using kaolin from Limoges, which was later replaced by Bornholm clay. From 1775 the factory was run as a limited company, until bought by the king in 1779. It was then called the "Kongelige Danske Porcelainsfabrik", and when it again became a private company in 1867 the firm retained the right to use this name. The artistic reputation of Copenhagen ware dates from after 1780 (the Flora Danica Service, 1790–1802); the modelling style suggests that German artists were involved (Fürstenberg?). The second great period was around 1900, when Arnold Krog was in charge of artistic policy. The factory then led European production particularly in decoration with plant motifs, landscape and animal figures painted in delicate greys, blues and greens. In 1853 another factory was set up in Copenhagen by the firm Bing & Grøndahl, producing porcelain in no way differing from that of the royal factory.

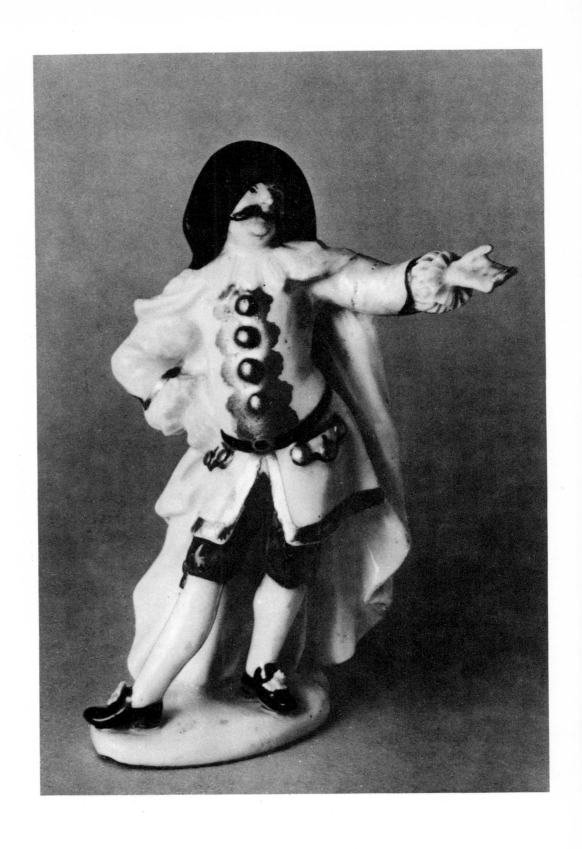

109 Commedia dell'arte, Doctor Boloardo, Meissen, modelled by P. Reinicke, 1743–4; height 13.9 cm

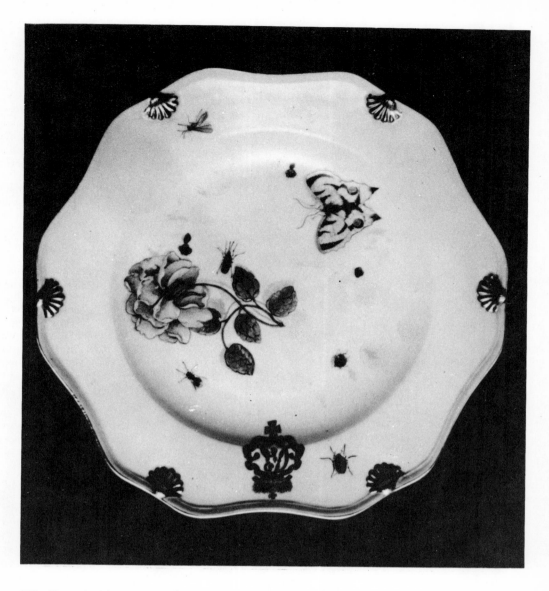

110 Deutsche Blumen, plate from the Clement Augustus service, Meissen 1741–2; diameter 25.5 cm

Cries of London, a series of London street figures, inspired by the Meissen series Cris de Paris, made in Derby in the 1760s.

Cris de Paris (Fr.), a series of figures of street sellers of fruit and flowers, traders and craftsmen, modelled by J. J. Kaendler in Meissen. He drew his inspiration from a stay in Paris in 1750. Later figures were modelled in Meissen by F. E. Meyer and Reinicke. Other factories also imitated them; the figures were modelled according to drawings by Bouchardon, engraved by Michel Le Clerc about 1740.

Cris de Vienne (Fr.), a series of Vienna street figures, inspired by the Meissen Cris de Paris, modelled in Vienna by J. J. Niedermayer.

Déjeuner (Fr.), a tea or coffee service for two, intended for breakfast use.

Derby: Duesbury 1770–84

Derby, England, factories:
Briand and Marchand, 1745. No details are

157

known of this factory, set up by Thomas Briand and James Marchand.

Duesbury, 1756 to the present day. Founded in 1756 by William Duesbury, who also acquired the Chelsea factory in 1769 and Bow in 1776. The figure porcelain was important; at first the influence of Meissen was very strong, but during the Chelsea-Derby period (1770–84) Sèvres Neoclassicism took over. The best of the modellers was John Bacon (c. 1765), while William Billingsley was outstanding among the painters (1775–96). Most of the figures are unmarked.

Deutsche Blumen (Germ.), German flowers, the term for a type of floral decoration on eighteenth century porcelain, representing European plants. It was first used in Vienna after 1725 on porcelain commissioned for the Dubský Palace cabinet. In Meissen it appeared after 1735, where J. W. Weinmann's *Phylanthus Iconographia* seems to have supplied the model (Augsburg 1737). In 1741 a variant of the German flowers appeared, known as "Ombrierte deutsche Blumen" — flowers throwing a shadow — or sometimes "Saxe ombré". The style was adopted by the Berlin factory about 1740, whence it spread all over Europe.

Doccia
both marks 18th century to c. 1850

Doccia, an Italian factory, 1737 up to the present day. Founded by Marquis Carlo Ginori it attained importance only in 1746 when the Vienna painter Anreiter von Zirnfeld was engaged. In the eighteenth century large vases and figures were produced, and there was a demand for smaller replicas of classical statues. From 1807 the factory also made wares in the style of Capodimonte, especially cups and vases. In the second half of the nineteenth century elaborate vessels in pseudo-Baroque style were made. The best modeller in the eighteent century at Doccia was Gasparo Bruschi.

Dresden china, the usual term given to Meissen porcelain in England in the eighteenth century and later.

Dubois, Robert, b. 1709 Bézancourt, d. ?, French arcanist and mould maker, working in Chantilly 1734–8, and without success in Vincennes, 1738–41. 1750–3 he was in Tournai, managing the factory of F. J. Peterinck.

Duché, André, a French Huguenot who discovered kaolin deposits in Georgia in 1730. He negotiated for the export of the clay to England, but there is no evidence that any quantity was actually delivered from America.

Duesbury, William, b. 1725 Longton Hall, d. 1785 Derby, an English porcelain painter who owned a workshop in London, 1751–3; in 1756 he bought the Derby works, later acquiring also Longton Hall (1760), Chelsea (1770) and Bow (1776). This made Derby, which was Duesbury's until his death, the most important porcelain factory in eighteenth century Europe.

Dulong-Muster, Dulong-Reliefzierat (Germ.), a type of raised relief on Meissen ware, with rocaille cartouches round the edge, interspersed with three arrows or palmettes. It was designed in 1743 and named after the Amsterdam firm of Godefroy et Dulong.

Du Paquier, Claudius Innocentius, b. ?, d. 1751, Vienna, founder and first owner of the Vienna porcelain factory (1718–44). His name is given to the wares of the first period of the Vienna factory.

Dwight, John, probably b. 1673, d. 1703, an English maker of stoneware who tried to make porcelain in his Fulham workshop but succeeded only in achieving stoneware with a porcelain appearance. The patent for porcelain production granted to him in 1671 by Charles II is the first written evidence of attempts to make porcelain in England.

Écaille (Germ. Ecaillemalerei), a painted decoration appearing as scales, used to decorate the edges of vessels or to fill in between patterns. First used in Vienna 1730–40, about 1760 in Meissen and Berlin. It was not often used outside Germany; in Worcester the "scale blue" was adapted from Meissen. In the eighteenth century the pattern was also called "mosaïque".

Eberlein, Johann Friedrich, b. 1696 Dresden, d. 1749 Meissen, modeller in the Meissen factory, working with Kaendler. From 1735 he remained with the factory until his death, working together with Kaendler (the Schwanenservice, Elementvasen, Augustus III in Polish costume, etc.) and on his own (animals, allegorical figures, raised decoration on tableware).

Eisenporzellan (Germ.), an outdated and inexact term for red stoneware of the type of Böttger's "Jaspisporzellan".

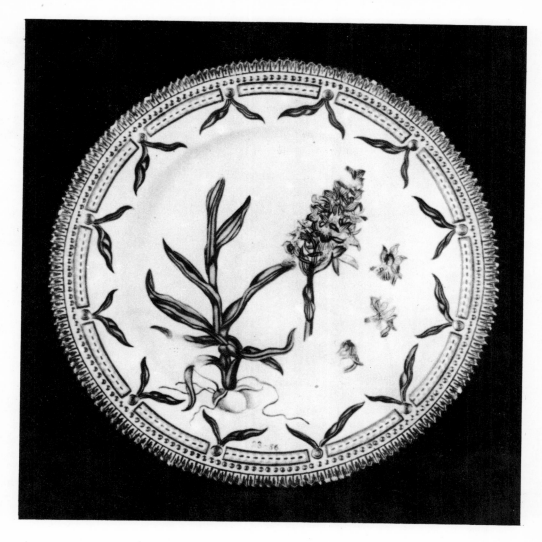

111 Plate from the "Flora Danica" service, Copenhagen, painted by J. C. Bayer, after 1769. De danske kongers kronologiske samling på Rosenborg, Copenhagen

Elfenbeinporzellan (Germ.), a yellowish porcelain with a dull ivory gleam, made in Worcester in the eighteenth century and later in Berlin and elsewhere.

English china, although meaning any porcelain made in England, is usually reserved for bone china.

Entrecolles, Père François Xavier d', b. 1662, d. 1741, a Jesuit missionary in China who sent a report on the making of porcelain in China to Paris in 1712 which was published in 1716 in the *Journal des Savants*.

Flacon, scent bottle, made in a variety of shapes by eighteenth century porcelain firms, from bottles to figures or tiny books.

Fliegender Hundmuster, a Meissen pattern taken from a Chinese motif of a winged animal, first painted about 1731.

Flintporslin (Swed.), not true porcelain but English-type stoneware (cream-colour ware) made in Marieberg, Sweden, in the eighteenth century.

Flora Danica Service, made in Copenhagen 1790–1802, had a specimen of the Danish flora painted on each piece, together with Linnaeus's botanical classification. It was painted by J. C. Bayer of Nuremberg. Originally intended as a gift for the Russian Czarina Catherine II, after her death in 1796 it remained in Denmark.

Floramuster *see* Gotzkowskys erhabene Blumen

Fontana, Flaminio, a potter from Urbino who worked with B. Buontalenti in Florence from 1573 in research and production of Medici porcelain.

Frankenthal, German factory, 1755–99. When Paul Anton Hannong was forbidden to make

porcelain in France, he moved his Strasbourg factory to Frankenthal, in 1755. The factory remained in the Hannong family until 1762, when it was sold to the Elector Palatinate. In 1795 the French occupied Frankenthal, and sold the factory to Peter van Recum, but in autumn 1795 it was again in the Elector's hands, until the peace of Campoformio in 1797 returned it finally to French ownership. Van Recum stopped production in 1799 and closed the works down for good in May 1800. The factory was famed for its figures (modelled by Johann and Karl Lück, J. P. Melchior and others) and for its painting on china (B. Magnus).

Fulda 1764–88

Frankenthal 1756–9

Frankenthal 1762–94

Frankenthal 1797–9

Frit porcelain, a soft-paste porcelain probably invented by L. Poterat in Rouen in the early 1670s. By its composition (potassium nitrate, soda, alum, ground quartz, etc.) without kaolin it must be considered a substitute, not a ceramic paste. The low firing temperature (1,100–1,250°C) made it possible to use a rich palette for the underglaze decoration. Frit porcelain was sensitive to changes in temperature, however, and the lead glaze was easily scratched, so that it was not a good material for household ware. Production was widespread in France, Italy, Spain and Belgium during the eighteenth century.

Frye, Thomas, b. 1710 near Dublin, d. 1762 London, English painter and inventor of bone china, which he patented in 1744 and 1748. He founded the Bow factory to produce bone china, and ran it until 1759, when he seems to have returned to his painting. Bone china was improved by Spode at the end of the eighteenth century.

Fulda, a German factory, 1764–89. "Fürstliche Fuldaische Porzellanfabrik" was founded in 1765 with the help of the arcanist Nicolaus Paul. It was completely burnt down in 1767. From 1770

it was managed by Abraham Ripp, until financial difficulties set in and it had to be closed down in 1789. The Fulda porcelain was of a clean body and clear glaze, and figures modelled after Meissen and Frankenthal were of good standard.

Fürstenberg 1753–70

Fürstenberg, a German factory, 1747 to the present day. Founded by Karl I of Brunswick in 1747, at first without success, until the first arcanist J. C. Glaser was joined by J. Benckgraff of Höchst in 1753; the first porcelain was fired the same year. The factory enjoyed its best period 1770–90, under J. E. Kohl. Under V. L. Gerverot (1795–1814) the French Neoclassical style prevailed. In 1859 the factory was rented out; it now works as a state enterprise. From the formal point of view Fürstenberg ware derives from Meissen and Sèvres models.

Gelbe Löwenmuster (Germ.), a design of yellow lions painted on a service for Augustus II of Dresden, made in Meissen in 1728 and decorated in the kakiemon Japanese style then fashionable.

Gera 1820–40

Gera, a German factory, 1779–1900. After J. G. Ehwaldt and J. G. Gottbrecht tried unsuccess-

(continued on page 169)

112 Guineapigs, Berlin, 1914–18; 10,5 cm high

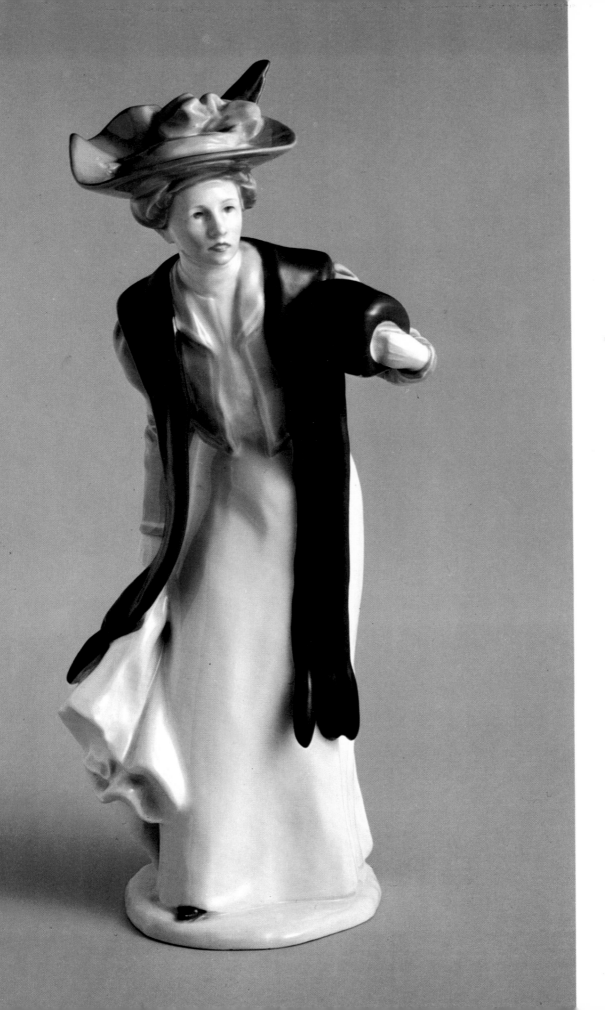

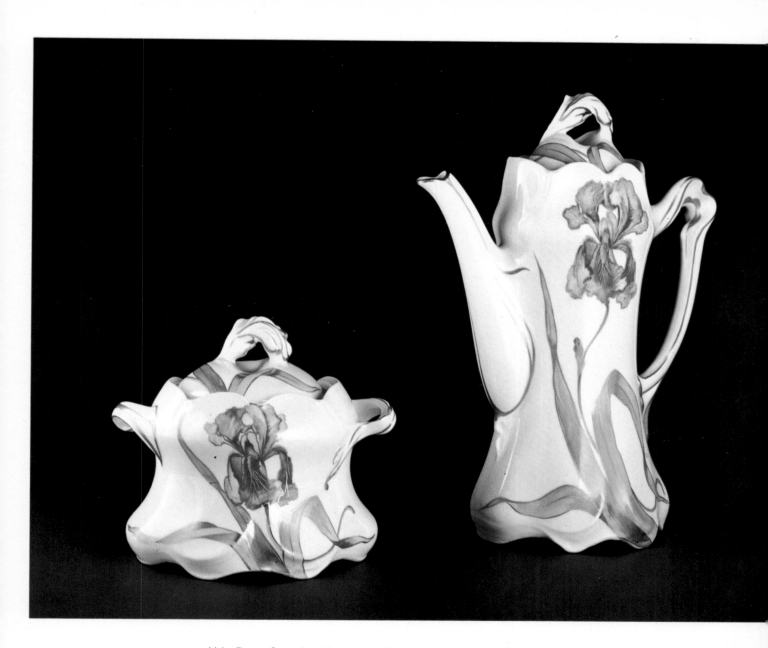

114 Part of an Art Nouveau coffee service,
Karlovy Vary, c. 1900; pot 25 cm high

◀

113 Woman with a muff, Meissen, 1910; 33 cm
high

163

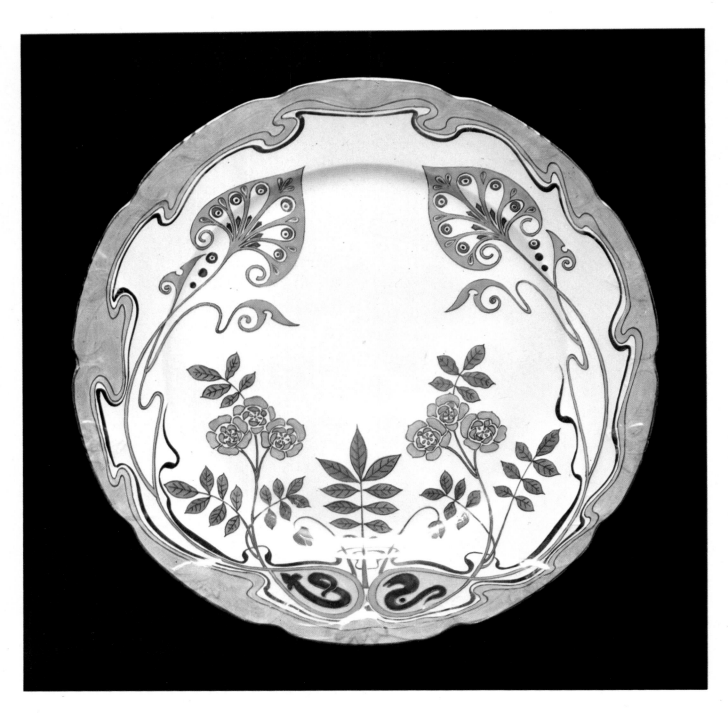

115 Plate with Art Nouveau decoration, Klášterec, after 1900; diameter 23.5 cm

116 Woman with a small hat, Nymphenburg, c. 1925; 22.3 cm high

164

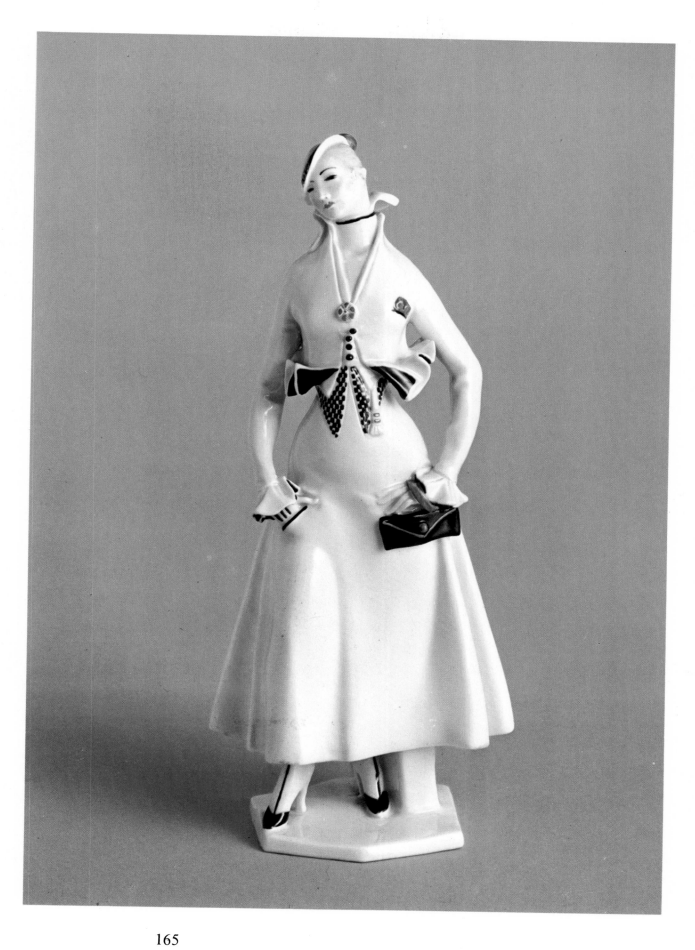

165

117 Militiawoman. Petrograd, modelled by Natalia J. Danko, 1920; 21.4 cm high

118 (*facing page*) Der Flötenunterricht, Vienna, modelled by D. Pollion, 1765–70; 27.8 cm high

167

119 Harlequin, Meissen, modelled by J. J.
Kaendler, 1736; 12.5 cm high. Private collec-
tion, Prague

fully to make porcelain there in 1779, the brothers Georg Wilhelm and Johann Andreas Greiner took the factory over in 1780. After the death of G. W. Greiner in 1792 and his brother in 1799, the factory passed to Louisa Greiner; from 1804 G. H. Leers was part-owner. The speciality of the firm were gift cups; the body of Gera ware was greyish and the glaze thick.

Gioanetti, Dr. Vittorio Amadeo, b. 1729, d. 1815, Italian chemist, reopened the Vinovo works in 1780 after P. A. Hannong of Strasbourg had failed to get it going. Gioanetti ran the factory until he died.

Girl in a Swing, the term for a group of English porcelain figures of which the "Girl in a Swing" is a characteristic example. The modelling is sharp, the body greyish; it is not known where this group of figures was made, but it may have been a small workshop in Chelsea (Charles Gouyn?). Dated 1749–58.

Goldchinesen (Germ.) a porcelain decoration in which small Chinese figures were engraved in a layer of gold and polished, first used before 1720 (the independent painter J. Auffenwerth) and then in Meissen up to about 1730; some factories continued using this style even later (Vienna after 1744).

Gotha 1757–87

Gotha, a German factory, 1757 – after 1900. This was the oldest Thuringian porcelain factory, established in 1757 by W. T. von Rotberg, rented out in 1782, and from 1802 the property of Prince Augustus of Gotha. 1813–81 the factory was the property of the Henneberg family. It produced mainly table ware of good quality, but the figures made there were uninteresting. The painting was of good standard (brown camaïeu, silhouettes) thanks to the artists C. Schulz, J. A. Brehm and J. G. Gabel, who rented the factory 1782–1805.

Gotzkowsky, Johann Ernst, b. 1710 Conitz, d. 1775 Berlin. A German merchant, who established the second porcelain factory in Berlin in 1761 (after Wegely) and sold it to the King of Prussia in 1763.

Gotzkowskys erhabene Blumen, a raised decoration used on Meissen ware, with a wreath of

Gotzkowskys erhabene Blumen

flowers on the body of the plate and raised flowers alternating with painting round the edge. It was designed by Eberlein in 1741 for a service commissioned by J. E. Gotzkowsky, and copied by the Berlin factory as "Floramuster".

Granite ware (U. S. A.), a type of earthenware resembling porcelain, made from about 1860 in U. S. A. and called variously also Stone china, Flint china, Opaque porcelain. After 1880 American hotel china and semi-porcelain were also invented.

Gravant, François, b. ?, d. 1765 Vincennes, French potter, originally a merchant. After the Dubois brothers had failed to make porcelain in Vincennes in 1741 he experimented himself, and in 1745 he made the first frit porcelain; production then began at Vincennes.

Gricci, Giuseppe, b. ?, d. 1770, Italian sculptor and modeller in Capodimonte 1743–59 and Buen Retiro 1760–70. He was the author of most of the figures made at both places, and the decoration of the porcelain cabinet in Portici 1757–9 and in Aranjuez 1760–7. His work is of high artistic value.

Grisaille *see* Camaïeu

Ground colour porcelain, was of the colour with white reserve panels decorated with different types of painting, modelled on Chinese vases of about 1700; the style appeared first in Meissen about 1725, and was at its height after 1730. Porcelain in this style was produced mainly by Meissen, Sèvres, Worcester and Chelsea.

The Hague

Hague, The, a Dutch factory, 1776–90. Anton Lijncker, a merchant, set up a workshop to decorate white porcelain, in the 1770s; he bought the

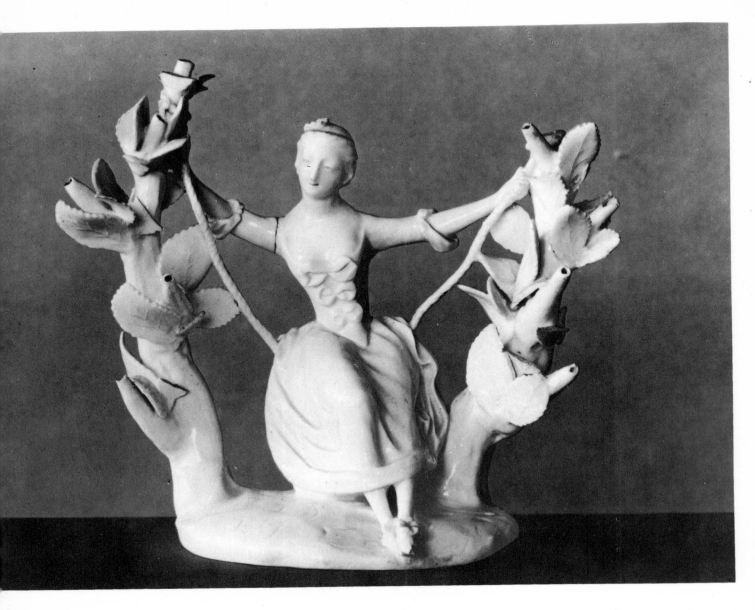

120 Girl in a swing, Chelsea, c. 1750. Victoria and Albert Museum, London

wares mostly in Germany (Ansbach, Meissen, Höchst, etc.). He was so successful that in 1776 he established his own porcelain factory, his porcelain being renowned for the high standard of the painted decoration. After Lijncker's death in 1781 the firm declined and the factory closed down in 1790.

Hancock, Robert, b. 1730 Burslem, d. 1817 Bristol, the English engraver who introduced transfer painting on porcelain and earthenware, in England. He probably gained his experience in the Battersea enamel works; he brought transfer printing to Bow (1756–7), Worcester (1757–74) and Caughley (1769–80?). From about 1780 he had his own workshop for porcelain with printed decoration in Oldbury.

Hard-paste (Fr. pâte dure), the English term for porcelain of the type made by Böttger, with a high kaolin content and high firing temperature (above 1,350 °C).

Hellot, Jean, b. 1685, d. 1766, French chemist experimenting primarily in ground coloured porcelain; technical manager of Vincennes and Sèvres 1751–66.

High-temperature colours, for underglaze painting, must be stable even at the high temperatures at which glaze is fired; the range is thus rather limited: cobalt blue, chrome green, uranium black and copper red. Because the colours are then protected by the glaze, this type of decoration is impervious to damage and cannot be washed off.

170

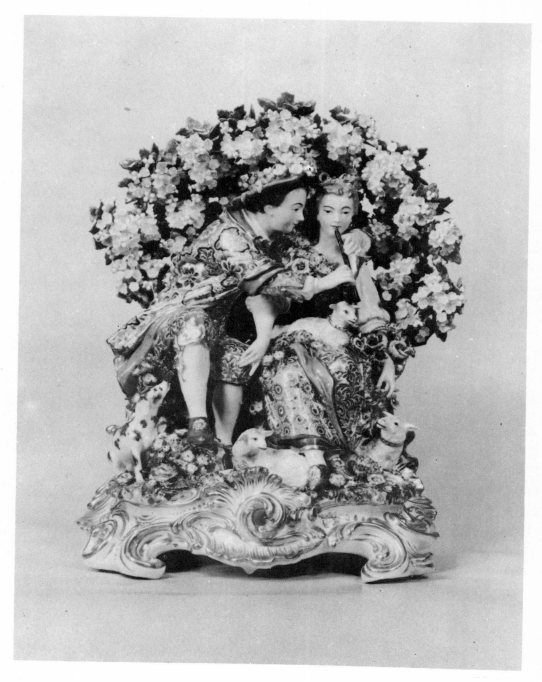

121 The music lesson, Chelsea, c. 1765; 40 cm high. Metropolitan Museum of Art, New York

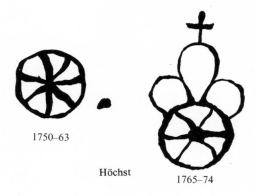

1750–63

Höchst

1765–74

Höchst, a German factory, 1746–96, founded by J. C. Göltz and J. F. Clarus. Their arcanist Adam F. von Löwenfinck, however, only succeeded in making "Fayenceporzellan", and so in 1750 J. Benckgraff and J. J. Ringler were brought in. They began making porcelain the same year. In 1756 the factory passed to the Elector; 1759–64 it was the property of Johann H. Maas; 1763–74 a limited company; 1778 state-owned; closed down in 1796. The porcelain figures were of a high standard (L. Russinger, J. P. Melchior).

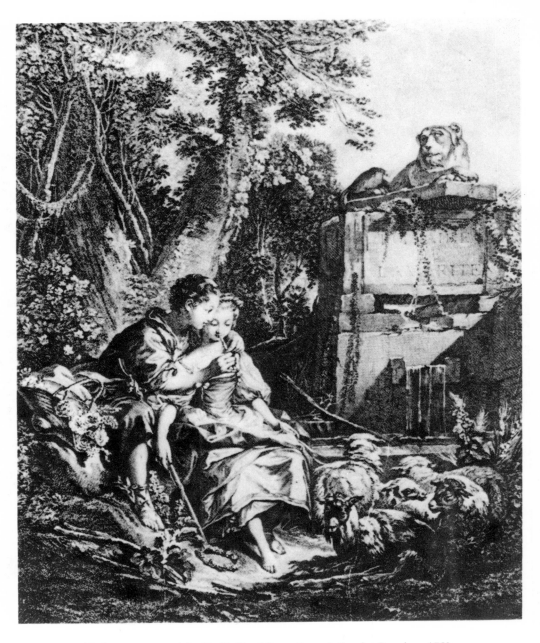

122 L'agréable leçon, engraved by R. Gaillard from the painting by Boucher, 1758

Höroldt, Johann Gregor, b. 1696 Jena, d. 1775 Meissen, German painter of porcelain. 1718 in Strasbourg, 1719 in Vienna painting wallpapers and porcelain, and in 1720 moved to Meissen with S. Stöltzel. There in May 1720 he signed a contract by which he worked for the porcelain factory as an independent artist. In 1723 he became court painter, until his retirement in 1765. He created the Meissen style of porcelain painting known as "Höroldt-malerei". Besides oriental models he painted European landscapes, harbour scenes, etc. After 1733 he had passed his best period, and after 1740 chinoiseries rapidly lost their popularity. The arrival of J. J. Kaendler brought fame to Meissen figures, at the expense of painted wares. Höroldt also helped to broaden the palette of muffle-kiln colours and ground colours.

Hunger, Christoph Conrad, 1715 a gilder in the Meissen factory, went to Vienna as arcanist to Du Paquier in 1717, but was not successful until Stöltzel came there in 1719. In 1720 he fled in secret to Venice, to the Vezzi brothers' factory, to reappear in Meissen again as a gilder in 1727. After working in various porcelain factories in Europe after 1729 (Rörstrand, Copenhagen), he tried unsuccessfully to make true porcelain in St. Petersburg, 1744–8.

172

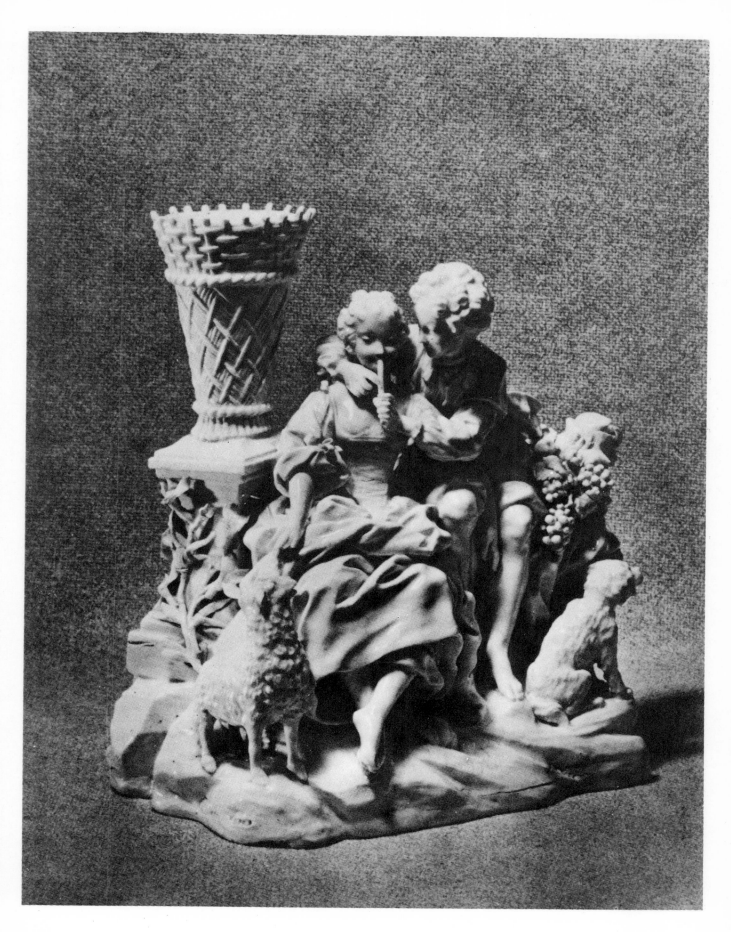

173

123 La leçon du flageolet, Vincennes, drawn for the factory
by F. Boucher, 1752; 26.7 cm high

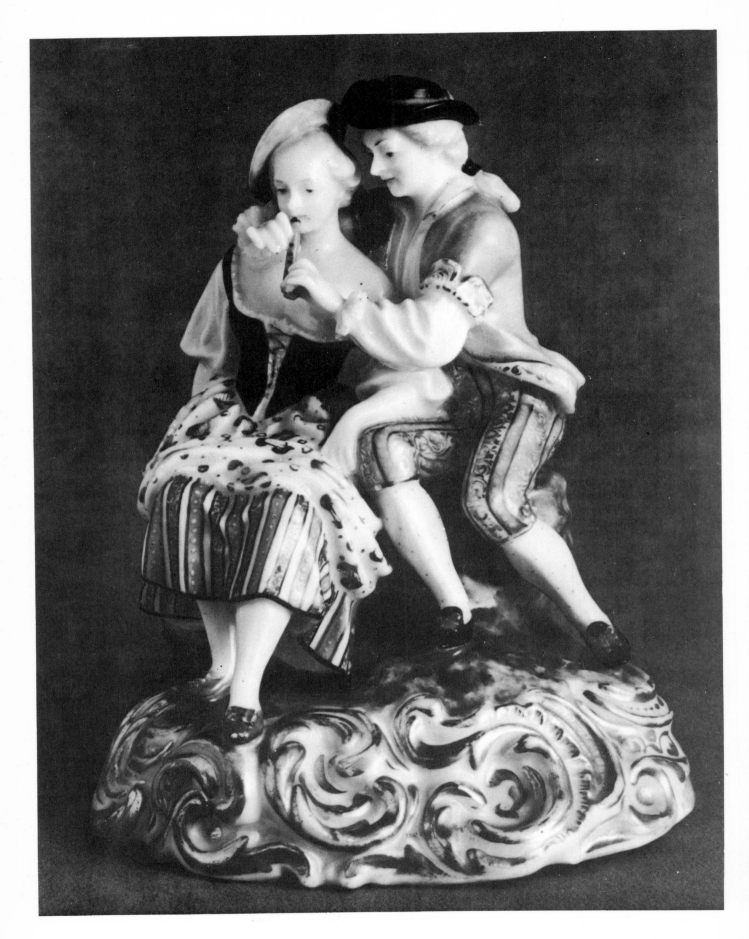

174

J

Ilmenau
17th to early 19th century

Ilmenau, a German factory, 1777 to the present day. A patent was granted to C. Z. Gräbner in 1777; from 1782 the Duke of Weimar ran the works, and from 1786 owned it; in 1808 it became private property, 1871 a limited company, and from 1947 onwards a state-owned enterprise, the Porzellankombinat Ilmenau. Eighteenth century pieces from Ilmenau are little known, but around 1800 blue and white plaques in relief were being made in the Wedgwood manner.

Imari patterns, called after the port of Imari, Japan, through which Arita porcelain was shipped to Europe, were mostly figural and floral designs in underglaze blue, touched with ferrous red and gold, and sometimes a rich brocade effect. It was the most widely copied pattern in European porcelain of the eighteenth century.

Independent decorator (Germ. Hausmaler; Fr. chambrelan), a painter on glass, porcelain or faience who worked on his own, not in the factory. Both oriental and European porcelain was decorated by such artists, particularly during the first half of the eighteenth century. There were three important centres, in Augsburg, Bayreuth and Wrocław. In Augsburg there was the Aufenwerth family during about 1715–30 (Johann Aufenwerth with his daughters Anna Wald and Sabina Hosennestl), who painted mainly polychrome figural scenes on Meissen ware; Abraham and Bartholomäus Seuter who specialized about 1725–50 in "Goldchinesen" on Meissen ware, which in turn influenced the decorators working in the Meissen factory itself. In Bayreuth J. C. Jucht and J. F. Metzch did excellent work in bright colours in the 1730s and 1740s. Ignaz Bottengruber of Wrocław was famous for his painting on Meissen ware, and after the purchase of Meissen white ware was prohibited he turned to Vienna. Ignaz Preissler went from Wrocław in 1729 to Kunštát in Bohemia, where he had been painting porcelain and glass, mostly for Count Liebsteinský of Kolowrat. The Wrocław decorators were excellent at painted ornament in black (Schwarzlot) and ferrous red and in the camaïeu technique. Unlike Bottengruber, whose designs covered most of the article, Preissler was sparing with his tendril patterns, interspersed with tiny Chinese figures, or birds, so that the porcelain itself showed up well. F. F. Mayer also worked in Bohemia; he came from Březnice near Podbořany, where he was active about 1745–80. Independent decorators should not be confused with amateurs, however interesting the latter sometimes were — for instance, A. O. von dem Busch, canon of Hildesheim, who incised designs on porcelain with a diamond and painted them in with black, about 1745–75.

Indian flowers, an eighteenth century style of floral design following oriental ("Indian") mod-

els which began in Meissen around 1720, to give way to European flowers 1735–40. After the eighteenth century "Indian flowers" appeared only on Kaendler's figures. Many other factories copied the Meissen fashion.

Italian comedy *see* Commedia dell'arte

Kaendler, Johann Joachim, b. 1706 Fischbach near Dresden, d. 1775 Meissen, German sculptor; apprenticed to the Dresden court sculptor B. Thomä, 1730 appointed court sculptor to the Elector of Saxony, 1731 modeller in the Meissen factory, 1733 master-modeller. His work created the tradition of European porcelain statuary. Hundreds of figures and their groups modelled under his leadership founded the fame of Meissen works. He also designed new vessels and sets of tableware: the Sulkowski and Schwanen services are the most famous.

Kakiemon, the name of a Japanese potter Sakaida Kizaemon, b. 1596, d. 1666, and of his style of porcelain painting, which was developed further by his followers in Hizen province. It employs plant and animal motifs, human figures being much less frequent; the colours are pale blue and ferrous red, more rarely yellow; green and underglaze blue. A limited amout of Kakiemon's work reached Europe, particularly in the second half of the seventeenth century, and was often imitated in European factories.

Kalkporzellan *see* Böttgerporzellan

Kaolin, the technical name for a mineral deposit formed mainly of kaolinite, felspar, mica and various clay substances. It is the basic raw material used in the making of European hardpaste porcelain. The name comes from Kaoling, where the first deposits of the clay were said to have been found, in Kiangsi province.

Kaolinite, the main component of kaolin, a whitish aluminium silicate.

Kapuzinerbraune Glasur, the first coloured glaze used on European porcelain; coffeebrown. Discovered in Meissen, 1720, by S. Stöltzel.

King of Prussia, a transfer-printed motif on Worcester porcelain 1756–7, by Robert Hancock, depicting Frederick the Great, the ally of England in the Seven Years' War (1756–63).

Kirchner, Johann Gottlieb, b. 1706 Merseburg, d. ?, German sculptor, modeller in Meissen from 1727. In 1728 he went to Weimar, but returned to Meissen in 1730, leaving for good in 1733. The first important modeller in Meissen, he created monumental porcelain figures of animals, saints and vases.

Klášterec nad Ohří, a Bohemian factory, 1793

◄ 124 Girl playing the flute, Prague, modelled by E. Popp, after 1852; 15.3 cm high

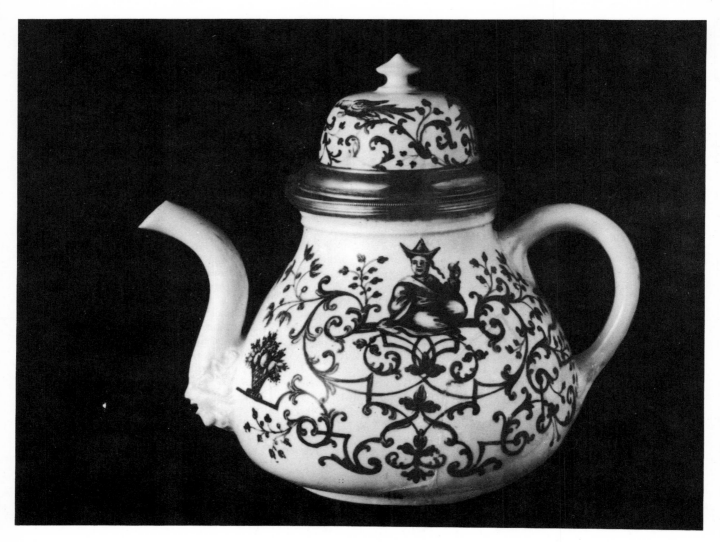

125　An independent decorator, painted by Ignaz Preissler 1725–30 on Böttger's Meissen porcelain; height with lid 15 cm

1830–93

Klášterec

1794–8

to the present day, founded by Johann Nicolaus Weber with the support of the landowner František Josef (Frank Joseph), Count Thun. The arcanist was Johann Gottlieb Sonntag of Thuringia. The first porcelain was fired here in 1794, but the factory was at its zenith 1848–58, when Revived Rococo ware was being made, especially table ware (Thun service, Imperial service). The figures made at that time were also of good quality.

Kloster-Veilsdorf, a German factory, 1760 to the present day, founded 1760 by Prince Frederick W. E. zu Hildburghausen, sold in 1797 to the sons of Gotthelf Greiner, who owned it until 1822. After passing through several hands, it became a limited company. It was 1763 before real porcelain was made at this factory; the wares were mainly tableware with well-painted flowers, birds and fruit as the ornament. The figures

1760–97

Kloster-Veilsdorf

1797–1853

176

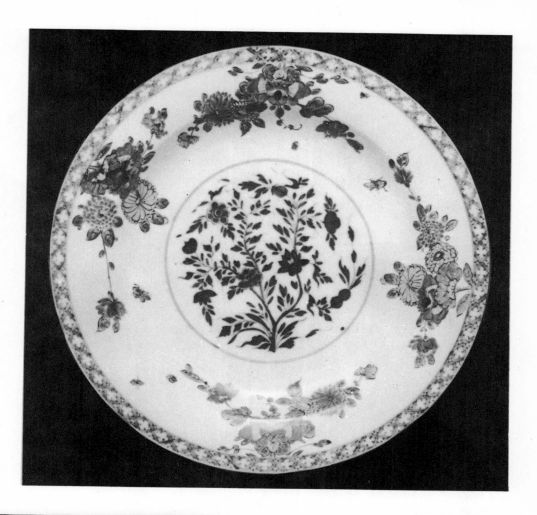

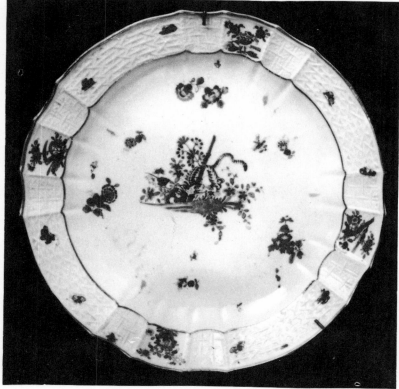

126 Indian flowers, underglaze cobalt and bright overglaze painting, Meissen, c. 1735; diameter 38.4 cm

127 Imari decoration, "yellow tiger" pattern, Meissen, c. 1740; diameter 34 cm

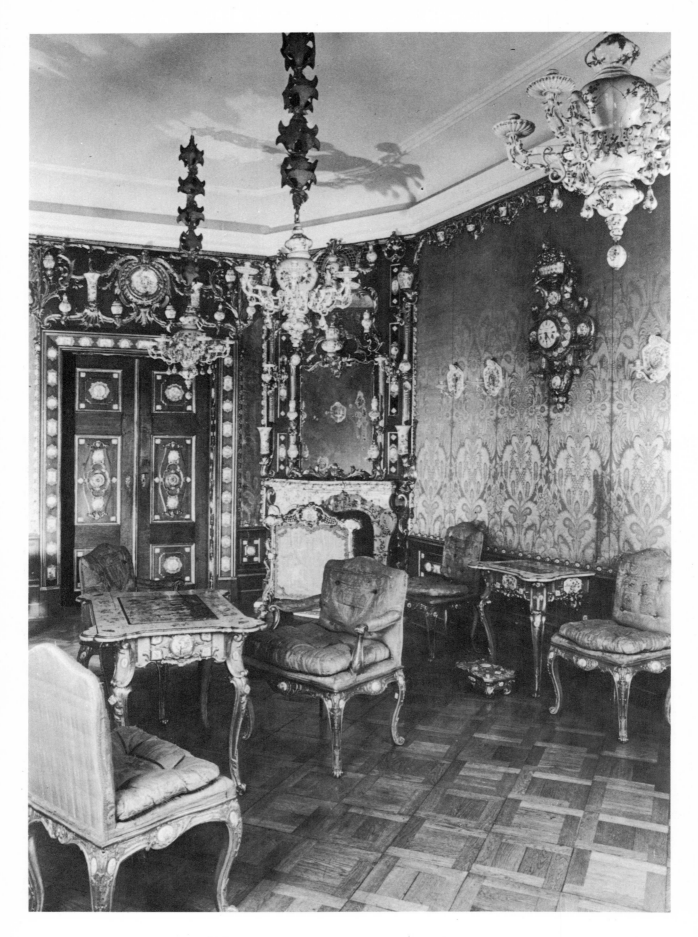

128 Porcelain cabinet, decoration of the cabinet in the Dubský Palace, Brno, executed by the Vienna factory, 1725 to 1730. Österreichisches Museum für angewandte Kunst, Vienna

were less notable. The body was milky-white, and the glaze was faultless.

Koppchen, Türkenkoppchen (Germ.), handleless cups in the Chinese fashion, produced by German factories for export to the Balkans and Asia Minor. The most important customers of the Meissen factory were Athanas Manasses of Sophia and Kosmas Demetri of Belgrade. These cups were made and exported practically throughout the eighteenth century.

Korzec 1790–6

Korzec, a Polish factory (today U.S.S.R.), 1790–1832, founded as a pottery by Józef Klemens Czartoryski, managed by Franciszek Mezer, produced porcelain from 1790. principally tableware. The painter was Kazimierz Sobiński (1791–6). At the end of 1796 the factory was burnt

down, and production was not resumed until 1800, when faience as well as porcelain was produced. In 1804 Méraud of Sèvres became manager, bringing with him a strong French influence. From 1807 only porcelain was fired there.

Krog, Arnold, b. 1856. d. 1931, artist and manager of the Copenhagen porcelain factory from 1885; in 1889 his underglaze painting won the Grand Prix at the Paris World Exhibition, and had a profound influence on porcelain decoration throughout Europe.

Kurlbaum & Schwartz, U. S. A., a hard-paste porcelain factory established in Kensington, Philadelphia, in 1851 by Charles Kurlbaum and John T. Schwartz; the factory, which was closed down in 1857/8, produced household wares of the French type.

Lauraguais-Brancas, Louis Léon Félicité, b. 1733, d. 1824, a French researcher who experimented with Alençon clay in his attempts to make true porcelain, on his estate in Lassay, 1763–8.

129 Kakiemon, cup and saucer, Meissen, 1725–30; cup 6 cm high

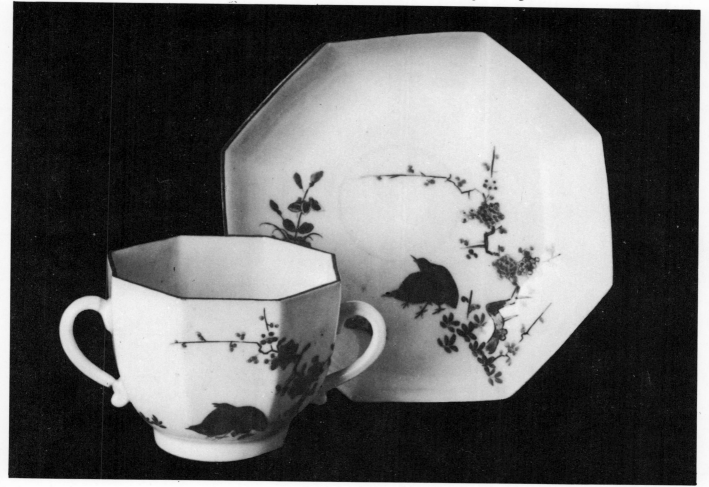

130 Guineafowl, Copenhagen, Bing & Grøndahl, c. 1910; 17,5 cm high

In 1766 he showed several samples of his first hard-paste porcelain to the French Academy, but it is not certain that he did not use Chinese kaolin smuggled into Europe for his work.

Lille, France, factories:
Dorez et Pelissier, 1711–30, a faience factory established by Barthélemy Dorez and Pierre

Lille: Dorez 1711–30

Pelissier in 1711, which produced a porcelain of the St. Cloud type up to 1730.
Leperre-Durot, 1784-1817, a porcelain factory founded by Leperre-Durot, which up to 1790 was under the patronage of the Crown Prince. the Dauphin. It was then taken over by a private company, until it was liquidated in 1817. The hard-paste porcelain followed the Paris model.

Lithophany, relief decoration, impressed usually on a bisque body, by means of a plaster mould. A light from behind shows up the relief and shadows, creating a delicate play of light and shade. It was used mainly on lampshades, panels, etc. and was first shown in Paris and Berlin about 1827.

Loket 1817–33

Loket, a Bohemian factory, 1815 to the present day, founded by the Haidinger brothers, Rudolf and Eugene; it remained in the family until 1872, when it became the firm Springer & Cie. Loket porcelain is among the finest produced in Bohemia. In 1836 transfer printing in black, from copper plates, was introduced. The finest ware was tableware in Revived Rococo style; the porcelain figures were imitations of Meissen ware.

Longport 1793 to c. 1850

Longport, an English factory, 1793–1882, founded by John Davenport; it was closed down in 1882. Typical decoration on Longton ware was a

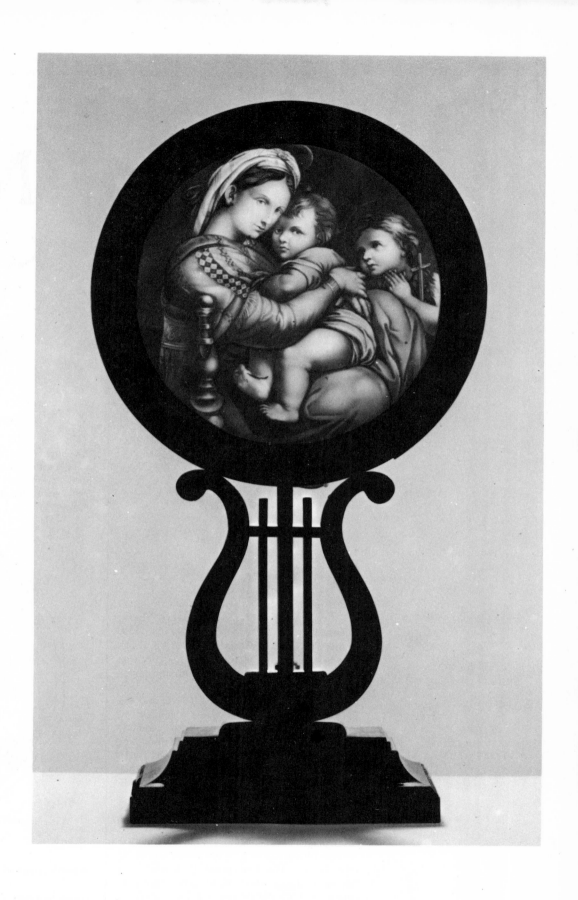

131 Lithophany (Berlin transparency), Bohemia, after 1830; 54.3 cm

181

richly gilded edge and realistically painted fruit and flowers. There was another porcelain factory in Longport, that of John Rogers.

Lotus ware *see* Belleek ware

Löwenfinck, Adam Friedrich von, b. 1714?, d. 1754, apprenticed to Höroldt in 1727, in Meissen; in 1736 he ran away to Bayreuth, hence to Ansbach 1737–40; in 1741 he went to Fulda, and in 1746 helped to set up the Höchst factory. Failing to agree with his partners, he went to Hagenau in Alsace, where he ran Hannong's faience factory.

Ludwigsburg c. 1764 Ludwigsburg 1765–70

Ludwigsburg 1793–5

Ludwigsburg, a German factory, 1758–1824, founded by Duke Karl Eugen. In 1760 J. J. Ringler was made manager. In 1816 the factory was rented out, in 1819 it was state-run, and under King Frederick William I it was closed down in 1824. The best period was 1760–76, and the finest work was in the figures, which clearly show the transition from Rococo to Neo-classicism (modellers J. C. W. Beyer, J. Weinmüller, P. F. Lejeune). The leading painter was G. F. Riedel, who developed the characteristic Ludwigsburg style. The typical Ludwigsburg body is greenish grey.

Marieberg, a Swedish factory, 1766–88, founded by J. E. Ehrenreich in 1758 but at first producing only faience. The Frenchman P. Berthevin of Mennecy, engaged in 1766, introduced frit porcelain. In 1769 the factory was taken over by Henrik Sten, who introduced a white chalk porcelain body which accounted for most of the

Swedish porcelain made during the eighteenth century. True hard-paste porcelain was made in Marienberg only 1778–9 by the arcanist Jacob Dortu. The Marienberg ware was strongly influenced by French designers and was decorated with painted floral and landscape motifs.

Marieberg 1766–9

Marieberg 1777–8

Marseillemuster (Germ.), a raised decoration on Meissen ware, composed of two cornucopias and floral garlands. It was first used in the early 1740s, probably influenced by Rouen faience ornament.

Marseillemuster

Mason's Ironstone China *see* Stone china

Masso bastardo (It.), the grey hard-paste body made in Doccia, Italy, almost to the end of the eighteenth century.

Medici porcelain, wares made from the clay body used before porcelain was invented in Europe. It was invention of a Florentine workshop set up by the Grand Duke Francesco Maria de Medici, F. Fontana and B. Buontalenti in the early 1570s. The body was yellowish, greyish or whitish, with blue or manganese red decoration fired "alla porcellana". Only about 59 pieces are known; the main production was 1581–6.

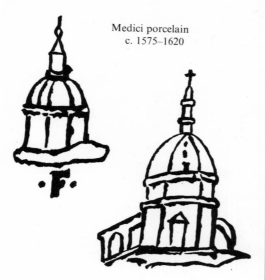

Medici porcelain
c. 1575–1620

Meissen, a German factory, 1710 to the present day, established by the Elector of Saxony, Augustus the Strong, 23rd January, after J. F. Böttger had successfully completed his experiments. Meissen was the first European factory for hard-paste porcelain. Artistically Meissen ware can be classified in the following periods: the Höroldt period (1720–33), famous for its painting; the Kaendler period (1733–63), which was the peak of figure modelling; the dot period (Punkzeit, 1763–74), when a dot was added to the crossed swords mark, characterized by the rise of Neo-classicism; the modeller at this time was M.-V. Acier; the Marcolini period (1774–1814), when Neo-classicism was in full swing;

Meissen
royal property mark
(Augustus Rex)

this period ended with the Napoleonic Wars, when the dot was replaced by a star. During the 1814–33 period the Empire style prevailed, but the factory was not particularly famous. Under Kühn (1833–70) the factory was modernized, and in design historical Romanticism was supreme. Art Nouveau took over around the turn of the century. The Meissen factory was of fundamental significance in the development of European porcelain.

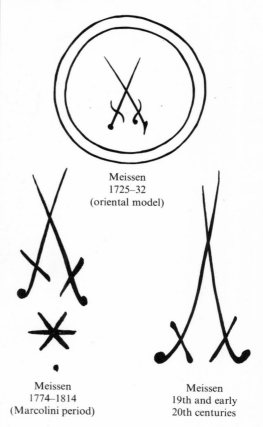

Meissen
1725–32
(oriental model)

Meissen
1774–1814
(Marcolini period)

Meissen
19th and early
20th centuries

Melchior, Johann Peter, b. 1747 Lintorf, d. 1825 Nymphenburg, German sculptor working as modeller for the Höchst factory 1767–79, in Frankenthal 1779–93 and in Nymphenburg 1797–1822. He was the leading interpreter of Neo-classicism in German porcelain design.

Meyer, Friedrich Elias, b. 1723 Erfurt, d. 1785 Berlin, German modeller working in Meissen 1748–61 and in Berlin 1761–85. In Meissen he worked with Kaendler, but was not entirely under his influence artistically. In Berlin, besides figures, he modelled relief decoration on table ware.

Mosaïque *see* Écaille

Mother and child pattern, a popular theme in Caughley and Worcester 1780–90; it shows a child holding a fan, with the mother near.

Muffle colours, fused on the glaze in the muffle

(continued on page 193)

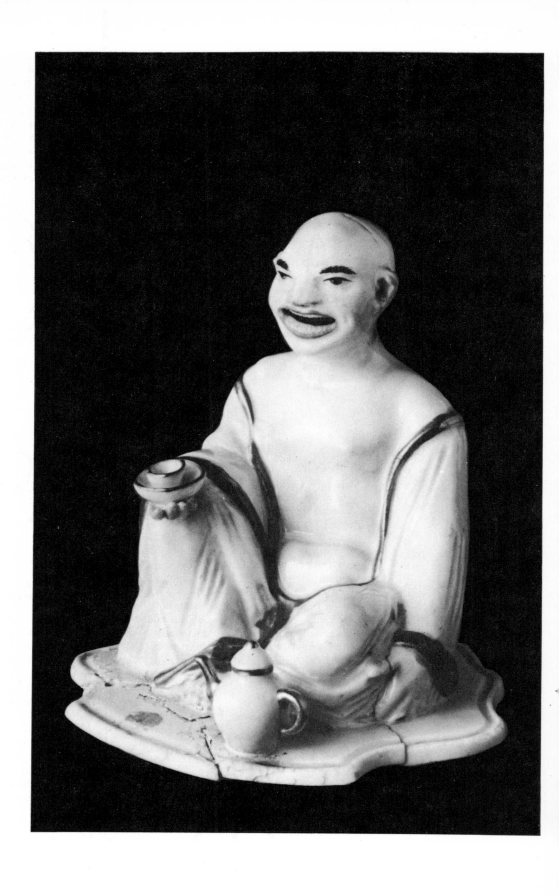

132 Pagoda, Meissen, Böttger's porcelain,
1715–20; 10.2 cm high

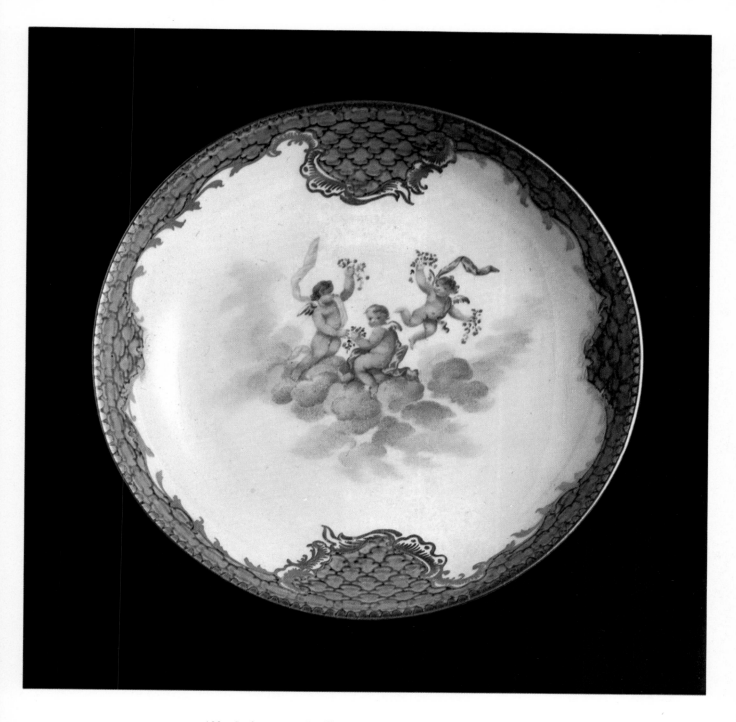

133 Scale-pattern (écaille), saucer, Meissen, c.
1760; diameter 13 cm

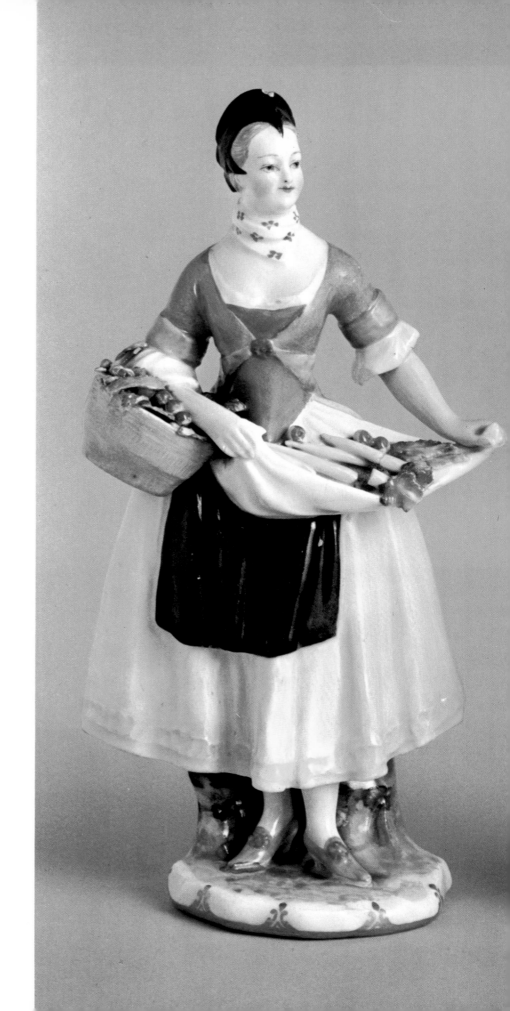

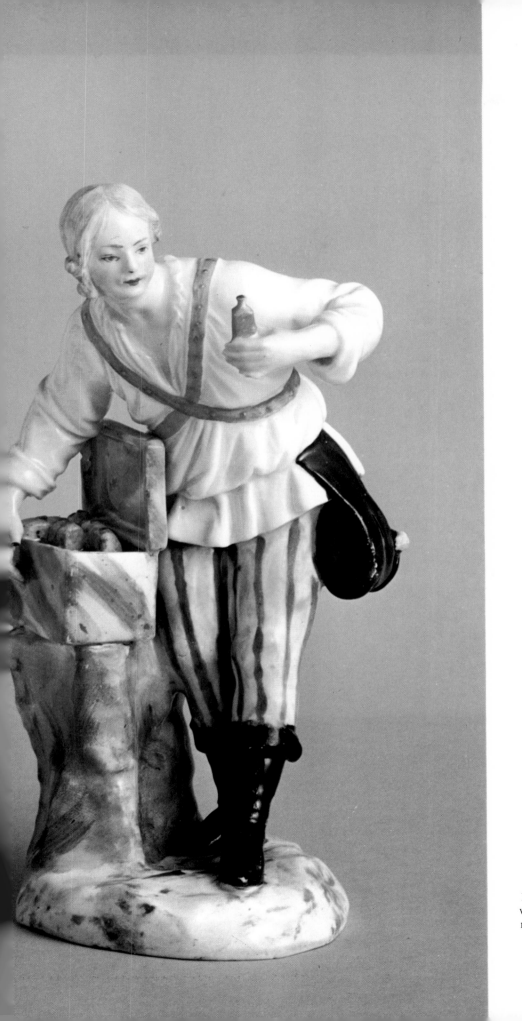

134 Cris de Vienne, a Slovak and a vegetable-woman, Vienna, 1760; 18.4 and 20.8 cm high, respectively

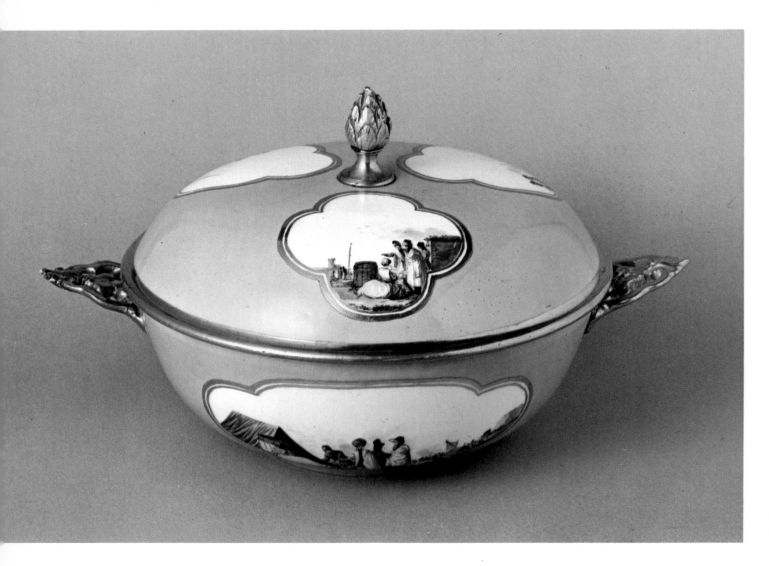

135 Ground colour porcelain, covered tureen,
"Seegrün" ground, white reserve panels gaily
painted, Meissen, c. 1740; height with cover,
13.8 cm

136 Pot-pourri jar, Vienna, 1755–60; 28.8 cm

137 Trembleuse, Vienna, c. 1725; cup 7.9 cm

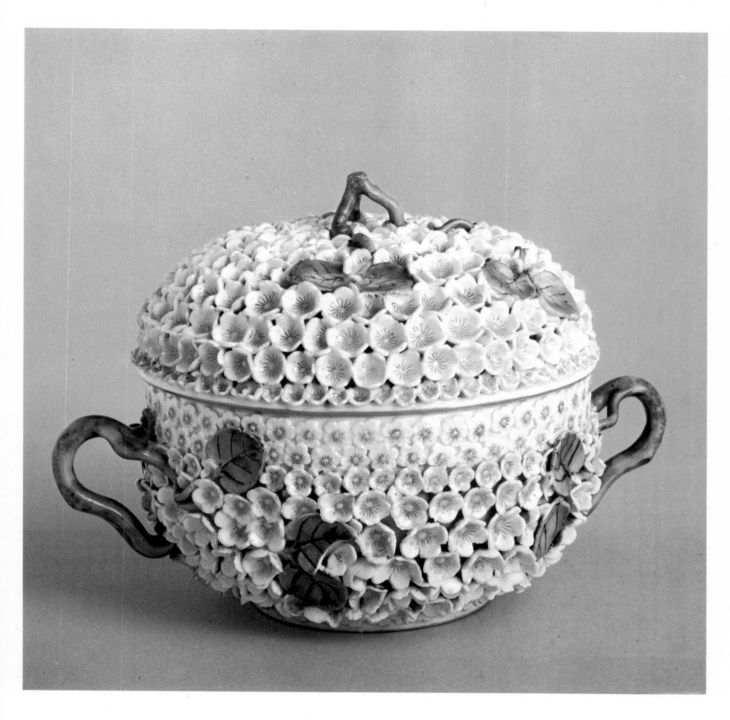

138 Schneeballbelag, covered jar, Meissen, c.
1745; height with lid 12.7 cm

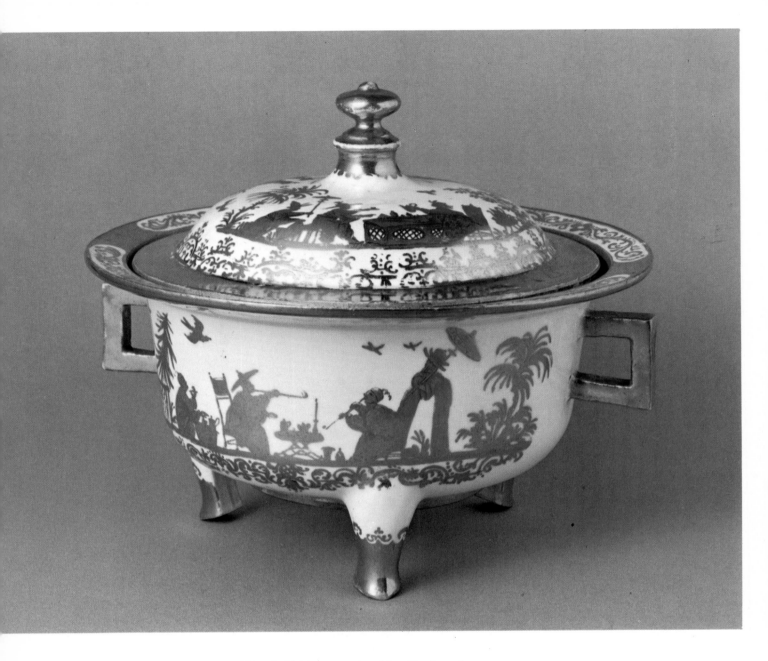

139 Goldchinesen, painted by Abraham Seuter, Augsburg, c. 1721, on a Meissen "Ollientopf"; height with cover 13.5 cm

kiln at relatively low temperatures (c. 800–900°C). These pigments are based on borax or lead glass, coloured by metal oxides. Since they do not require high temperature firing, there is a broad palette of these colours, which also include precious metals and lustre. They are applied with brush or pen. Not being protected by the layer of glaze, they are less durable. The muffle is the protective structure inside the kiln, in which wares are placed for firing.

Müller, Frants Heinrich, b. 1732, d. 1820, a chemist, devised the body for Copenhagen hard-paste porcelain. He founded the royal Copenhagen factory in 1773 and directed it until 1801.

Musiksoli (Germ.), a series of figures of musicians playing various instruments, modelled by J. C. Beyer 1765–6 for the Ludwigsburg factory. Beyer's genre pieces not only reflect the atmosphere of the time, but are informative about contemporary musical instruments.

Neu-Brandensteinmuster

Neu-Brandensteinmuster (Germ.), a raised pattern on Meissen ware, in which two different weaves alternate symmetrically, interspersed with S-shaped staves running up the sides of the vessel. It vas designed by J. F. Eberlein in 1744 as a variation on the Alt-Brandenstein pattern.

Neu-Dulongemuster (Germ.), a raised pattern on Meissen ware, in which flat panels divided by strokes alternate with raised rocaille, festoons and plant motifs. It was invented in 1743 by J. F. Eberlein as a variation on the Dulongemuster.

Neu-Oziermuster

Neu-Oziermuster (Germ.), a raised pattern on Meissen ware which appeared 1744–5, along with the Neu-Brandenstein pattern. Basketweave panels alternate regularly, divided by slanting strokes.

Neuzieratmuster (Germ.), a raised pattern used on Berlin ware, a variation on the "Reliefzierat"; it was popular in the 1780s, adding Rococo ornament to ware which in the English model was plain.

New china *see* Stone china

Niedermayr, Franz Ignaz, b. 1710 Munich, d. 1772 Munich, a potter who was encouraged by the Elector of Bavaria to experiment with porcelain pastes in Neudeck from 1747. It was not until J. J. Ringler came in 1754, however, that the first true porcelain was fired there.

Niedermayer, Johann Joseph, b. 1710 Vienna, d. 1784 Vienna, an Austrian sculptor who headed the modelling department in Vienna 1747–84, and whose porcelain figures especially after 1755 are typical of Vienna Rococo.

Nymphenburg 1754–80

Nymphenburg, a German factory, 1747 to the present day. Attempts to make porcelain had been

going on in Neudeck since 1747 (with the potter F. I. Niedermayr), but the first true porcelain was fired under J. J. Ringler 1753. In 1761 the factory was moved into the Nymphenburg palace grounds, where new buildings were equipped for it. Nymphenburg was artistically renowned for its figures, modelled by three masters: F. A. Bustelli (1754–63), Dominik Auliczek (1763–97) and J. P. Melchior (1797–1822). The Nymphenburg table ware is also known for its excellent forms and painted decoration. Much of the porcelain was painted elsewhere, however, and it is difficult to distinguish the work of independent decorators from that of the Nymphenburg painters. Around 1900 Nymphenburg adopted the Copenhagen style for a time, producing Art Nouveau porcelain, but later returned to old models copying eighteenth century originals even in colour décor.

Nyon 1781–1813

Nyon, a Swiss factory, 1781–1813, founded by two porcelain painters, J. J. Dortu of Berlin and F. Müller of Frankenthal. Dortu left in 1786, leaving Müller sole owner; in 1788 Müller had to leave Nyon, and Dortu returned, setting up the firm of Dortu & Cie, which continued production until 1813 under changing shareholders. The Nyon ware is faultless, and pure white; so far figures have not been indisputably assigned to Nyon, while in both shape and decoration the table ware follows Sèvres (ground colour) and Meissen (onion pattern).

Onion pattern, a Meissen design in underglaze blue, derived from Chinese patterns about 1738–9. The central motif is an aster on a stem, with a bud, and a bamboo, while the border of peaches and pomegranates at first faced all the same way, later alternating. The stylized forms of these exotic fruits resembled onions to European eyes, hence the misleading name. The pattern was copied in many European and Japanese factories. The onion pattern in red is very rare.

Opaque china is not true porcelain, but white stoneware made in Swansea by Cambrian Pottery, 1815–40. Similar ware of the same name was made in the U.S.A. from 1860s, where it was also called Paris Granite, Semi-porcelain, etc.

Oziermuster (Germ.), a Meissen raised pattern on table ware, with a border of raised basket-work. It was used from the early 1730s, and variations were evolved: Sulkowski-muster, Neu-Ozier, and Alt-Ozier.

Pagoda, an incense burner or statuette in the shape of a seated Chinese idol, made particularly in Meissen from the 1720s onwards; in 1760 Frederick II of Prussia commissioned 10 pagodas which were modelled by Kaendler. These figures were copied in many European factories.

Parian ware (England), a variety of hard-paste porcelain, unglazed, introduced by W. Copeland, Stoke-on-Trent, in 1846; it was mainly used for statuary. Usually white, it was sometimes produced in a coloured body. It was named after the marble of Paros, which it somewhat resembled.

Parian ware (U. S. A.); in the 1850s and 1860s American firms began producing Parian porcelain on the English model (United States Pottery, Bennington, Vermont). The body served not only for figures, but also for household ware, vases, jugs, etc.; a favourite decoration was in white relief on a coloured ground. Later, Parian ware was made in fairly large quantities by firms in Trenton, Baltimore, etc.

Paris, France, factories: when the Sèvres monopoly was not so jealously guarded, in the early 1770s, small factories sprang up particularly in Paris; for the most part they produced hard-paste porcelain, and by the end of the century there were already twenty-seven such factories in Paris, most of them undistinguished from the artistic point of view. Most remarkable was the factory in the Rue Fontaine-au-Roy (La Courtille), 1771–1840, while we should also mention the "Manufacture du Duc d'Angoulême" (1780–1829) in the Rue de Bondy (1780–1829), the "Manufacture du Duc d'Orléans" founded in 1784 in the Rue Amelot, and the "Fabrique de la Reine", founded 1786 in the Rue Thiroux.

Pâte dure (Fr.) *see* Hard-paste

Pâte-sur-pâte (Fr.), a technique inspired by Chinese porcelain. Coloured grounds were covered with white slip to varying degrees, so that the ground colour showed through with delicately shaded effects. This technique was devised in Sèvres in the 1860s by Solon, who brought it to England after 1871. It was brought to perfection in Meissen and in Berlin at the end of the nineteenth century.

Pâte tendre (Fr.), a body with no or little kaolin, fired at relatively low temperatures (less than 1350°C); the type includes frit porcelain and various English pastes such as bone china, soapstone china, etc. Known in English as "soft-paste" or "artificial" porcelain.

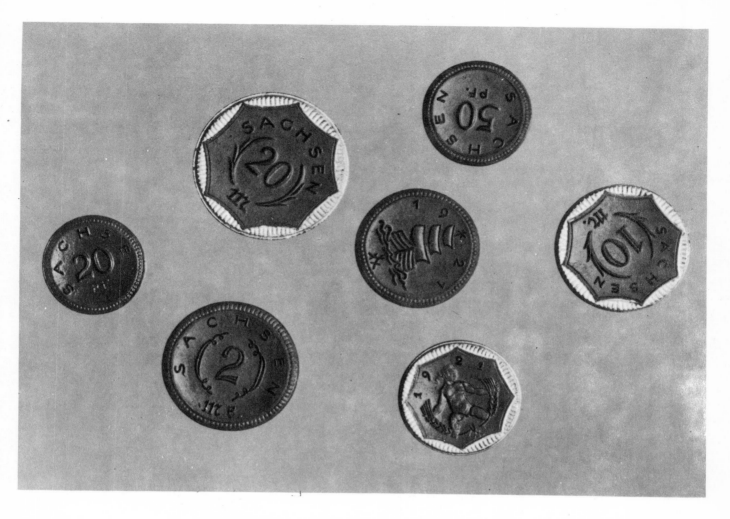

140 Porcelain coins, Meissen, Böttger type stoneware, 1921; largest diameter 3.1 cm

Patent Ironstone China *see* Stone China

Paul, Nicolaus, b. 1711 Sossenheim, d. 1788 Höxter, an employee of the Höchst factory (1753), where he apparently learned the "arcanum" from J. J. Ringler. He then worked as an arcanist in Berlin (1755–7), Fürstenberg (1757–60), Weesp (1760–4), Fulda (1764–5) and Cassel (1766–9).

Pinselrelief *see* Pâte-sur-pâte

Place, Francis, b. 1647 Yorkshire, d. 1728 York, English painter; experimenting at Manor House, York, he seems to have made a hard-glaze stoneware. In 1714 he stopped work, for financial reasons.

Plymouth, an English factory, 1768–70, the first to make hard-paste porcelain; founded by W. Cookworthy after he had discovered deposits of kaolin in Cornwall, at St. Austell. In 1770 the factory was transferred to Bristol. Plymouth ware was sometimes well painted; figures were also made.

Porcelain cabinet, a room devoted entirely to porcelain. The idea derived from the Renaissance cabinets of curiosities, but mostly these cabinets were purely decorative. Designs were suggested as early as 1675–83 in the work of F. Blondel; the earliest examples were those in the Munich and Bamberg palaces (both c. 1700), while the most ambitious project was that for the Japanese palace in Dresden, begun in 1719 but never completed.

Porcelain coins were made in Meissen 1920–21, in Böttger's red stoneware, and in white bisque. In 1922 after emergency coinage was prohibited, these coins were no longer made.

Porcelaine à émaux (Germ. Juwelenporzellan), a technique introduced in Sèvres in the 1770s; gold foil was fired on the surface of the porcelain and covered with transparent enamel. The technique was also employed in nineteenth century England. Böttger's decoration of his stoneware with jewels (garnets, emeralds, etc.) was the forerunner of this jewelling technique.

Porcelaine de Saxe, a French term for Meissen ware.

Poterat, Louis, b. 1641, d. 1696, a French potter who made frit porcelain in his Rouen workshop by a patent granted in 1673; together with C. Réverend of Paris he is regarded as the inventor of the "pâte tendre". Nothing has been preserved of Réverend's work, and so we cannot judge their composition.

Pot-pourri (Fr.), a pot, usually with a lid, for a fragrant mixture made from flower petals; the lid was usually perforated. This was a popular product in the eighteenth century.

Prague 1842–52

Prague, a Bohemian factory, 1837–94. Originally set up as a factory for English-type stoneware in 1791, it went over to porcelain production in 1837. It was closed down in 1894. Production centred on figures in the Revived Rococo style, the best produced in Bohemia. They were modelled by the sculptor E. Popp.

Preussisch-musikalisches Dessin (Germ.), a raised design on Meissen ware, featuring musical instruments and astronomical gadgets in Rococo cartouches. The design may have been commissioned by the King of Prusia, Frederick II, as the name would suggest; in any case it dates from the 1760s. It was the last Rococo design made in Meissen.

Prints have played an important role in the art of porcelain manufacture. Every factory probably possessed a collection of prints which were used in decorating porcelain; prints had the advantage of being readily obtainable and not too expensive. Their engravers reacted flexibly to changes in taste and style, and were accustomed to reproduce the work of popular contemporary artists. Complete books were also published, intended for the use of porcelain decorations and designers. Some of these were standard reference works for many of the European porcelain factories, like Jacques Callot's engravings, *Varie figure – Gobbi* (1622), reprinted in Amsterdam in 1716 with the title *Il Calloto resuscitato*; Callot depicted dwarfs and cripples. Another popular handbook contained the twelve engravings of Commedia dell'arte figures by L. Riccoboni –

this was the *Histoire du théâtre italien* of 1728. In the Rococo period engravings of the pictures of Watteau and Boucher and their fellows were of enormous significance. A typical example of the way such scenes passed through all the porcelain factories of Europe was the pastoral idyll by Boucher's "La leçon de flageolet"; it was copied by the engravers René Gaillard and J. Nilson, modelled first in the Vincennes factory in 1752, then in 1760 in Frankenthal, later to be one of the finest Chelsea figures. The Vienna factory used Nilson's engraving when it put the figure on the market in 1765, and in the Revived Rococo period, the Prague factory again used Boucher's subject from 1852 onwards. It has been calculated that the Meissen factory alone reproduced about ten thousand such subjects in the course of the eighteenth century; this would be an impossible feat for the most numerous staff of sculptors and modellers imaginable, without the use of prints.

Punktzeit

Punktzeit (Germ.), the production period of Meissen manufacture (1764–74) when a blue dot is added to the crossed swords mark.

Radiertes Dessin *see* Reliefzierat

Rachette, Antoine Jacques Dominique, b. 1744 Valençay or Copenhagen, d. 1809 St. Petersburg, the chief modeller at the St. Petersburg factory 1779–1804. He designed porcelain figures, busts and medallions, as well as a series of figures in Russian folk costume, 1777–9.

Réaumur, René Antoine Ferchault de, b. 1683, d. 1757, French physicist, chemist and zoologist, originally a lawyer. From 1708 he was a member of the French Academy. His best known inventions today are the Réaumur thermometer and Réaumur porcelain, published in 1739. This was not a ceramic body, but glass which acquired the appearance of porcelain by a special process.

Réchaud (Fr.), a table-warmer for food or drink; the vessel was placed on a round stand in which

a flame maintained a certain degree of heat. It was a popular article made by almost all factories up to the middle of the nineteenth century.

Red porcelain (Germ. Rotes Porzellan), not true porcelain, but oriental unglazed stoneware, brown or red in colour, which Europeans at first confused with porcelain. It was imitated in Delft 1677–8 (Ary de Milde) and in England about 1690 (the Elers brothers). The "Jaspisporzellan" of Böttger belongs to this type of stoneware.

Reinicke, Peter, b. 1715 Danzig, d. 1768 Meissen, worked with Kaendler in Meissen from 1743. Besides his work on Kaendler's figures, he carried out his own designs (characters from the Commedia dell'arte, Chinese, Turks, etc.).

Reliefzierat

Reliefzierat (Germ.), a raised pattern on Berlin table ware, in rocaille, designed by the modeller F. E. Meyer, 1764. There were several variations, e.g. "Reliefzierat mit Spalier", with cartouches, with flowers, etc.

Repairer (Germ. Bossierer), a specialist whose task was to put together the parts of porcelain figures moulded or cast separately, and to add the finishing touches to the complete figure. Figures from the same mould can thus display minor differences.

Reserve panels, white panels in a porcelain body of ground colour, usually marked off by an ornamental frame, intended for painted decoration (flowers, landscapes, portaits, etc.).

Réverend, Claude, the first French potter to be granted a patent for the production of porcelain (1664). Nothing is known of his work, but it would appear that he made faience of the Delft type. Nevertheless, together with Poterat, he is regarded as the inventor of frit porcelain.

Ringler, Joseph Jacob, b. 1730 Vienna, d. 1804 Ludwigsburg, an arcanist who learned the secret of porcelain when he was employed in the Vienna works about 1745–50, and who spread his knowledge throughout Germany (Höchst 1750–1, Strasbourg 1752, Nymphenburg 1753–7, Ellwangen 1757–9). From 1760 to 1802 he held a leading position in the Ludwigsburg factory.

Rose du Barry *see* Rose Pompadour

Rose Pompadour (Fr.), a pink ground colour invented in Sèvres about 1757; the credit is perhaps due to the chemist Hellot or to the painter Chrouet. It was not used after the death of Madame de Pompadour in 1764. It was often imitated, especially in England; in Chelsea and Worcester it was known as "claret" in the eighteenth century, and in the nineteenth century other English porcelain factories imitated it, using the incorrect name "Rose du Barry".

Rote Drache (Germ.), a motif in Meissen painted decoration, representing a red dragon; it dates from about 1730, and derives from a Japanese model. Up to 1918 the motif was the prerogative of the Saxon court, but from the middle of the century it was reproduced in green, blue, brown etc. for the general public.

St. Cloud
1677–1722

St. Cloud
1722–66

St. Cloud, a French factory, before 1677–1766. It appears from the 1702 patent that frit porcelain was already being made by Pierre Chicaneau,

197

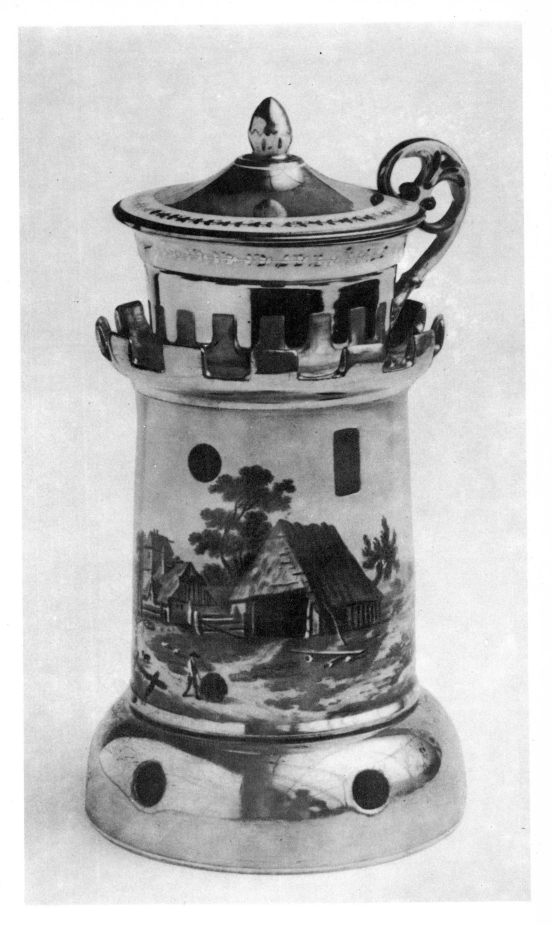

141 Réchaud, Vienna, 1827;
total height 23 cm

198

who died in 1678. In 1683 his descendants improved the frit body. The widow of Pierre Chicaneau married Henri-Charles Trou, and the factory remained in the family until it closed down in 1766. The St. Cloud body is ivory white, and the glaze shiny.

St. Petersburg
1744–62

St. Petersburg
1762–96

St. Petersburg
1796–1801

St. Petersburg, a Russian factory (now Leningrad), 1744 to the present day. Founded in 1744 as the "Czar's factory", after various foreign arcanists failed, D. I. Vinogradov first produced porcelain in 1747. By 1749 the porcelain was of good quality. In 1918 the factory was renamed the "Petrograd State Porcelain Factory", and in 1925 it became the "Lomonosov Porcelain Works". It flourished particularly in the 1770s, renowned especially for good quality services (arabesque, boat, Yusupov and other designs) and for porcelain figures (e.g. an interesting series of the "nations of Russia"). At this time the chief modeller was A. J. Rachette, 1779–1804. In the first half of the nineteenth century the Empire style table ware was of very good quality. In the second half of the century production veered towards historical romanticism. An interesting feature of post 1918 production was the "propaganda porcelain", figures and decorative motifs on table ware with revolutionary themes (e.g. "The Woman Propagandist").

Salopian ware, the name chosen by the Caughley works in Shropshire (Salop) for its products; both the body and the glaze were similar to Worcester porcelain.

San Simeone, Antonio di, a Venetian alchemist who tried to make porcelain about the year 1470; he succeeded in making frosted glass which he decorated in blue "alla porcellana". The

articles he made are the earliest examples of experimental European porcelain to survive.

Saqui (Monsieur Saqui), a porcelain painter in England in the 1760s and 1770s in Plymouth, Bristol and Worcester. He was probably a Frenchman, perhaps from the Sèvres factory. He painted landscapes enlivened by birds, and his work is of a good standard.

Sassonia, alla, the Italian term for porcelain in the Meissen style (Sassonia, Saxony).

Saxe, the French term for porcelain from Meissen, Saxony.

Saxe ombré *see* Deutsche Blumen

Seger cones

Seger, Hermann A., b. 1839, d. 1893, German technologist appointed in 1878 to head the research institute attached to the royal porcelain factory in Berlin. His work received international recognition; his name is connected particularly with the Seger cones used for temperature testing in kilns; they are variously composed and according to the reaction of the cones (softening, bending) the kiln temperature can be set. Seger classified and tabulated the reaction of different bodies to various temperatures.

Semi-porcelain (Amer.), not true porcelain, but a ceramic product which resembles it. It is also known as hotel china, Paris granite, etc. Discovered in the U. S. A. in the 1880s, it was used for table ware, toilet sets, etc.

Settala, Manfredo, b. 1600, d. 1680, Italian canon of Milan, who is believed to have found porcelain; he was visited in 1676 by E. W. von Tschirnhaus, but Settala would not reveal secret.

Sèvres *see* Vincennes

Schneeballbelag (Germ.), a raised pattern used

in Meissen, imitating the flowers of the snowball tree (Viburnum opulus L.). As a rule the design covered the entire surface of vases, bowls, services, etc.; each flower was hand-modelled. This exacting design was proposed by Kaendler in 1739.

Schwanenservice (Germ.), the largest (said to comprise 2,200 pieces) and most ostentatious service made in Meissen, 1737–42. The name was taken from the central motif, the swan, which appeared on each piece in relief or modelled as figures. Some of the vessels were shaped like swans (bowls with lids, sauce boats). The swan was accompanied by herons and reeds in bas-relief. The composition made use of other water motifs, fishes, water plants, and mythological figures. Kaendler was assisted in this great task by J. F. Eberlein and J. G. Ehder. The service was made for the Count von Brühl, and his arms, together with those of his wife (Francis M. of Kolowrat), appear on each piece of the service.

Sisto, Nicolo, an Italian potter who is said to have produced porcelain in Florence and in Pisa (1619). His connections with the Medici workshop are not clear, however.

1810–1820 from 1830

Slavkov

Slavkov, a Bohemian factory, 1792 to the present day, founded by Jan Jiří Paulus; the arcanist was J. J. Reumann from Hildburghausen in Thuringia. In 1800 Louisa Greiner purchased the factory, and in 1808 it was the property of Lippert & Haas until 1867 when it passed to Haas & Cžjižek; today it is a state-run enterprise. The peak of artistic achievement was attained 1820–40, when Empire forms were predominant; from 1835 the porcelain figures were made in the Revived Rococo style.

Sloane, Sir Hans, **flowers**, a Chelsea motif 1752–6, taken from botanical handbooks, especially P. Miller's *Gardener's Dictionary* of 1752. Miller was in charge of the Chelsea Botanical Gardens, the patron of which was Sir Hans Sloane.

Smear glaze, a thin, delicate glaze on some English bisque porcelain; it is only faintly visible.

Soft paste *see* Pâte tendre

Soft-paste porcelain, all bodies fired at a temperature below 1,350°C. There are two principal types of soft-paste porcelain:

1) that with a lower kaolin content than hard-paste porcelain, i.e. less than 30 %; this includes all oriental porcelain as well as some English types such as bone china;
2) frit porcelain, usually made without kaolin, but of non-ceramic materials.

Solitaire (Fr.), a tea or coffee service for one person.

Spode, Josiah, b. 1754, d. 1827, son of Josiah Spode the elder; he took over the family firm and in 1795 improved the "bone-ash paste" which then became standard English porcelain body of the nineteenth century (English bone china or bone porcelain). Spode ware was of a high technical standard.

Statuary porcelain *see* Parian porcelain

Stöltzel, Samuel, b. 1685 Scharffenberg, d. 1737 Meissen, a kiln master skilled in the preparation of porcelain for firing. He worked with Böttger in Meissen from 1705, leaving to work with Du Paquier in Vienna in 1719. After starting porcelain production there he returned to Meissen in 1720, with the painter J. G. Höroldt.

Stone china, not true porcelain, but stoneware resembling porcelain in appearance, invented by John Turner about the year 1800. In 1805 Josiah Spode was granted a patent for this ware, which he called "stone china" or "new china". A similar body was patented in 1813 by C. J. Mason of Lane Delph in Staffordshire, and called "Mason's Ironstone China". It is also sometimes called "Patent Ironstone China".

Strasbourg 1751–4

Strasbourg 1766–81

Strasbourg, a French factory, 1751–4 and 1768–81. In 1745 Paul Anton Hannong experimented with porcelain in the faience works founded in 1721, but was not successful until J. J. Ringler joined him in 1751. In 1754 production was suspended because it infringed the monopoly granted to the Vincennes factory, and Hannong

142 Schwannenservice, plate, Meissen, after 1740; diameter 23 cm

moved his factory to Frankenthal. After the Sèvres monopoly was abrogated Joseph Adam Hannong made porcelain during 1768–81, but was forced to leave Strasbourg when he got into financial difficulties and could not pay his debts. The porcelain of 1751–4 was of good quality, and was followed closely by the Frankenthal factory; the 1768–81 production was of poor quality.

Stuff painter (Germ. Staffierer, Fr. étoffeur), a painter working in the porcelain factory and decorating not only figures, but also the raised ornament on table ware.

Sulkowskimuster *see* Sulkowski-Service

Sulkowski-Service (Germ.), first large table service made by Meissen, 1735–7. It was designed by Kaendler; besides the basketweave pattern ("Sulkowski-Ozierrelief") in bas-relief, the dishes were decorated with figures (half-length women's figures, putti heads, lions, etc.) and every piece of the service bore the Sulkowski-Stein coats of arms overglaze painted. The service was commissioned by the Saxon-Polish minister, Count A. J. Sulkowski.

Tebo, a modeller in the Bow factory (about 1752–68), Plymouth (1768–9), Worcester (1769–72) and Bristol (1772–4), probably a Frenchman whose real name may have been Thibaud.

Tête-à-tête *see* Déjeuner

Tournai (Flem. Doornik), a Belgian factory, 1750–1850, the first in the country, founded in 1750 by F. J. Peterinck. The arcanists were the brothers Robert and Gilles Dubois of Vincennes.

201

143 Solitaire, painted after oriental lacquer work, Vienna, c. 1795; jug 12.3 cm high; tray diameter 31.3 cm

1751–60

1756 to end
of the 18th century

Tournai

The factory made frit porcelain until it was sold in 1850 to the Boch brothers, who made earthenware up to 1891. Tournai porcelain was very popular and was exported widely throughout Europe. White ware was often decorated by A. Lijncker in The Hague.

Transfer-printing (Germ. Druckdekor), the decoration of porcelain by means of copperplate engravings transferred to the ware on paper or some other suitable material, and coloured. It was first used in England by R. Hancock and S. F. Ravenet at Bow in 1756, and spread to the Continent through Sweden. From the first half of the nineteenth century it came into universal use.

Trembleuse (Fr.), a cup for a "trembling hand", held on the saucer by a ring, sometimes in openwork; made by all the porcelain factories in the eighteenth century.

Tschirnhaus(en), Ehrenfried Walter von, b. 1651 Kieslingswalde, d. 1708 Dresden, physicist and mathematician, entrusted by the Elector Augustus the Strong with a survey of the natural resources of Saxony. In the 1760s he began to experiment with ceramics, arriving at a frit (?) porcelain body. He was charged with the supervision of Böttger's experiments in alchemy, and

144 Plate from the Sulkowski-Service, Meissen, after 1735; diameter 38.6 cm

turned the latter's attention to ceramics. He died before the Meissen factory was founded. Tschirnhaus is regarded as one of the inventors of European hard-paste porcelain.

Tureen, a covered dish for soup or vegetables, first made in the first half of the seventeenth century. In eighteenth-century services it was the main feature, and was therefore designed with particular care.

United States Pottery, founded in 1847 in Bennington, Vermont, by Christopher W. Fenton, producing various types of soft-paste porcelain such as "flint enamel ware", Belleek porcelain and Parian porcelain, both table ware and figures. The "corn pitcher" was an original American design. The factory closed down in 1858.

Veilleuse *see* Réchaud

Venice (Italy), factories:
Vezzi, 1720–27. When C. C. Hunger left Vienna he went to Venice, where he helped the Vezzi brothers, who were goldsmiths, to set up the first porcelain factory in Italy, They made hard-paste porcelain, using kaolin imported from Aue in Saxony. When the export of kaolin was prohibited in 1727 the Vezzi factory closed down. The ware was translucent, cream-coloured, grey

Ven à

Venice: Vezzi 1720–7

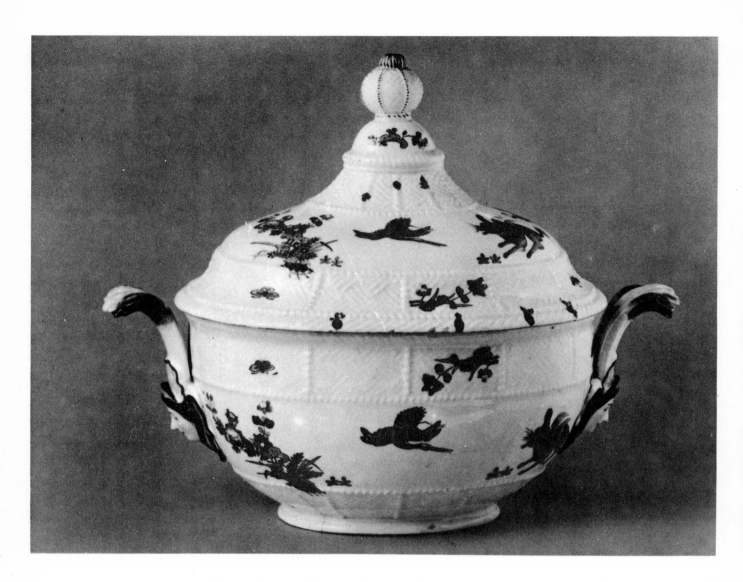

145 Tureen with the raised Sulkowski-Ozier pattern and Kakiemon style painted decoration, Meissen, after 1735; height with cover 27.5 cm

or white, and was decorated with underglaze blue before the technique was introduced in Meissen. Hewelcke, 1758–63. In March 1758 the Senate of Venice granted a twenty-year monopoly of porcelain production to a Dresden merchant, Nathaniel Friedrich Hewelcke. He formed a company with the banker G. Cozzi, and the monopoly was passed on to P. Antibono of Le Nove in April 1763. The factory used kaolin from Tretto, near Vicenza; the body was yellowish.

Cozzi, 1765–1812. The banker was granted a monopoly by the Senate in 1765, and seems to have used Tretto kaolin; his hard-paste porcelain was decorated at first with oriental motifs, later copying Meissen decoration. From 1769 Cozzi also produced maiolica and from 1781 stoneware after the English model. The factory closed down in 1812. The body of the porcelain was very grey, and the glaze had a hard gleam.

Venice: Hewelcke 1758–63

Venice: Cozzi 1765–1812

Verbilki, Moscow, a Russian factory 1766 to the present day. The factory was founded by an Englishman, Francis Gardner, who was granted a patent on 21st February 1766, and remained in the family until 1891, when M. S. Kuznetsov became the owner. The table ware was excellent, and the services decorated with the emblems of the Orders of St. Vladimir, St. George, St. Andrew and St. Alexander Nevsky (1778, 1780, 1785) were famous.

1765–1800 1765–1800

Verbilki

Vermiculé (Fr.). an all-over Sèvres pattern in the 1750s formed of twisting worm-like lines imitating marble, sometimes on a pink or blue ground.

Vestunenmuster (Germ.), a raised pattern on Meissen ware, with floral garlands alternating with cherubs' heads and ribbons. The plates were edged with an openwork chain pattern, with raised flowers. The pattern was said to have been drawn by Frederick the Great of Prussia himself in 1762; J. J. Kaendler designed the service.

Vienna, an Austrian factory, 1718–1864, founded in 1717 by Du Paquier, who was granted a patent in 1718. C. C. Hunger of Meissen was the arcanist, but his experiments were not successful; in 1719 S. Stöltzel also came over from Meissen, and the first porcelain was fired. In 1744 Du Paquier sold the factory to the state when he ran into financial difficulties, and it was state-run until it closed down in 1864. Vienna porcelain is dated in three periods:
1) the Du Paquier period (1718–44), known as "Wien vor der Marke" because the ware was not marked; table ware after oriental and Meissen models, with Indian flower decoration, and later also with European flowers; black painted decoration (Schwarzlot) was popular;
2) 1744–84, with Rococo as the prevailing style, and scenes from Watteau and Boucher as the decoration; figures modelled chiefly by J. J. Niedermayer are of interest;
3) 1784–1864, at first characterized by the Neoclassical style introduced by the director K. von Sorgenthal and modelled by A. Grassi. The early nineteenth century saw the finest period of Vienna ware, with painted scenes of Vienna and landscapes. Sèvres exerted a strong influence. Later, in the period of historical romanticism, the standard declined, and in 1864 the factory closed down.

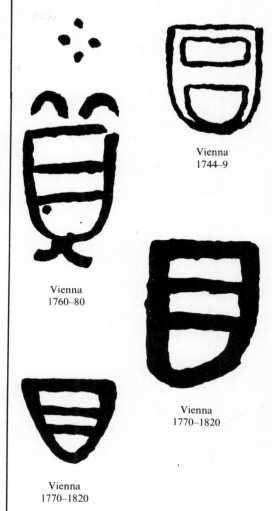

Vienna
1744–9

Vienna
1760–80

Vienna
1770–1820

Vienna
1770–1820

Vincennes-Sèvres, a French factory, 1738 to the present day, founded in 1738 by Orry de Fulvy, with the Dubois brothers as arcanists. They were unsuccessful, and were succeeded by F. Gravant who found a suitable frit porcelain in 1745. The limited company set up that year was granted the monopoly of porcelain "à la façon Saxe". Among the shareholders in the new company formed in 1752 was the King of France. A monopoly granted in 1753 included all ceramic ware with coloured decoration. In 1756 the factory was moved to Sèvres, and from 1759 it was royal property. Hard-paste porcelain was introduced in 1772, and the monopoly of coloured ornament was withdrawn in 1780. From 1804 only hard-paste porcelain was made. The factory became the Emperor's private property in 1805. At first Sèvres ware was strongly influenced by Meissen. In the middle of the eighteenth century it became famous for raised floral designs. Soft-paste porcelain could make use of

a wide range of luminous colours which could not stand the high temperatures of hard-paste production, the most famous ground colours being "bleu de roi" and "rose Pompadour"; they were often heightened with gold, applied in several shades. The reserve panels were painted with scenes in the Boucher style, and later in Louis Seize and Empire styles. Designs for Sèvres figures came from famous French artists, chief among them F. Boucher. The soft-paste porcelain was particularly suitable for bisque ware. After 1800, under Napoleon, Sèvres exerted its greatest influence on porcelain throughout Europe, imitated not only by all the German factories, including Meissen and Berlin, but elsewhere as well, especially Vienna.

Vinovo 1776–80

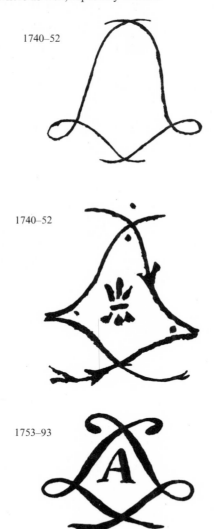

1740–52

1740–52

1753–93

Vincennes

Vinogradov, Dimitry Ivanovich, b. 1720, d. 1758, a Russian arcanist, by profession a mining engineer, who made the first Russian hard-paste porcelain in the Czarist factory in St. Petersburg early in 1747. In 1749 he improved the body, so that good quality porcelain was made.

Vinovo, an Italian factory, 1776–1820, founded by the broker Giovanni Vittorio Brodel with Peter Anton Hannong of Strasbourg as his arcanist. In 1780 the factory was taken over by D. Vittorio Gioanetti, who ran it until 1796. It was then closed until Giovanni Lomello started production again in 1815. In 1820 it closed down for good. Vinovo ware is cream-coloured, and although kaolin is used the body resembles French frit porcelain in structure.

1760–87

1795–1807

Volkstedt

Volkstedt, a German factory, 1760 to the present day, founded in Sitzendorf to make porcelain according to the formula invented by G. H. Macheleid in 1760, independently of Böttger. In 1762 the factory was moved to Volkstedt; the company rented it out to C. Nonne, 1767–97, and then sold it to Prince von Hessen-Philippsthal. During the nineteenth century it changed hands several times, and after the Second World War it became a state enterprise. The porcelain was influenced by Meissen ware; under Nonne Watteauesque themes were popular. About ninety groups of figures are known, and pot-pourri jars are interesting.

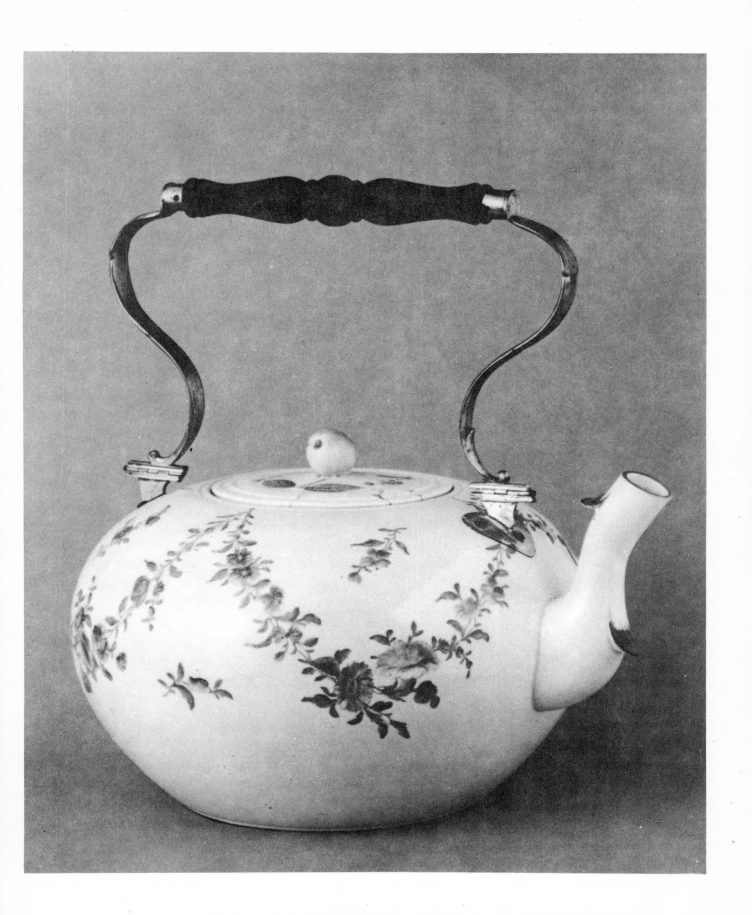

146 Teapot, Weesp, c. 1765; height without handle 14.5 cm. Private collection, Prague

Wallendorf 1763–87

Wallendorf, a German factory, 1764 to the present day, founded in 1763 by J. W. Hammann. and the brothers Johann Gotthelf and Johann Gottfried Greiner. G. Greiner left in 1772, and the factory remained in the Hammann family until 1833, when it was sold to Friedrich Christian Hutschenreuther, F. Kämpfe and G. Heubach. In 1897 a limited company was formed. In the eighteenth century Wallendorf copied Meissen ware in a rustic manner, for sale in the country and to town families. The quality improved towards the end of the century, in the ground colours, the painting and figure modelling.

Wappenporzellan (Germ.), a comprehensive term for porcelain (usually table ware) on which the central motif is the owner's coat of arms. European customers began to order this decoration on porcelain imported from China (the earliest known examples date from the sixteenth century). Most of the armorial porcelain made in Europe dates from the mid eighteenth to the mid nineteenth centuries; the first Meissen service of this type which is dated was made for the King of Sardinia in 1725.

Weesp 1759–71

Weesp, a Dutch factory, 1757–71; a faience factory set up in 1757 was bought in 1759 by Count van Gronsveldt-Diepenbroik, who brought in the German arcanist N. Paul. Hard-paste porcelain was made from 1762. The factory closed in 1771. The porcelain body was white and glass-like.

Wegely, Wilhelm Caspar, b. 1714 Berlin, d. 1764 Berlin, a woollen cloth manufacturer who found-ed the first porcelain factory in Berlin in 1751, with a monopoly granted by Frederick II. He seems to have acquired the arcanum from J. Benckgraff of Höchst, and N. Paul of Höchst helped with production. At its height the factory employed as many as 150 workers. The Seven Years War and lack of government support forced Wegely to close down in 1757.

White Granite *see* Granite ware

White-ware
1) any white porcelain glazed but not decorated;
2) eighteenth century salt-glazed white stoneware;
3) Granite ware.

Worcester (all 1755–90)

Worcester, an English factory, 1751 to the present day, founded in 1751 by a group headed by W. Davil and Dr. J. Wall the chemist. In 1752 they bought Lund's Bristol workshop and moved it to Worcester. In 1783 the Flight family bought the factory, later joined by the Barr family, and their initials formed a new mark. After changing hands several times in the first half of the century, the factory became the property of the "Royal Worcester Company" in 1862. In the eighteenth century Worcester porcelain was made with steatite from Cornwall, giving an excellent body for table ware. Worcester porcelain was already being imitated in the eighteenth century (Caughley, Lowestoft).

Würzburg, a German factory, 1775–80, owned by the chancery and consistory councillor J. C. Geyger. The hard-paste porcelain made here varied very much in quality, and included both table ware and figures. The decoration was painted by Geyger himself and by the miniature painter H. Tünnich, while the Würzburg sculptor F. Tietze modelled figures of all kinds.

Zurich, a Swiss factory, 1763–90, founded in 1763 by company, with Adam Spengler as manager. Hard-paste and French-type frit porcelain and faience were all made there. Of the modellers we should mention V. Sonnenschein and J. Nees, and of the painters S. Gessner and J. Daffinger.

Zurich

European Porcelain Factories in the Eighteenth Century and their Important Modellers

Factory	Modellers
Ansbach 1758–1860	Georg Ludwig Bartholomae 1767–70
	Georg Dengler c. 1785
	Johann Friedrich Kaendler 1758–91
	Carl Gottlob Laut 1758–1802
	Johann Friedrich Scherber 1764–6
	Karl August Weidel 1793–1817
Berlin 1751–7 (Wegely) 1761–present	Friedrich Elias Meyer 1761–85
	Wilhelm Christian Meyer 1766–72
	Johann Georg Müller 1763–89
	Ernst Heinrich Reichard 1751–64
	Johann Karl F. Riese 1770–1834
Bow 1744–76	Tebo c. 1752–63
Bristol 1748–52 1770–82	Thomas Briand c. 1777
	Pierre Stephan c. 1772
	Tebo 1772–4
Buen Retiro 1760–1808	Carlos Frate c. 1775
	Carlos Fumo c. 1775
	Gaetano Fumo from 1760
	Ambrogio di Giorgio from 1760
	Carlos Gricci died 1795
	Felipe Gricci died 1803
	Giuseppe Gricci died 1770
	Stefano Gricci from 1760
	Juan López c. 1800
Capodimonte 1743–59	Gaetano Fumo 1745–59
	Giuseppe Gricci 1743–59
	Stefano Gricci 1743–59
Chantilly 1725–1800	Louis Fournier 1752–9
	Louis-Jacques Goujon 1736
Copenhagen 1759–present	Louis Fournier 1759–66
	Andreas Madsen Hald 1780–1811
	Jesper Johansen Holm 1780–1816
	Gert Nielsen Kalleberg 1779–1811
	Anton Carl Luplau 1776–95
	Johann Jacob Schmid 1779–86
	Jacob Schmidt 1778–1807
	Frederik Sigmann 1777–88
	Simon Carl Stanley 1759–61
	Claus Rasmussen Tvede 1775–84
Derby 1745–present	William Coffee 1794–1810
	George Holmes 1765–87
	Andrew Planché 1756
	John Charles Felix Rossi 1788–9
	Johann Jakob Spengler 1790–6
	Pierre Stephan 1770–3
Doccia 1737–present	Gaspare Bruschi up to 1778
	Giuseppe Bruschi up to 1778
Ellwangen 1758–9	Joseph Nees 1758

211

Frankenthal	Adam Clair (Clär) 1776–99
1755–99	Adam Bauer 1777–8
	Simon Failner 1770–97
	Johann Wilhelm Lanz 1755–61
	Franz Konrad Linck 1762–80
	Johann Friedrich Lück 1758–64
	Karl Gottlieb Lück 1758–75
	Johann Peter Melchior 1779–93
	Peter Anton von Verschaffelt 1762–93
Fulda	Georg Ludwig Bartholomae 1770–88
1764–89	Wenzel Neu 1768–74
	Johann Valentin Schaum 1765
	Johann Georg Schumann from 1765
Fürstenberg	Desoches 1769–74
1747–present	Simon Feilner 1753–68
	Johann Georg Leimberger 1755–63
	Anton Carl Luplau 1759–76
	Johann Christoph Rombrich 1758–94
	Carl Gottlieb Schubert 1778–1808
Höchst	Jacob Carlstadt 1769–71
1746–96	Johann Gottfried Becker 1746–56; 1759–60
	Simon Feilner 1751–3
	Eberhard Laurentius Heller 1746–54; 1757–79
	Jakob Melchior Höckel 1759–67; 1775–89
	Johann Christoph Kilber 1753–6; 1773–6
	Christian Gottlob Lück 1758–64
	Johann Friedrich Lück 1758
	Karl Gottlieb Lück 1758
	Johann Peter Melchior 1767–79
	Johann Jakob Meyer 1773–8
	Karl Ries 1774–92
	Laurentius Russinger 1753–67
	Carl Vogelmann 1777
Kloster-Veilsdorf	Franz Kotta 1777–8
1760–present	Wenzel Neu 1762–7
Ludwigsburg	Adam Bauer 1765–77
1758–1824	Johann Christian Wilhelm Beyer 1759–67
	Cornelius Carlstadt 1765–71
	Jacob Carlstadt 1766–9
	Johann Heinrich Dannecker c. 1790–c. 1795
	Johann Christoph Haselmeyer 1760–71
	Domenico Ferretti 1764–7
	Johann Göz 1759–62
	Pierre François Lejeune 1768–78
	Jean Jacques Louis 1762–72
	Johann Jakob Mayer 1765–75
	Josef Nees 1759–68
	Gottlieb Friedrich Riedel 1759–79
	Peter Adam Seefried 1766–7
	Philipp Jacob Scheffauer c. 1790–5
	Johann Heinrich Schmidt 1766–1821
	Johann Valentin Sonnenschein 1770–5
	Carl Vogelmann 1759–61
	Joseph Weinmüller 1765–7
Meissen	Michel-Victor Acier 1764–81
1710–present	Johann Friedrich Eberlein 1735–49
	Christian Gottfried Jüchtzer 1769–1812
	Johann Joachym Kaendler 1731–75
	Johann Gottlieb Kirchner 1727–8; 1730–3
	Christian Gottlob Lück 1764–97
	Johann Friedrich Lück 1741–57; 1764–97
	Karl Gottlieb Lück 1744–57
	Johann Christoph Ludwig Lück 1728–9
	Johann Gottlieb Matthäi 1773–95

	Friedrich Elias Meyer 1748–61
	Karl Christoph Punet 1762–5
	Peter Reinicke 1743–68
	Johann Karl Schönheit 1745–1805
Nymphenburg	Dominicus Auliczek 1763–97
1747–present	Franz Anton Bustelli 1754–63
	Franz Josef Ess 1764–75
	Johann Peter Melchior 1797–1822
	Joseph Ponhauser 1754–5
	Peter Anton Seefried 1756–66; 1769–1810
Niderviller	Charles Gabriel Sauvage, known as Lemire père after 1775–1806
1765–1827	
Plymouth	Tebo 1768–9
1768–1770	
St. Petersburg	Karlowski 1768–?
1744–present	Antoine Jacques Dominique Rachette 1779–1804
Sèvres-Vincennes	Blondeau 1752–3
1738–present	Boileau fils aîné 1773–81
	Le Boîtteux 1752
	Bourdois 1773
	Jean-Charles-Nicolas Brachard aîné 1782–1805; 1806–24
	Jean-Nicolas-Alexandre Brachard jeune 1784–92; 1795–9; 1802–27
	Henri Florentin Chanou 1746–79; 1758–92
	Jean-Baptiste Chanou 1779–84; 1785–9; 1790–1825
	Delatre cadet 1745–58
	Depierreux 1746–8
	Desprez 1774–92
	Claude-Thomas Duplessis 1745–c. 1755
	Etienne-Maurice Falconet 1757–66
	Louis Fournier 1747–9
	Nicolas Joseph Gauron 1754
	Letourner 1756–62
	Jacques-Jean Oger 1784–1802; 1802–21
	Josse-François-Joseph Le Riche 1757–1801
	Le Tronne 1753–7
	Vandervoost 1752
Strasbourg	Johann Wilhelm Lanz (1748) 1751–4 (1755)
1751–4	
Vienna	Domenico Bosello c. 1770
1718–1864	Franz Caradea before 1770–after 1784
	Leopold Dannhauser before 1744–1786
	Anton Grassi 1778–1807
	Elias Hütter 1789–1857
	Johann Christoph Ludwig Lück 1750–1
	Johann Joseph Niedermayer 1747–84
	Martin Schneider 1780–83
Zurich	Gabriel Klein 1780–90
1763–90	Johann Jakob Mayer 1764
	Josef Nees 1768–75
	Johann Valentin Sonnenschein 1775–9
	Johann Jakob Wilhelm Spengler 1772–7
Zweibrücken	Jakob Melchior Höckel 1767–75
1767–75	Laurentius Russinger 1767–8

213

Bibliography

Alfasa, P. – Guérin, J.: Porcelaine française du XVIIᵉ au milieu du XIXᵉ siècle; Paris 1932

Ballu, Nicole: La porcelaine française; Paris 1958

Barber, Edwin AtLie: The Pottery and Porcelain of the United States and Marks of American Potters; New York 1909 (reprinted 1976)

Batet, Leo: Ludwigsburger Porzellan; Stuttgart 1911

Berdel – Harkort: Keram. Praktikum; Coburg 1958 (second edition)

Berges, Ruth: From Gold to Porcelain; New York – London 1963

Bing et Grøndahl manufacture de porcelaine Copenhague; Paris 1925

Boger, L. A.: The Dictionary of World Pottery and Porcelain; New York 1971

Böhm, L.: Frankenthaler Porzellan; Mannheim 1960

Bourgeois, Émile – Lechevalier-Chevignard, Georges: Le biscuit de Sévres. Recueil des modèles de la manufacture de Sèvres au 18ᵉ siècle; Paris (undated)

Braun-Ronsdorf, M.: 200 Jahre Nymphenburger Tafelgeschirr; Darmstadt (undated)

Brožová, Jarmila: Historismus – umělecké řemeslo 1860–1900. Exhibition catalogue; Prague 1975

Brunet, M: Les marques de Sèvres; Paris 1953

Brüning, Adolf: Kupferstiche als Vorbilder für Porzellan (*Kunst und Kunsthandwerk* 8, 1905)

Burton, W.: A General History of Porcelain, London 1921

Chaffers, W.: A Collector's Handbook of Marks and Monograms on Pottery and Porcelain; London 1952 (third edition)

Chavagnac – Grollier: Histoire des manufactures françaises de porcelaine; Paris 1906

Christ, Hans: Ludwigsburger Porzellanfiguren; Stuttgart – Berlin 1921

Chrościcki, L: Porcelana – znaki wytwórni europejskich; Warsaw 1974

Clark, Garth – Hughto, Margie: A Century of Ceramics in the United States 1878–1978; New York 1979

Csányi, Karl: Geschichte der ungarischen Keramik, des Porzellans und ihre Marken; Budapest 1954

Danckert, Ludwig: Handbuch des europäischen Porzellans; Munich 1954 (second edition 1967)

Dauterman, Carl Christian: Sèvres; London 1970

Daydí, M. O.: Das europäische Porzellan von den Anfängen bis zum Beginn des 19. Jahrhunderts; Berlin 1955

Deonna, W.: Porzellanfabrikation in Nyon (*Pro Arte*, May 1947)

Diebitsch, C.: Figuren. Die Porzellanplastik einst und jetzt; Bamberg 1959

Diviš, Jan: Pražský figurální porcelán (*Acta Musei Pragensis* 80); Prague 1980

Döry, L: Höchster Porzellan; Frankfurt-am-Main 1963

Ducret, Siegfried: Deutsches Porzellan und deutsche Fayencen; Baden–Baden 1962

Ducret, Siegfried: Keramik und Grafik des 18. Jahrhunderts. Vorlagen für Maler und Modelleure; Brunswick 1973

Eisner Eisenhof, Angelo de: Le Porcellane di Capodimonte; Milan 1925

Emme, B. N.: Russky khudozestvenny farfor; Moscow – Leningrad 1950

Erichsen–Firle, Ursula: Figürliches Porzellan; Katalog des Kunstgewerbemuseums; Cologne 1975

Ernst, R.: Wiener Porzellan des Klassizismus. Die Slg. Bloch–Bauer; Vienna 1925

Festschrift H. Seger; Goslar 1959

Folnecics, J. – Braun, E. W.: Geschichte der K. K. Wiener Porzellan-Manufaktur; Vienna 1907

Forberger, R. – Walcha, O. – Mields, M.: 250 Jahre Staatliche Porzellan-Manufaktur Meissen; Meissen 1960

Frothingham, A. W.: Capodimonte and Buen Retiro porcelains, period of Charles porcelains; New York 1955

Garnier, E.: La porcelaine tendre de Sèvres; 1891

Godden, Geoffrey A.: Victorian Porcelain; London 1962

Godden, Geoffrey A.: Encyclopedia of British Pottery and Porcelain Marks; London 1964

Godden, Geoffrey A.: British Pottery and Porcelain 1780–1850; London 1968

Gollerbach, Eric: La porcelaine de la Manufacture d'État; Moscow 1922

Graesse, J. G. – Jaennicke. E.: Vollständiges Verzeichnis der auf älterem und neuem Porzellan, Steingut usw. befindlichen Marken; Brunswick 1967

Graul, R. – Kurzwelly, A.: Altthüringer Porzellan; Leipzig 1910

Gröger, W.: Johann Joachim Kaendler, der Meister des Porzellans; Dresden 1956

Hackenbroch, J.: Chelsea and Other Porcelain; (undated)

Hannover, E. – Rackham, B.: European Porcelain; London 1925

Hayden, Arthur: Kopenhagener Porzellan; Leipzig 1924 (also in English)

Hayward, J. F.: Viennese Porcelain of the Du Paquier Period; London 1952

Hegeman, H.: Die Herstellung des Porzellans; 1938

Hermarck, Carl: Fajans och Porslin; Stockholm 1959

Hofmann, F. H.: Das europäische Porzellan des Bayerischen Nationalmuseums München; Munich 1908

Hofmann, F. H.: Frankenthaler Porzellan; 1911

Hofmann, F. H.: Geschichte der Bayerischen Porzellan-Manufaktur Nymphenburg; Leipzig 1923

Hofmann, F. H.: Das Porzellan der europäischen Manufakturen des 18. Jahrhunderts; Berlin 1932

Honey, W. B.: English Pottery and Porcelain; London 1945

Honey, W. B.: Dresden China; London 1947

Honey, W. B.: Eighteenth-Century French Porcelain; London 1950

Honey, W. B.: European Ceramic Art from the End of the Middle Ages to about 1815; London 1952

Hood, Graham: Bonnin and Morris of Philadelphia. The First American Porcelain Factory, 1770–1772; Williamsburg 1972

Horn, O.: Die Münzen und Medaillen aus der Staatlichen Porzellan-Manufaktur zu Meissen; Leipzig 1923

Hurlbrett, F.: Chelsea China; Liverpool – London 1937

Jedding, H.: Europäisches Porzellan, vol. I; Munich 1971

Jiřík, F. X.: Porculán; Prague 1925

Jiřík, F. X.: Ruský porcelán; Prague 1926

Josten, H.: Fuldaer Porzellanfiguren; Berlin 1929

Köllmann, Erich: Berliner Porzellan 1763–1963; Brunswick 1966

Köllmann, Erich: Meissner Porzellan. Ein Brevier; Brunswick 1971 (fourth edition)

Kowecka, Elźbieta: Polska porcelana; Wrocław 1975

Landais, H.: Porcelane francesi; Milan 1962

Landberger, M.: Alt-Ludwigsburger Porzellan. Austellungskatalog; Stuttgart 1959

Lane, Arthur: Italian Porcelain; London 1954

Lane, Arthur: English Porcelain Figures of the 18th Century; London 1961

Lansere, A. K.: Russky farfor; Leningrad 1968

Lauschke, R.: Praxis der Porzellanmalerei; Leipzig 1965

Lechevalier-Chevigniard, H.: La Manufacture de porcelaine de Sèvres; Paris 1908

Leistikow-Duchardt, Annelore: Die Entwicklung eines neuen Stiles im Porzellan; Heidelberg 1957

Lenz, A.: Die landgräfliche Porzellanmanufaktur zu Kassel (*Jahrb. der Preuss. Kunstslgn.*, Berlin II; undated)

Liebscher, I. – Willert, F.: Technologie der Keramik; Dresden 1955

Liverani, G.: Catalogo delle porcellane dei Medici; Faenza 1936

Ludwigsburger Porzellan in Württemberg. Landesmuseum; Stuttgart 1970

Lukomsky, G.: Russisches Porzellan 1744–1923; Berlin 1923

Mackenna, F. S.: Chelsea Porcelain; Leigh-on-Sea 1948–52

Mayer, H.: Böhmisches Porzellan und Steingut; Leipzig 1927

Miller, J. Jefferson: The Porcelain Trade in America (*Discovering Antiques* 1971, I, 43)

Mitchell, James R.: The American Porcelain Tradition (*The Connoisseur* 1972, vol. 179)

Morazzoni, G. – Leni, S.: Le porcellane italiane; Milan 1960

Morley–Fletcher, H.: Meissen; London 1970

Mrazek, Wilhelm: Wiener Porzellan aus der Manufaktur Du Paquiers (1718–1744); Vienna 1952

Neuburger, A.: Echt oder Fälschung?; Leipzig 1924

Neuwirth, Waltraud: Porzellan aus Wien. Von du Paquier zur Manufaktur im Augarten; 1974

Neuwirth, Waltraud: Wiener Porzellan, echt oder gafälscht; Vienna 1976

Neuwirth, Waltraud: Porzellanmaler Lexikon 1840–1914; Brunswick 1977

Nikiforova, L. R.: Russky farfor v Ermitazhe; Leningrad 1973

Pappilon, G.: Musée national de la céramique de Sèvres; Paris 1921

Pazaurek, Gustav: Deutsche Fayence- und Porzellan-Hausmaler; Leipzig 1925

Pazaurek, Gustav: Meissner Porzellanmalerei des 18. Jh.; Stuttgart 1929

Pelichet, E.: Merveilleuse Porcelaine de Nyon; Lausanne 1973

Penkala, M.: European Porcelain. A Handbook for the Collector; London 1947

Pfeiffer, B.: Alt-Ludwigsburg; 1906

Poche, Emanuel: Český porcelán; Prague 1954

Poche, Emanuel: Porzellanmarken aus aller Welt; Prague 1978 (third edition)

Porcelaines (Catalogue of the exhibition "Porcelaine de Paris de 1800–1850"); Sèvres 1970

Rada, Pravoslav: Techniken der Kunsttöpferei; Berlin 1960

Rakebrand, H.: Meissner Tafelgeschirre des 18. Jahrhunderts; Darmstadt (undated)

Reinhecke¹, Günter: Plast. Dekorationsformen in Meissner Porzellan des 18. Jahrhunderts (*Keramos* 41/42, 1968)

Röder, Kurt: Das Kelsterbacher Porzellan; Darmstadt 1931

Rollo, Charles: Continental Porcelain of the Eighteenth Century; London – Toronto 1964

Rosenfeld, David: Porcelain Figures of the Eighteenth Century; London – New York 1949

Ross, Marvin C.: Russian Porcelains; Norman 1968

Rostock, Xenius: The Royal Copenhagen Porcelain Manufactory and the Faience Manufactory Aluminia; Copenhagen 1939

Rückert, R.: Franz Anton Bustelli; Munich 1963

Rückert, R.: Meissner Porzellan 1710–1810 (Catalogue); Munich 1966

Saure, W.: Die Ursprünge von Sèvres Porzellan von Vincennes (*Weltkunst* 47, 1977)

Savage, G.: 18th-Century English Porcelain; London 1952

Savage, G.: 18th-Century German Porcelain; London 1958

Savage, G.: Seventeenth- and Eighteenth-Century French Porcelain; London 1960

Savage, G.: Porcelain through the Ages; London 1961

Savage, G. – Newman, H.: An Illustrated Dictionary of Ceramics; London 1974

Schade, G.: Berliner Porzellan; Leipzig 1978

Scherer, Christian: Das Fürstenberger Porzellan; Berlin 1909

Scherf, H.: Altthüringer Porzellan; Leipzig 1969

Schmidt, Robert: Das Porzellan als Kunstwerk und Kulturspiegel; Munich 1925

Schnorr von Carlosfeld, L.: Porzellan der europäischen Fabriken; Brunswick 1974 (sixth edition)

Schönberger, Arno: Deutsches Porzellan; Munich 1949

Schwartz, Marvin D. – Wolfe, Richard: A History of American Art Porcelain; New York 1967

Sempill, C.: English Pottery and Porcelain; London 1945

Seyffarth, Richard: Von Pfuschern und Fälschern (*Keramos* 1966, p. 123 ff.)

Shono Masako: Japanisches Aritaporzellan im sogenannten "Kakiemonstil" als Vorbilder für die Meissner Porzellanmanufaktur; Munich 1973

Sovetsky khudozhestvenny farfor. Catalogue; Moscow 1962

Spargo, John: Early American Pottery and China; New York 1926

Syz, H.: Some Oriental Aspects of European Ceramic Decoration (*Antiques*, May, July and August 1969)

Tait, Hugh: Porcelain; London 1962

Tilmans, Émile: Porcelaines de France; Paris 1953

Verlet, P. – Grandjean, S. – Brunet, M.: Sèvres; Paris 1953

Walcha, O.: Meissner Porzellan; Dresden 1973

Ware, G. W.: German and Austrian Porcelain; Frankfurt-am-Main 1951

Weiss, Gustav: Ullstein Porzellanbuch; Berlin 1966

Widmann, J. – Handt, I. – Rakebrand, H.: Meissner Porzellan des achtzehnten Jahrhunderts 1710–1750; Dresden 1956

Zick, Gisela: D'après Boucher (*Keramos* 29, 1965)

Zimmermann, E.: Meissner Porzellan; Leipzig 1926

Zoelner, Adalbert: Das Buch vom Porzellan; Leipzig 1925

List of Illustrations

Unless otherwise indicated, the pieces illustrated are from the collections of the Museum of Decorative Arts, Prague

29 Cup and saucer in "Leithner blue" camaïeu, Vienna, 1795; cup 8 cm high

30 Silhouette of Kaendler, c. 1740. VEB Staatliche Porzellan-Manufaktur, Meissen

31 A page from J. J. Kaendler's sketchbook. VEB Staatliche Porzellan-Manufaktur, Meissen

32 Crinoline group (The clavichord), Meissen, modelled by J. J. Kaendler, 1741 (the painting is later); 16 cm high

33 The Albrechtsburg fortress, Meissen; the lift needed for timber for the factory can be clearly seen. VEB Staatliche Porzellan-Manufaktur, Meissen

34 Love's Test (Liebesprüfung), Meissen, M. V. Acier, 1774; 23 cm high

35 St. John the Baptist, Meissen, c. 1800; 20.4 cm high

36 Plate from the hunting service for Prince Trivulzio, Vienna, apparently painted by J. Helchis, 1735–40; diameter 25 cm

37 The Czech Princess Libuše, painted on porcelain, signed A. A. v. Z (Ant. Anreiter), 1756; 7.4 × 5.5 cm

38 Part of the table decoration for Prince Franz Joseph Auersperg, Vienna, 1749; 18 cm high

39 Chinaman with a lute, Nymphenburg, modelled by F. A. Bustelli, c. 1760; 16.8 cm high

40 Mercury, Berlin, modelled by F. E. Meyer, c. 1763; 34.2 cm high

41 Lidded jug with floral design in purple, Wallendorf, c. 1780; 24.7 cm high

42 Plate with design of everlasting flowers in cobalt blue, Gera, c. 1790; diameter 23 cm

43 Lidded jug with design of everlasting flowers in cobalt blue, Gotha, c. 1795; 16.5 cm high

44 Lidded jar with Bérain decoration in blue, St. Cloud, after 1700; 10.3 cm high

45 Paris and Helen, Vienna, modelled by J. J. Niedermayer, 1755–60; 28.5 cm high. Private collection, Prague

46 Vase with raised floral decoration ("Vase Duplessis à fleurs ballustre rocaille"), Vincennes, 1752; 22.5 cm high

47 Cup and saucer, Sèvres, painted by F. Aloncie, "bleu lapis" ground, 1771; cup 5.8 cm high

48 Plate with "European flowers" and a gallant scene, Chelsea, after 1760; diameter 28.5 cm

49 Plate with scale background and exotic birds and beetles, Worcester, after 1760; diameter 28.5 cm

50 Part of a coffee service, Berlin, 1765–70; pot 21 cm high

51 Allegorical figure of Water, from a set "Die vier Elemente", Berlin, modelled by F. E. Meyer, 1763–65; 22 cm high

52 Mars, from a set of classical gods, Nymphenburg, modelled by D. Auliczek, 1763–67; 41.2 cm high

53 Plate with gay floral pattern, St. Petersburg, c. 1780; diameter 23.2 cm

54 A tray with a colourful decoration, St. Cloud, c. 1730; width 23 cm. De danske kongers kronologiske samling på Rosenborg, Copenhagen

55 Designs for porcelain for the Copenhagen Royal Factory, Elias Mayer, coloured pen and ink sketches, c. 1780–90. Den kongelige Porcelainsfabrik, Copenhagen

56 Vase mounted on gilded bronze, Chantilly, c. 1735; 17.3 cm high

57 A porcelain painter at work, France, anonymous drawing, eighteenth century. Manufacture nationale de Sèvres, archives, Sèvres

58 Boy with flute and tambourine, Sèvres, E. M. Falconet, 1757–60; 12.5 cm high. Private collection, Prague

59 Cup and saucer with raised plant design, Capodimonte, 1745–50; cup 6.3 cm high

60 Basket decorated in underglaze blue, Philadelphia, Bonnin & Morris, 1771–2; height c. 6.3 cm. Yale University Art Gallery, New Haven

61 The lion hunt, Nymphenburg, modelled by D. Auliczek, 1765; 11.7 cm high

62 Abundantia (Plenty), Ludwigsburg, modelled by J. C. Bayer, 1766; 25.5 cm high

63 Pot from a coffee set, Ludwigsburg, c. 1770; height with lid 15.8 cm

64 The family, Frankenthal, modelled by K. G. Lück from the painting by J. B. Greuse, 1770; 17.6 cm high

65 Boy at the dog-kennel, Höchst, modelled by L. Russinger, 1760–65; 17.4 cm high

66 Gallantry in an arbour, Ansbach, after 1760; 25.8 cm high

67 The gardener, Chelsea, c. 1756; 25 cm high

68 Plate with figures and buildings in a landscape, in purple, Tournai, before 1770; diameter 23.7 cm

69 Cup and saucer, St. Petersburg, 1830; cup 9.2 cm high. Private collection, Prague

70 Allegory of Night, modelled after the relief by B. Thorvaldsen of 1815, Copenhagen, Royal Factory, after 1867; diameter 35.8 cm

71 Psyché, modelled after a statue by B. Thorvaldsen of 1811, Copenhagen, Royal Factory, after 1867; 31 cm high

72 Rudolph I of Hapsburg, after the statue on the tomb of Maximilian I in Innsbruck dating from the first quarter of the sixteenth century, Prague, before 1852; 25.8 cm high

73 Cup and saucer with pseudo-Gothic ornament, Meissen, before 1850; cup 6.1 cm high

74 Cup and saucer in Neo-renaissance style, Paris, J. Brianchon the Elder, 1878; cup 7 cm high

75 Cup and saucer in Neo-renaissance style, Paris, A. Hachez & Pépin Lehalleur, before 1878; cup 6.5 cm high

76 Coffee-pot, early Art Nouveau period, Březová, c. 1895; 26 cm high

77 Vase with Art Nouveau ornament, Meissen, c. 1910; 40 cm high

78 Venus, Meissen, modelled by Paul Scheurich, c. 1920; 34.8 cm high

79 Part of a tea set in functionalist style, Loket, designed by L. Sutnar, 1928–32; pot 17.7 cm high

80 Covered jar in Art Déco style, Karlovy Vary, c. 1925; 20.2 cm high

81 Jug; Philadelphia, W. E. Tucker. before 1832; height 24.2 cm. Collection of the Newark Museum, Newark

82 Cup and saucer (the oldest surviving Bohemian porcelain); Klášterec, 15th September 1794; cup 5.6 cm high

83 Cup and saucer, Sèvres, signed by the woman painter J. Denois, 1820; cup 9 cm high. Private collection, Prague

84 Large tureen from the Thun service, Klášterec, 1856; height with lid 33.8 cm

85 Cup and saucer, Vienna, signed by the painter Daffinger, early nineteenth century; cup 5.9 cm high. Private collection, Prague

86 Cup and saucer, the cup bears the inscription "Die Königsbrücke in Berlin", Berlin, c. 1835; cup 13.4 cm high

87 The sportsman, Prague, modelled by E. Popp, after 1852; 23.4 cm high

88 Lidded jar, Meissen, c. 1780; height with lid 16.9 cm

89 Cup and saucer, the cup with a portrait of the Emperor Franz Joseph I, Vienna, 1858; cup 13.7 cm high

90 Grinding mill (Fig. 1) and Sieving the ground clay (Fig. 2). From F. J. Weber, *Die Kunst das ächte Porzellain zu verfertigen*, Hanover 1798

91 The shaping shop at the Albrechtsburg works, Meissen, in 1850. VEB Staatliche Porzellan-Manufaktur, Meissen

92 Bull and dogs, fired clay, modelled by D. Auliczek for the Nymphenburg factory, 1765; 12.9 cm high

93 Fig. 1. Cross-section of a Vienna kiln
Fig. 2. Lay-out of a Vienna kiln
Fig. 3. Lay-out of a French kiln
Fig. 4. Cross-section of a French kiln
From F. J. Weber, *Die Kunst das ächte Porzellain zu verfertigen*, Hanover 1798

94 Plate from the "service des Arts Industriels" with a painting of an artist's and gilder's studio, Sèvres, painted by C. Develly, 1823. Musée national de céramique, Sèvres, France

95 The "Mercury's staff" mark on Meissen ware, used c. 1721–2 to c. 1731, underglaze blue

96 An impressed mark, Vienna, 1744–9

97 The AR mark on Meissen ware, used about 1723–36 on porcelain for the king or for royal gifts

98 The Meissen factory mark combined with a "D" in gold; the gold letters seem to have been used to mark all the pieces of a given set

99 Large decorative vase in Revived Rococo style, Březová, before 1846; height 48.8 cm

100 Cup and saucer with pseudo-classical decoration, Březová, after 1853; cup 7.1 cm high

101 Dancing girl, pâte-sur-pâte technique, painting signed "FP" (Paul Albert Fournier), Paris, before 1878; 17 × 9.4 cm

102 Vase in Neo-renaissance style, Meissen, perhaps painted by Gross, c. 1878; 57 cm high

103 Plate in Neo-baroque style, with a view of the Chiemsee, Meissen, c. 1885; diameter 26 cm

104 Cup and saucer in the third (neo) Rococo style, Berlin, late nineteenth century; cup 7 cm high

105 Jug of Parian ware, Bennington, United States Pottery, c. 1855; height c. 18.4 cm, Metropolitan Museum of Art, New York

106 Fruit dish, Copenhagen, Royal Factory, 1905–10; 12.1 cm high

107 Affenkapelle, Meissen, modelled by P. Reinicke, 1765, cast in mid nineteenth century; height of the tallest figure 15 cm

108 The onion pattern, plate, Meissen, 1740, diameter 26 cm. Private collection, Prague

109 Commedia dell'arte, Doctor Boloardo, Meissen, modelled by P. Reinicke, 1743–4; height 13.9 cm

110 Deutsche Blumen, plate from the Clement Augustus service, Meissen 1741–2; diameter 25.5 cm

111 Plate from the "Flora Danica" service, Copenhagen, painted by J. C. Bayer, after 1769. De danske kongers kronologiske samling på Rosenborg, Copenhagen

112 Guineapigs, Berlin, 1914–18; 10.5 cm high

113 Woman with a muff, Meissen, 1910; 33 cm high

114 Part of an Art Nouveau coffee service, Karlovy Vary, c. 1900; pot 25 cm high

115 Plate with Art Nouveau decoration, Klášterec, after 1900; diameter 23.5 cm

116 Woman with a small hat, Nymphenburg, c. 1925; 22.3 cm high

117 Militiawoman, Petrograd, modelled by Natalia J. Danko, 1920; 21.4 cm high

118 Der Flötenunterricht, Vienna, modelled by D. Pollion, 1765–70; 27.8 cm high

119 Harlequin, Meissen, modelled by J. J. Kaendler, 1736; 12.5 cm high. Private collection, Prague

120 Girl in a swing, Chelsea, c. 1750. Victoria and Albert Museum, London

121 The music lesson, Chelsea, c. 1765; 40 cm high. Metropolitan Museum of Art, New York

122 L'agréable leçon, engraved by R. Gaillard from the painting by Boucher, 1758

123 La leçon du flageolet, Vincennes, drawn for the factory by F. Boucher, 1752; 26.7 cm high

124 Girl playing the flute, Prague, modelled by E. Popp, after 1852; 15.3 cm high

125 An independent decorator, painted by Ignaz Preissler 1725–30 on Böttger's Meissen porcelain; height with lid 15 cm

126 Indian flowers, underglaze cobalt and bright overglaze painting, Meissen, c. 1735; diameter 38.4 cm

127 Imari decoration, "yellow tiger" pattern, Meissen, c. 1740; diameter 34 cm

128 Porcelain cabinet, decoration of the cabinet in the Dubský Palace, Brno, executed by the Vienna factory, 1725–30. Österreichisches Museum für angewandte Kunst, Vienna

129 Kakiemon, cup and saucer, Meissen, 1725–30; cup 6 cm high

130 Guineafowl, Copenhagen, Bing & Grøndahl, c. 1910; 17.5 cm high

131 Lithophany (Berlin transparency), Bohemia, after 1830; 54.3 cm

132 Pagoda, Meissen, Böttger's porcelain, 1715–20; 10.2 cm high

133 Scale-pattern (écaille), saucer, Meissen, c. 1760; diameter 13 cm

134 Cris de Vienne, a Slovak and a vegetable-woman, Vienna, 1760; 18.4 and 20.8 cm high, respectively

135 Ground colour porcelain, covered tureen, "Seegrün" ground, white reserve panels gaily painted, Meissen, c. 1740; height with cover, 13.8 cm

136 Pot-pourri jar, Vienna, 1755–60; 28.8 cm high

137 Trembleuse, Vienna, c. 1725; cup 7.9 cm high

138 Schneeballbelag, covered jar, Meissen, c. 1745; height with lid 12.7 cm

139 Goldchinesen, painted by Abraham Seuter, Augsburg, c. 1721, on a Meissen "Ollientopf"; height with cover 13.5 cm

140 Porcelain coins, Meissen, Böttger type stoneware, 1921; largest diameter 3.1 cm

141 Réchaud, Vienna, 1827; total height 23 cm

142 Schwannenservice, plate, Meissen, after 1740; diameter 23 cm

143 Solitaire, painted after oriental lacquer work, Vienna, c. 1795; jug 12.3 cm high; tray diameter 31.3 cm

144 Plate from the Sulkowski-Service, Meissen, after 1735; diameter 38.6 cm

145 Tureen with the raised Sulkowski-Ozier pattern and Kakiemon style painted decoration, Meissen, after 1735; height with cover 27.5 cm

146 Teapot, Weesp, c. 1765; height without handle 14.5 cm. Private collection, Prague

Summary
of Sources

Museum of Decorative Arts, Prague, Czechoslovakia

1, 5, 6, 7, 8, 9, 10, 11, 12, 13, 17, 18, 19, 20, 21, 22, 23, 24, 25, 27, 28, 29, 32, 34, 35, 36, 37, 38, 39, 40, 41, 42, 43, 44, 46, 47, 48, 49, 50, 51, 52, 53, 56, 59, 61, 62, 63, 64, 65, 66, 67, 68, 70, 71, 72, 73, 74, 75, 76, 77, 78, 79, 80, 82, 84, 86, 87, 88, 89, 90, 92, 93, 95, 96, 97, 98, 99, 100, 101, 102, 103, 104, 105, 106, 107, 109, 110, 112, 113, 114, 115, 116, 117, 118, 122, 123, 124, 125, 126, 127, 129, 130, 131, 132, 133, 134, 135, 136, 137, 138, 139, 140, 141, 142, 143, 144, 145

Private collections, Prague, Czechoslovakia
26, 45, 58, 69, 83, 85, 108, 119, 146

Museo di Capodimonte, Naples, Italy
3

Staatsarchiv, Dresden, GDR
2

Österreichisches Museum für angewandte Kunst, Vienna, Austria
4, 128

Musée national de céramique, Sèvres, France
14, 94

Manufacture nationale de Sèvres, archives, Sèvres, France
57

VEB Staatliche Porzellan-Manufaktur, Meissen, GDR
15, 16, 30, 31, 33, 91

Den Kongelige Porcelainsfabrik, Copenhagen, Denmark
55

Collection of the Newark Museum, Newark, USA
81

Metropolitan Museum of Art, New York, USA
105, 121

De danske kronologiske samling, Rosenborg-Copenhagen, Denmark
54, 111

Victoria and Albert Museum, London, Great Britain
120

Yale University Art Gallery, New Haven, USA
60

Index of Names and Places

Roman numbers indicate pages.
Numbers in italics are those
of the illustrations.